buddha

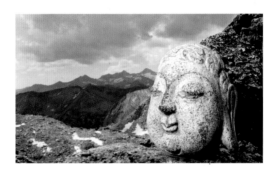

THIS IS A CARLTON BOOK

Text copyright © 2003 Michael Jordan
Design copyright © 2003 Carlton Books Limited

This edition published by
Carlton Books Limited
20 Mortimer Street
London W1T 3JW

ISBN 1–84222–944–3

Printed and bound in China

Editorial Manager: Judith More
Art Director: Penny Stock
Project Editor: Catherine Rubinstein
Design: DW Design
Production Manager: Marianna Wolf
Picture Researcher: Elena Goodinson
Index: Diana LeCore

The author and publisher have made every effort
to ensure that all information is correct and up to
date at the time of publication. Neither the
author nor the publisher can accept
responsibility for any accident, injury or damage
that results from using the ideas, information
and advice offered in this book.

Right
A person walking by the
foot of the vast Buddha at
Leshan, Sichuan province,
China (see pages 166, 168
and 180) brings home its
dramatic size.

buddha

HIS LIFE IN IMAGES

michael jordan

CARLTON
BOOKS

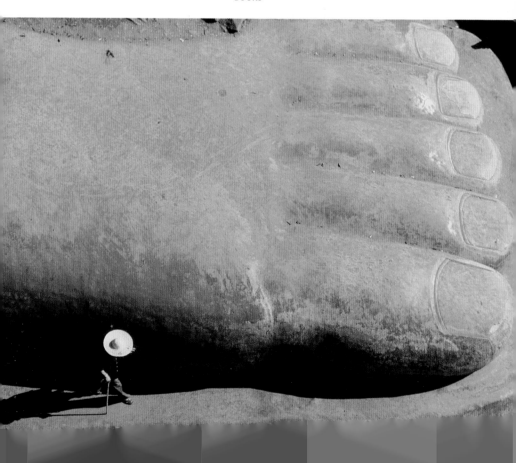

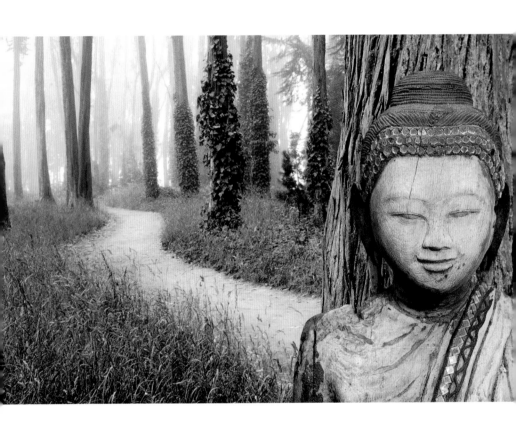

CONTENTS

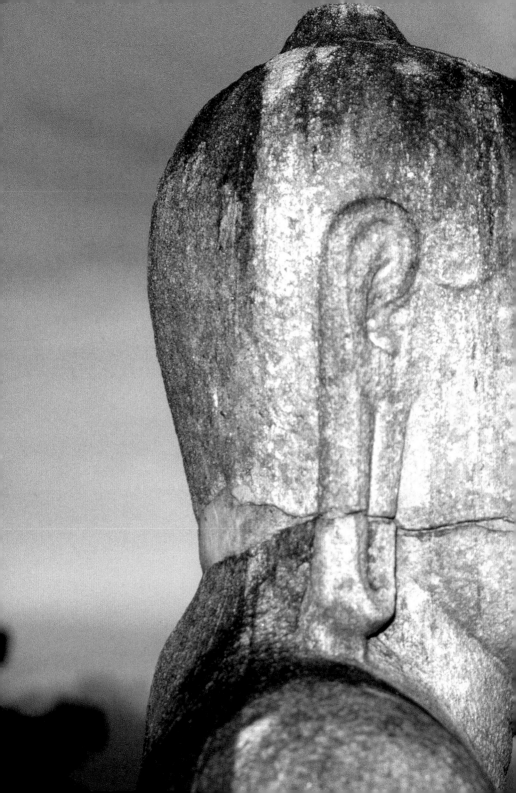

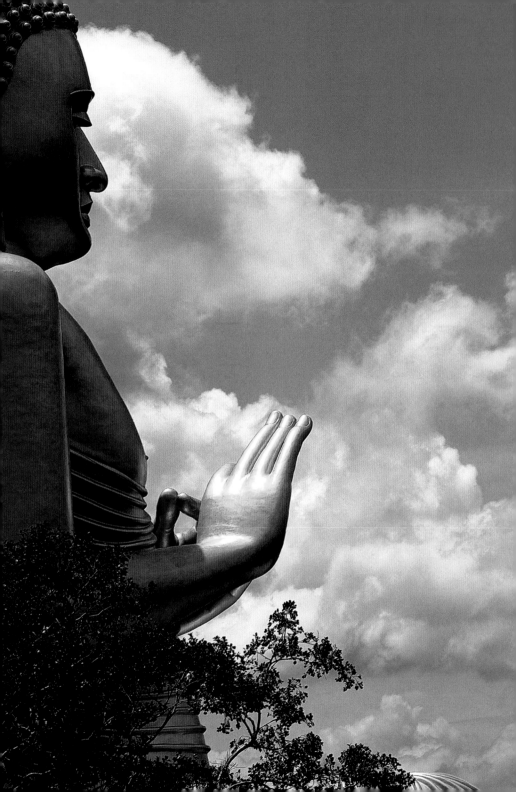

FOREWORD

From its roots as a monastic movement in northeast India more than 2,500 years ago, Buddhism is now the fastest- growing global religion, with a congregation estimated at between 150 and 300 million. Its devotees are concentrated mainly in Southeast Asia but they are to be found in every continent. Outside of India, the greatest impact has been in Sri Lanka, Tibet, Indo-China, China, Korea and Japan.

Buddhists understand that the cycle of human existence from birth to death and to rebirth, *samsara*, is a cycle of suffering, caused by ignorance of reality and craving for things essentially unreal. It is to be overcome by enlightenment, and this spiritual awareness may be gained through study of the doctrine, *dharma*, and through following the correct path of discipline, *vinaya*. These are the Four Noble Truths that set a human on the difficult path towards becoming a *buddha*; less a personal name than an expression describing one who has achieved perfect enlightenment.

The most profound expressions of Buddhist faith and practice include collections of ancient scriptures and an extraordinary wealth of art and architecture – inspired by the beliefs of Buddhism but at the same time shaped by the skills, conventions and preferences of artists working across a vast range of countries, cultures and epochs. **Buddha** is a celebration of these exquisite, often quite breathtaking words and images.

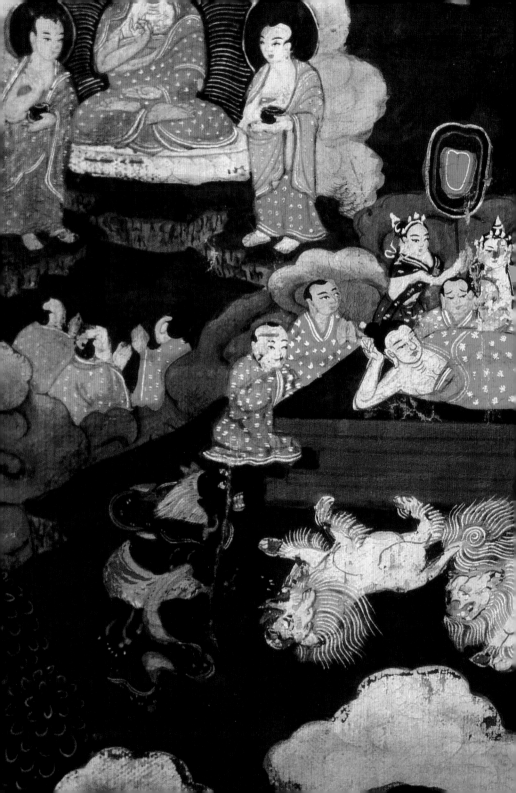

1
The
Buddha
Story

"It is hard to be born as a human being; The life of mortals is truly onerous. Burdensome is the learning of the true path. And difficult is the dawn of enlightenment."

From the *Dhammapada*

Once in a while in the history of the world an ordinary person achieves the extraordinary during his or her lifetime. He or she becomes imbued with true greatness and leaves an enduring impression on the record of human achievement. Such a person was Gautama Siddharta: it was through his inspired vision and power of self-resolve that the faith of Buddhism came to be.

Siddharta was born at Kapilavastu (Lumbini), near Gorakhpur in the Himalayan foothills, in the mid-sixth century BCE (Before Common Era, equivalent to BC). His father Suddhodhana was king of the Shakya people, a clan dominating a hilly part of northern India that would later became incorporated with Nepal. Romance has it that his mother, Queen Maya, conceived while still a virgin after an elephant placed a white lotus in her womb, and that the child Siddharta emerged from her thigh.

Previous page
The Buddha reclines, surrounded by his followers, in a scene from his later life. Tibet, 18th century.

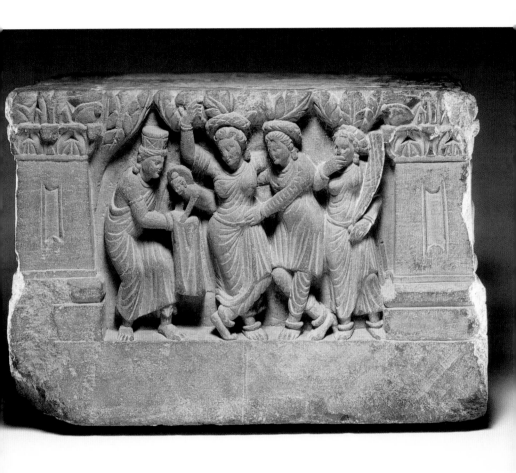

Above

Stone relief depicting the birth of Gautama Siddharta, later to become the Buddha, from the thigh of his mother, Queen Maya, beneath a tree in the gardens at Lumbini (Kapilavastu). Eastern India, 10th century.

13

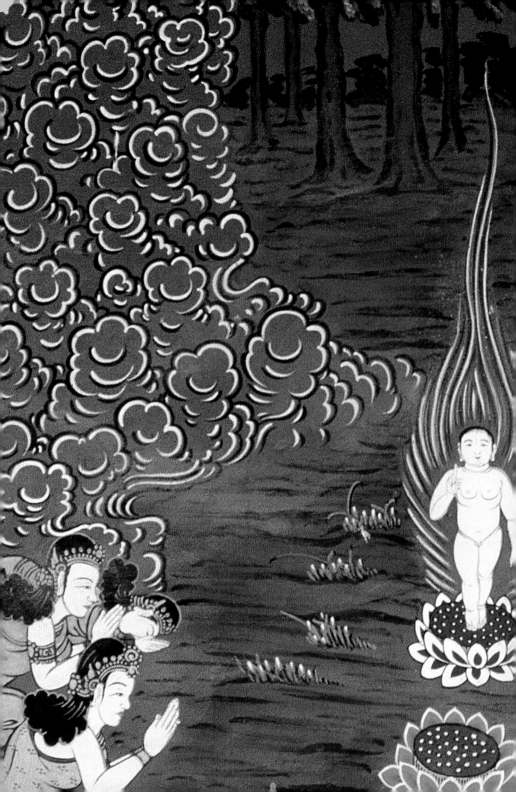

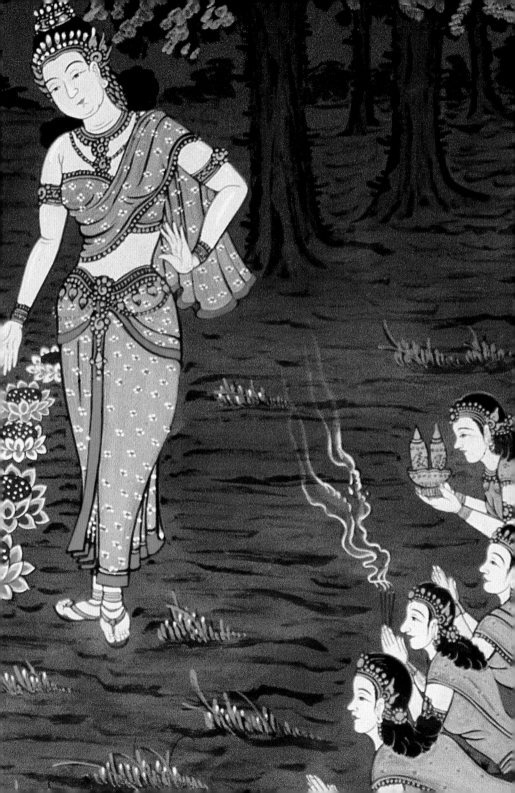

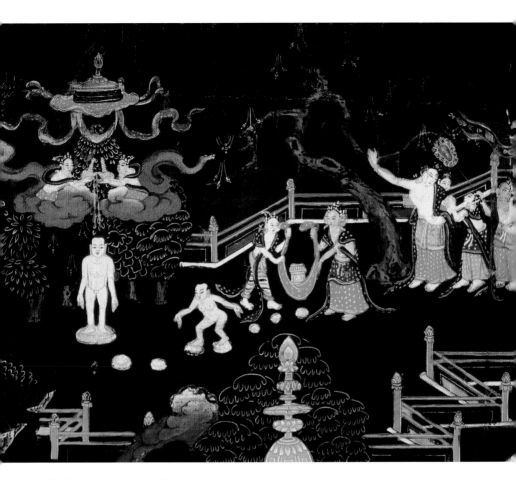

Previous page

Painting of the birth of Gautama Buddha from a lotus blossom, attended by his mother, Queen Maya. Temple of Yongsu, Suwon, South Korea.

Above

Detail from a painting of stages in the babyhood of Siddharta, depicting his birth from his mother's side, his first seven steps in each direction of the compass and his bath. Tibet, 18th century.

Right

Detail from the ten symbolic stages in the spiritual development of a Buddhist. From a series of murals adorning the exterior of Chogye-sa temple, Seoul, South Korea.

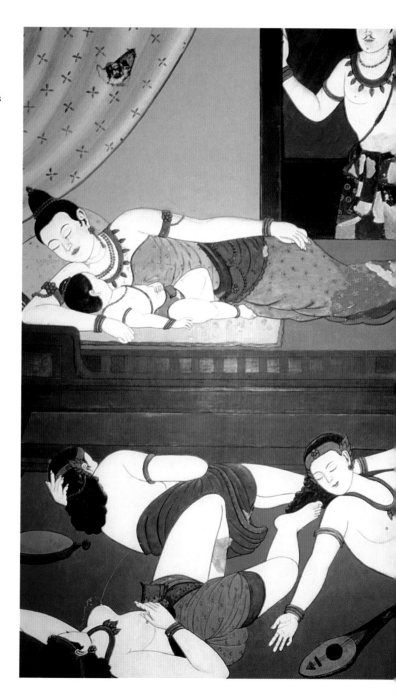

"Happy indeed are we
who live possessing nothing.
Let us feed on joy,
like the shining gods."

From the *Dhammapada*

In reality, Siddharta seems to have grown from babyhood to adolescence and manhood much like any other youngster from a privileged Hindu background. As some of the images from his youth suggest, he played, laughed and danced his way through the years with scarcely a care. Yet there is also a familiar pose of the mature man, depicted in Buddhist art down the centuries, that relates to a more significant childhood incident. Immediately after his birth, goes the legend, Siddharta took seven steps to the east, south, west and north with his right hand raised in a gesture of fearlessness, *abhayamudra*, and his left turned downwards in the grant of wishes, *varadamudra*. His uncertain infant steps represent a foretaste of momentous things to come.

Right
Modern sculpture depicting a dancing Siddharta by Clough William Ellis. Portmeiron village, Wales.

Left

Siddharta practising
archery with a playmate,
watched by his parents, in
the gardens of the royal
palace at Lumbini. Painting
on canvas, China, 8th–10th
century CE.

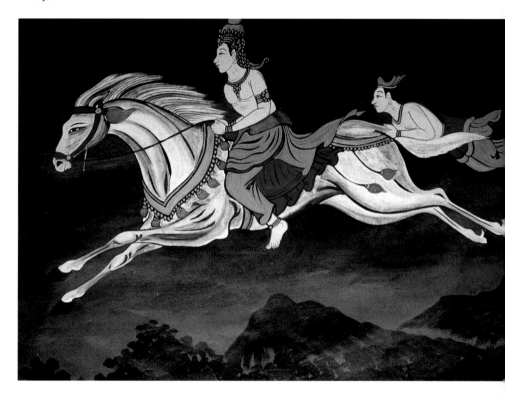

Above

Siddharta mounted upon a
flying horse, accompanied
by a disciple, as he
abandons his family and
the privileged existence of
his youth to become an
ascetic. Temple of Yongsu,
Suwon, South Korea.

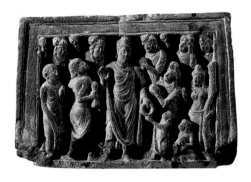

"From meditation comes wisdom. But through lack of meditation, wisdom is lost. Whoever understand this twofold path of rise and fall must strive towards gaining wisdom."

From the *Dhammapada*

As a young teenage prince, Siddharta married his cousin Princess Yasodhara; he continued enjoying a hedonistic life of luxury for more than another decade, until he reached the age of 29. Then Yasodhara gave birth to a son, Rahula, and with the new arrival there came an unexpected change of purpose and vision that was to drive Siddharta for the rest of his life. He chose to abandon family and material possessions and became a mendicant, an ascetic monk travelling the hot and dusty roads of India in a quest for understanding of *samsara*, the endless and painful cycle of life and death that he had grown up with as a Hindu believer.

Discarding all material possessions other than a ragged shirt, a staff and a begging bowl, he wandered from place to place for six years, begging food and alms, emulating the ways of the Hindu ascetics, until chance brought him to rest from the heat beneath the shade of a *bodhi* (pipal) tree on the banks of the River Nairanjana in the Ganges basin, in what is now the Indian state of Bihar. There he sat, pondering on existence, and there, at the place that was to become known as Bodh Gaya, the Buddhist "Navel of the Earth", he finally found the answers to the questions that had been troubling him for so long and at such physical cost.

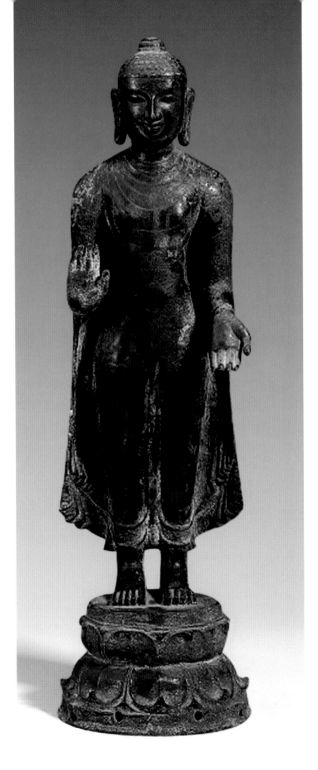

Opposite
Stone frieze depicting a
moment in the life of the
Buddha as a wandering
ascetic, holding out his
begging bowl and
surrounded by disciples
as two boys offer him a
handful of dust to eat.
Gandhara (northern
Pakistan/Afghanistan),
c. 3rd century CE.

Left
Gautama Buddha standing
on a lotus, his right hand
raised in a gesture of
reassurance, the
abhayamudra, and his
left lowered in the
varadamudra. He wears a
diaphanous robe. Bronze
sculpture, south India,
11th century.

"The mind goes before its objects. They are created and controlled in the mind. To speak or act with a mind that is muddied is to draw pain like the wheel drawn by the feet of a beast of burden."

From the *Dhammapada*

Below

Painting of Gautama Buddha seated in meditation on a lotus throne with a fiery *mandorla*, one of the emblems of his spiritual power, surrounding him. Temple of Yongsu, Suwon, South Korea.

Right

The wheel of life, the *dharmacakra*, is turned by Yama, Lord of Death. Around the periphery are scenes symbolizing the causes of painful rebirth, *samsara*. Wall hanging, Tibet.

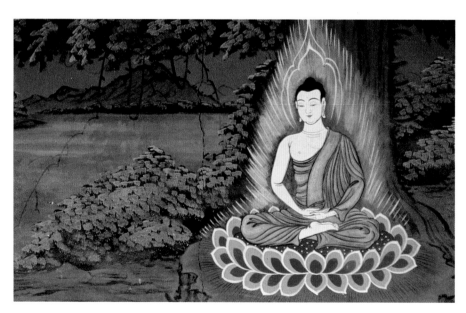

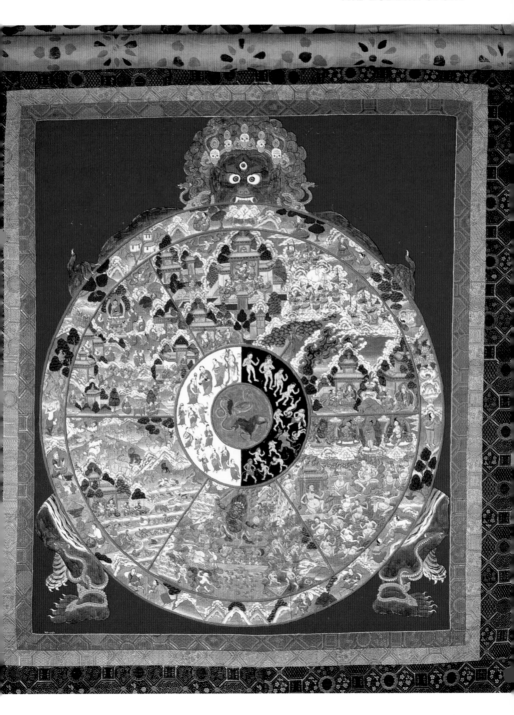

For the last and decisive time, Gautama Siddharta wrestled with the temptations of the material world and its values, in the shape of the demon Mara. For many days and weeks, seated beneath his *bodhi* tree, he fasted, eating no more than a grain of rice a day and reaching a state of emaciation that brought him close to death. He was also in a state of disillusionment as the realization dawned that physical deprivation and mental discipline had not succeeded in bringing him any closer to the enlightenment he craved.

Tradition has it that one day he bathed himself in the river and, on his return, a peasant girl persuaded him to accept some food. The nourishment

Right
Stone carving of Gautama Buddha as an emaciated ascetic, seated in meditation and wearing rags. The nimbus framing his head is a mark of greatness. Gandhara style, displaying clear Greek influence. Northern Pakistan/Afghanistan, 1st–4th century CE.

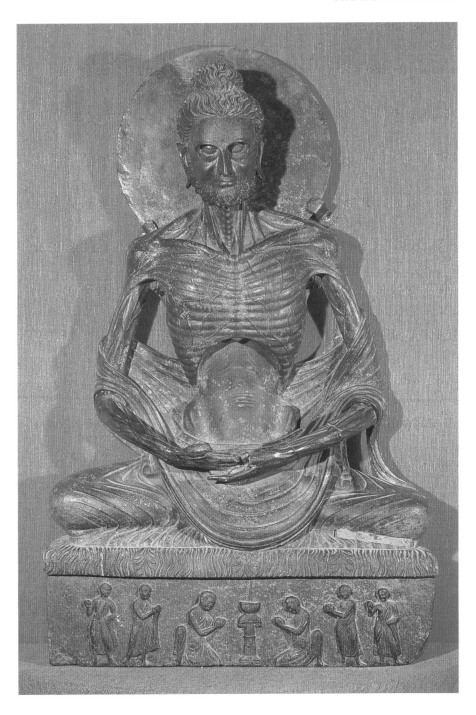

Right

Gautama Buddha seated in an elevated position above the world, accompanied by his disciples Sariptura and Maudgalyayana, his right hand touching the earth in the *bhumisparsamudra* gesture. Tibet, 18th century.

both strengthened his resolve against Mara and brought him understanding that extreme denial was not the right path to follow to enlightenment: there was a better Middle Way, involving neither indulgence nor extreme deprivation but rather self-discipline and denial of material pleasures.

When Mara challenged him to prove that he was on the verge of enlightenment – that he was what was to become termed a *bodhisattva*, a *buddha*-elect (see page 39) – he responded with a small gesture that has captured the imagination of artists the world over. He reached down and touched the ground with the fingertips of his right hand. The power of this apparently insignificant movement triggered a massive earthquake, from which Mara and his demonic attendants fled in terror. During the night that followed, Siddharta witnessed a dream-like revelation of all his past incarnations, birth leading inexorably to death. Now, at last, he understood the reality of *samsara* and the material world that governs it. He had achieved the perfect enlightenment for which he had striven with such immense pain and denial.

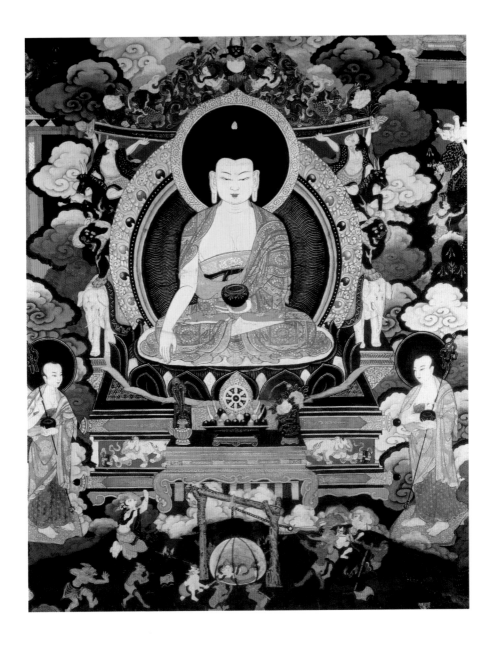

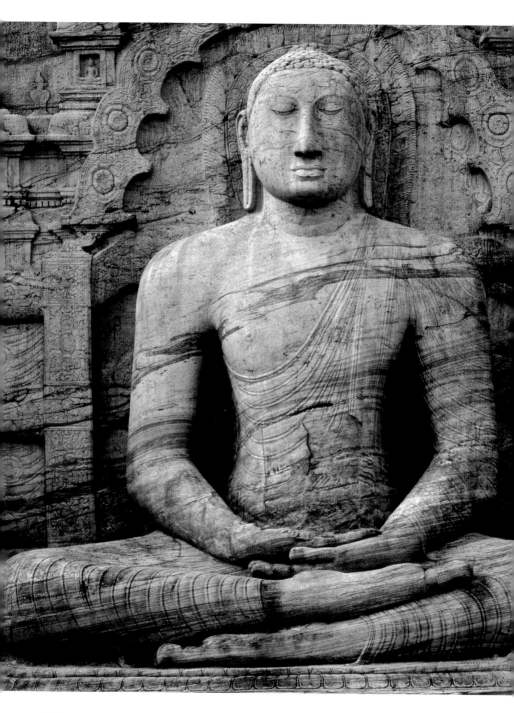

Siddharta was to live for some forty more years, during which it is said that he delivered nearly 50,000 sermons of varying length. His followers during these long years of pilgrimage spoke of him familiarly as Shakyamuni, "the wise man of the Shakya people", while the world came to recognize him as the living Buddha. The term *buddha* is often misunderstood. Strictly speaking, it refers to a state of mind, perfect enlightenment, the way to *nirvana* that Shakyamuni believed could end the cycle of life and death, but it is also used to denote a being who has achieved this enlightenment. Shakyamuni Buddha is alternatively known as Gautama Buddha.

Left
Imposing granite carving of Gautama Buddha seated in meditative repose and framed by an ornate temple niche. Gal Vihara rock shrine, Polonnaruwa, Sri Lanka.

Some of the finest art of Buddhist sculptors and painters provides reminders of key events that took place during the years after the Buddha's enlightenment. One of the more symbolic icons is a pair of footprints on which are superimposed spoked wheels. This depicts an incident when a Brahman who was walking behind the Buddha noticed that the imprint of his feet in the soft earth included the outline of a wheel with a thousand spokes, the number of followers in the first Buddhist community or *sangha*.

As the Buddha gained recognition, his father, Suddhodhana, decreed that one male heir from each branch of the Shakya nobility should enter the infant Buddhist *sangha*. Among the earliest converts to the new faith were two men who were destined to accompany their leader for the rest of his life: an ascetic named Sariputra and one of the Shakya nobility, Ananda, who became the person closest to the Buddha and his personal assistant. These and others are often included in group sculptures, usually standing beside the Buddha to his left and right.

Another personality of significance in his life was Devadatta, a cousin who became increasingly jealous of his authority and eventually rebelled against him when the Buddha was about 70 years of age, attempting his assassination on more than one occasion (see page 251). At first this caused a schism amongst the ranks of disciples, but Devadatta eventually became an outcast and is said to have descended into the lowest realms of hell when he died.

Left
Relief sculpture in stone of the wheel of life, the *dharmachakra*, superimposed on the footprint of Gautama Buddha. From the great stupa at Sanchi, India, built by King Ashoka. Maurya Dynasty, 3rd century BCE.

Others among Shakyamuni's former
clansmen refused to acknowledge him
as the Buddha, and so in order to
persuade them of his true credentials he
performed a miracle. Before a crowd of
sceptical onlookers at Kapilavastu
(Lumbini), the place of his birth, he
arose into the air, at the same time
causing flames to erupt from his head
and streams of water to cascade from
the lower part of his body. He then
created a pavement of precious stones
in the sky, along which he walked.

Not even his extraordinary powers
over fire and water, however, quite
matched up to a remarkable spectacle
that the Buddha is said to have
performed on the banks of a tributary of
the Ganges. After the early death of his
mother, Maya, he is believed to have

Right
Stele in white marble
depicting Gautama Buddha
seated beneath the *bodhi*
tree at Bodh Gaya,
surrounded by
bodhisattvas and other
disciples, his right hand
raised in the *abhayamudra*
gesture. From Lincheng,
Hebei province, China.
Northern Qi Dynasty,
6th century CE.

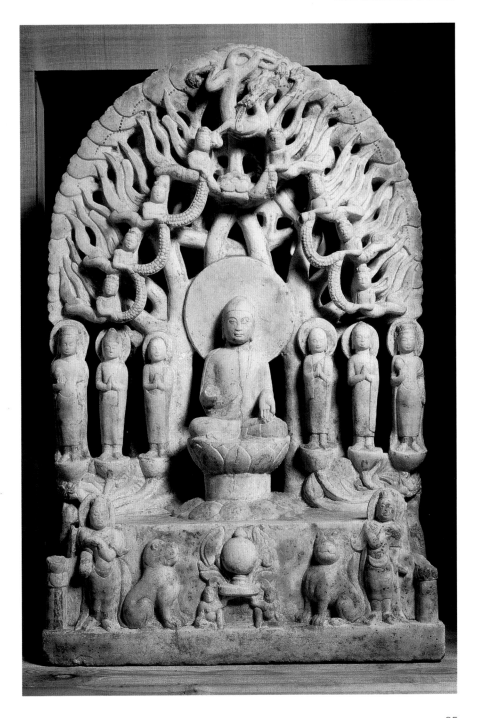

ascended to the heaven of the 33 major Hindu gods, the *triyastrimsa*, in order to persuade her to embrace the True Path of enlightenment. It is his return to earth, at a place called Samkasya, that is celebrated most vividly in art. One night, at the time of the full moon, he willed into being three gold and silver staircases encrusted with precious stones, and was seen by the local townspeople descending in glory accompanied by two of the greatest of the Hindu deities, Brahma on his right and Indra to the left.

It is important to keep in mind that the Buddha grew up as a Hindu, respecting the pantheon of Hindu gods and goddesses. Buddhism does not

Right

Gautama Buddha at Samkasya, descending from heaven down the triple staircase accompanied by Brahma and Indra, after urging his mother to embrace the Buddhist faith. National Museum, Bangkok, Thailand, 18th century.

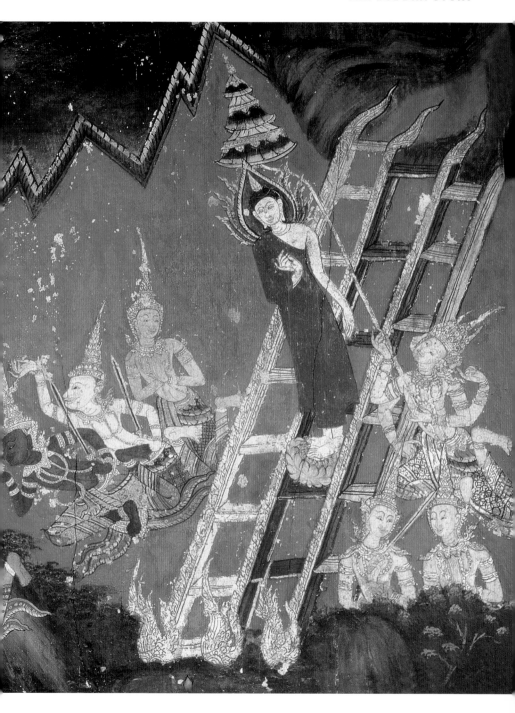

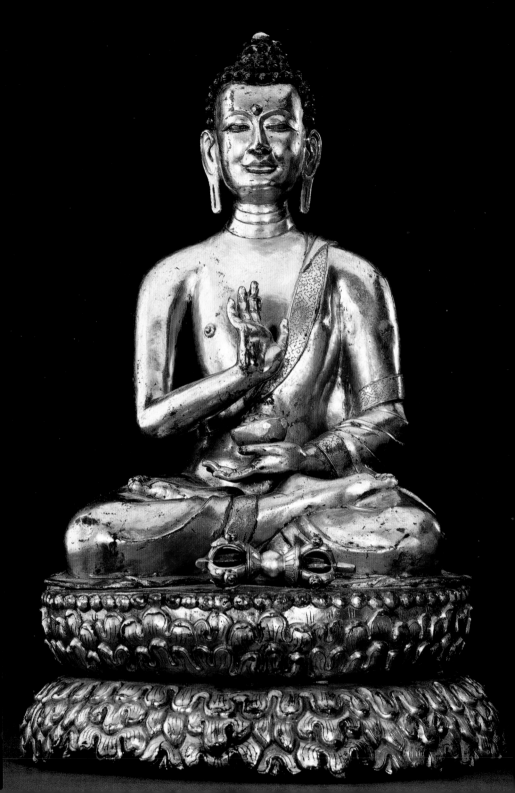

generally encompass the worship of deities, but it does recognize more than one being who has achieved the highest enlightenment and become *buddha*. According to Mahayana tradition (see pages 50–53), Shakyamuni was the fourth in a line of living *buddhas* or *manusibuddhas*, his predecessors having lived in a "once upon a time age". The fifth living Buddha, Maitreya, is yet to come. Mahayana Buddhists also revere Adibuddha – the essential divine Buddha, primordial force in the universe – and five spiritual beings or *dhyanibuddhas*, envisaged as manifestations of Adibuddha: Vairocana, Aksobhya, Ratnasambhava, Amitabha and Amoghasiddhi.

It is perhaps the close of the Buddha's earthly life and his departure to *nirvana*, the Buddhist paradise, finally rid of the cycle of death and rebirth, that

Left
Bronze of the *dhyanibuddha* Aksobhya seated upon a lotus throne, his right hand raised in *abhayamudra* and his left holding a skull as a begging bowl. Before him is a *vajra* or lightning trident. Tibet, 17th century.

Below

The *dhyanibuddha* Vairocana in gilded dry lacquer, with an elaborate *mandorla* that includes a large number of *buddhabimbas* representing his many manifestations. Beyond him is the thousand-armed goddess of mercy, Kannon, derived from the *bodhisattva* Avalokitesvara. Toshodai-ji temple, near Nara, Japan, 8th century CE.

Right

Seated image of Ratnasambhava, one of the five spiritual *dhyanibuddhas*, emanations of the Adibuddha. Sculpted in bronze with silver and copper inlays. Tibet, 14th–15th century.

Overleaf

A monk holding a traditional umbrella appears dwarfed beside a massive reclining image of Gautama Buddha, some 14 metres (46 feet) in length, carved in granite. Gal Vihara rock shrine, Polonnaruwa, Sri Lanka, 12th century.

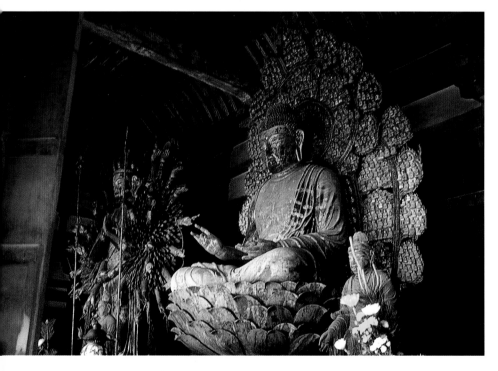

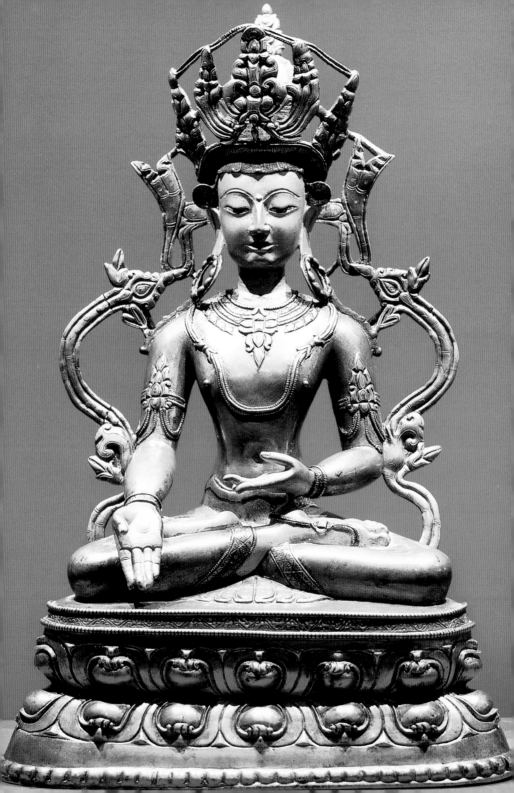

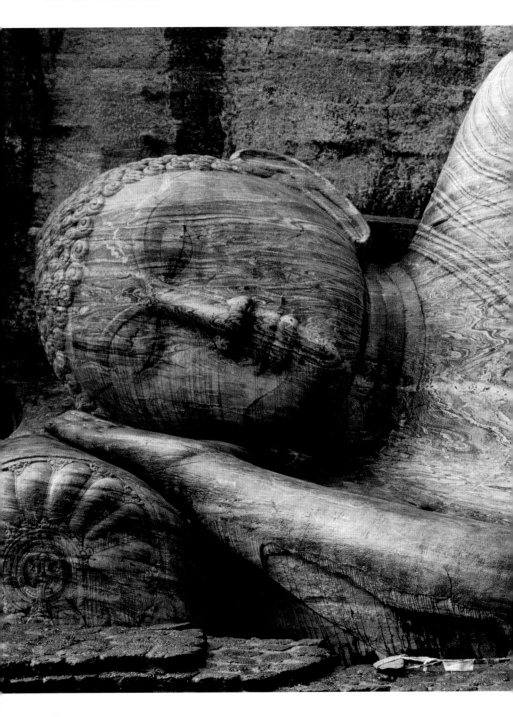

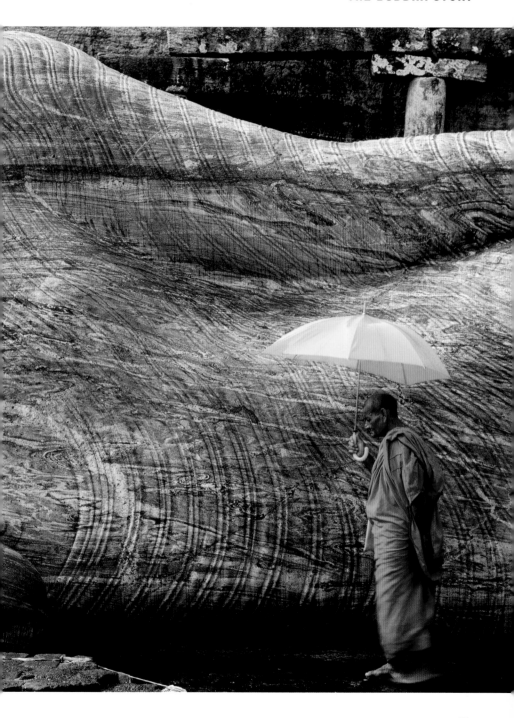

has captured the attention of artists in the most memorable fashion. His death is said to have come in 486 BCE. As an old man, having become progressively frail, he walked, as was his lifelong custom, to a small village called Kusinagara near the Nepalese border. There he commanded his closest followers to bring him a last meal. True to his code of physical deprivation, it was to be the "food of pigs". He ate alone and in great pain before asking to rest beside a small muddy stream, which he first commanded to run clean as his final earthly miracle.

Then he was laid upon a couch on his right side with his head pointing to the north. He died during the night and was cremated by his closest followers. He had not chosen to name a successor, so there was no future Buddha incarnation standing in the wings, and for 25 centuries Buddhism has been without a central authority. If there is to be another living Buddha, the Maitreya, he awaits his incarnation somewhere in humankind's future.

The last words of instruction uttered by the *manusibuddha* of history to his disciples as he lay dying remain appropriately enigmatic: "Impermanent are all composites, strive earnestly."

Right

Brightly painted figure of Gautama Buddha lying on his right side in the final repose of death. The fiery *mandorla* backdrop may indicate his cremation. Chayamangkalaram temple, Malaysia.

"I have run the course of many rebirths, seeking the builder of the dwelling. The endlessness of rebirth is a poignant thing. But now, builder, I have found you out and you shall not build this house again. Your rafters are broken, your ridge-pole shattered. My thoughts are stilled, my desires snuffed out."

From the *Dhammapada*

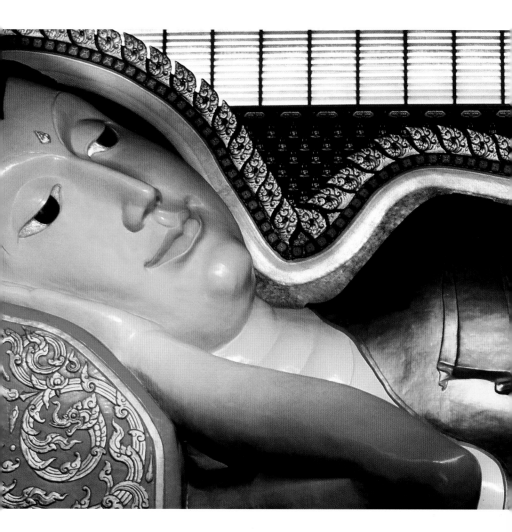

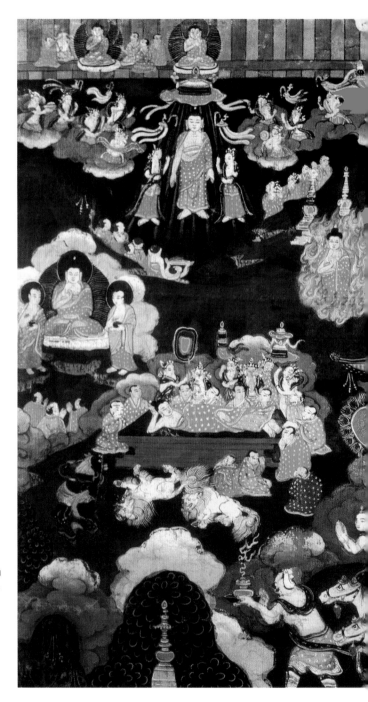

Right
Scenes from the life of
Gautama Buddha, including
his cremation on the banks
of a small river at
Kusinagara, attended by
his closest followers,
among whom his remains
are being divided. Tibet,
18th century.

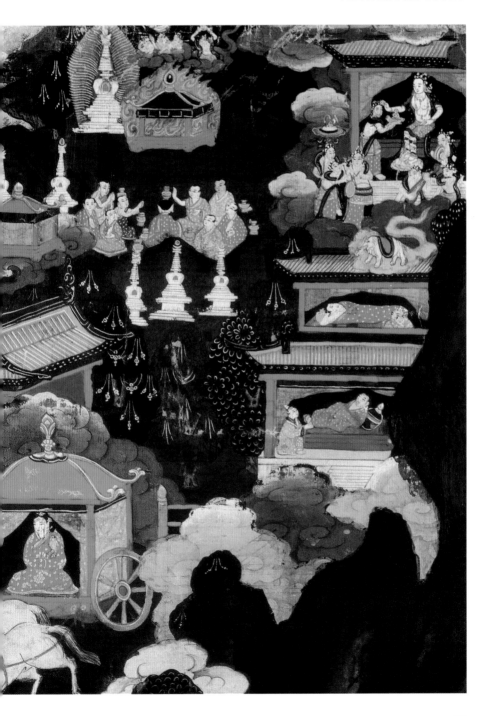

2
A Sense
of Place…

Buddhism has been described as "The Vagrant Lotus" – a curiously apt title because the history of Buddhism has been one of movement or migration from one culture to another. Like no other major religion, it has adapted itself to local beliefs and traditions along the way. It spread from its heartland and birthplace in northern India like the ripples from a pebble cast into a pond and, as a consequence of its willingness to accommodate the beliefs of others, it evolved with its own distinct "national" flavour in every country it reached. The Buddhism of India is accountably different from that of Thailand, or Cambodia, Burma or Tibet; that of China stands in sharp contrast with all these and its traditions differ still further from those found in Korea and Japan. Yet it would be wrong to imagine that this was ever an easy expansion. The transplanting of Mahayana Buddhism from India to China represents one of the most extraordinary achievements in religious history, achieved by wholly peaceful means and without the backing of empires.

After the death of Gautama Buddha, the fledgling Buddhist movement separated into two wings. This was an amicable parting of the ways that probably took place gradually over several centuries, and the underlying reasons for the split are not entirely clear. Probably differences of opinion arose about the best way to interpret the monastic rules or *vinaya* that the Buddha laid down during his lifetime.

Theravada Buddhism (the Way of the Elders) is the older and more conservative wing of the religion, as followed by the early Buddhist communities in India. Theravada is also sometimes called Hinayana, meaning the Lesser Vehicle, but the term is not popular because it appears derogatory. Despite the implications of the name, this school eventually became the more widespread form of Buddhism and remained loyal to the letter of the Buddha's teaching. Theravada includes some magical aspects and also recognizes a number of Hindu deities and other celestial beings in six heavens, but focuses mainly on Gautama Buddha. The *bodhisattva*

Right
Detail from the depiction of a thousand buddhas painted on the ceiling of cave 10 in the Ajanta cave-temple complex, Maharashtra state, India, 2nd century CE.

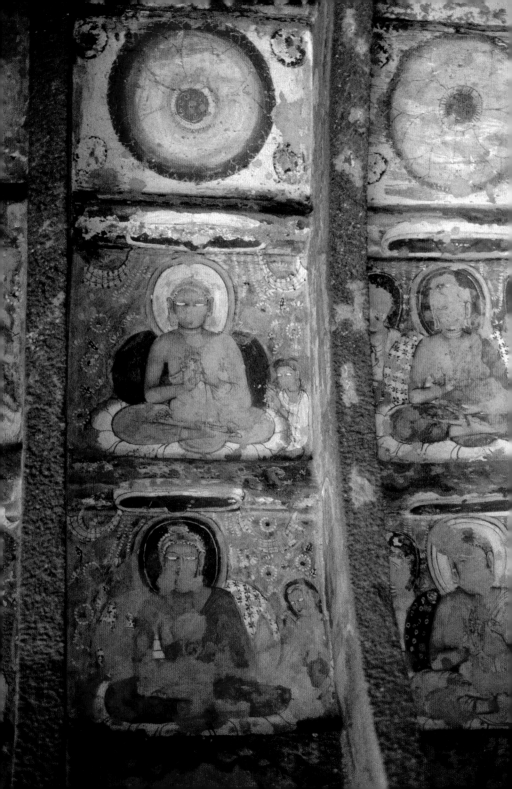

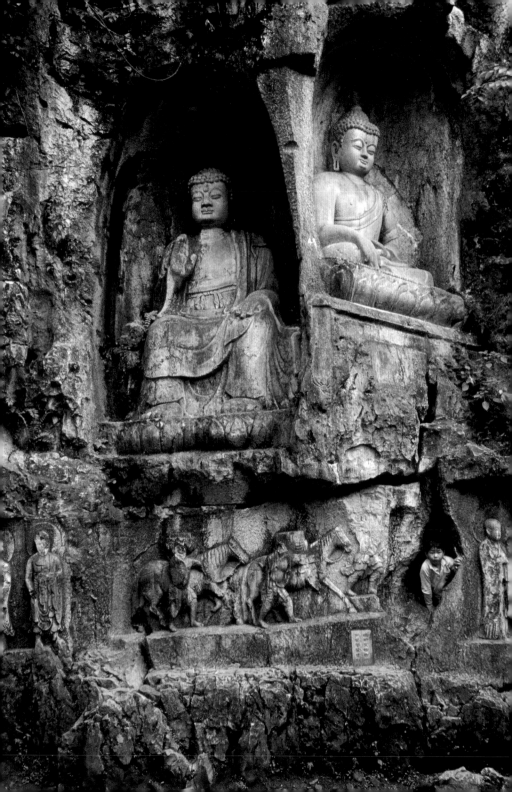

Avalokitesvara features strongly in Theravada art, but often known by regional names, such as Lokesvara in Thailand and Lokanat in Burma.

In about the first century CE a second school, somewhat more liberal and democratic in its outlook, broke away from Theravada. Known as Mahayana (the Great Vehicle), it emphasized individual interpretation of Buddhism, with a variety of approaches to achieving enlightenment and a major role for *bodhisattvas* (*buddhas*-in-waiting), who were seen as delaying their own salvation in order to help others attain theirs. Mahayana acquired an aura of the supernatural and a complex celestial cosmology of *manusibuddhas* and *dhyanibuddhas* (see page 39), evident in its art. Over the years the school developed splinter movements, ranging from the dramatic, magical Vajrayana Buddhism of Tibet to the austerely meditative Zen, and this diversity is also reflected in art.

The two schools expanded in different directions. Interest in Theravada was strongest in southern India and from there spread to Sri Lanka and then east through Burma, Thailand and the rest of Indo-China. Mahayana expanded northwards, first into Nepal and then through Tibet to Mongolia and China and finally east to Korea and Japan. With each move, Buddhist disciples successfully blended their own beliefs with those of the older-established ethnic creeds, including Wu in China (Taoism was still in a fledgling state) and Shintoism in Japan.

In each country, the art of Buddhist sculptors and painters willingly took on the colouring and styles demanded by local traditions, and with this any Indian influence eventually faded away. Names, roles and sometimes even the sex of *buddhas* also changed or adapted. By the time he has migrated to China and Japan, Avalokitesvara, the original Indian *bodhisattva* (probably first modelled on the Hindu god Vishnu), has been transformed into Guanyin and Kannon respectively. This popular masculine icon of Mahayana, recognized both in Nepal and as the tutelary Buddha of Tibet, takes on distinctly female form, becoming a much-loved goddess of mercy.

Opposite
A boy peers from a crevice beneath rock carvings of *buddhas* near Lingyin-si temple, Hangzhou, Zhejiang province, China, 10th–14th century.

Overleaf
An unusually positioned semi-reclining *buddha* in front of a *stupa* in Myanmar (Burma).

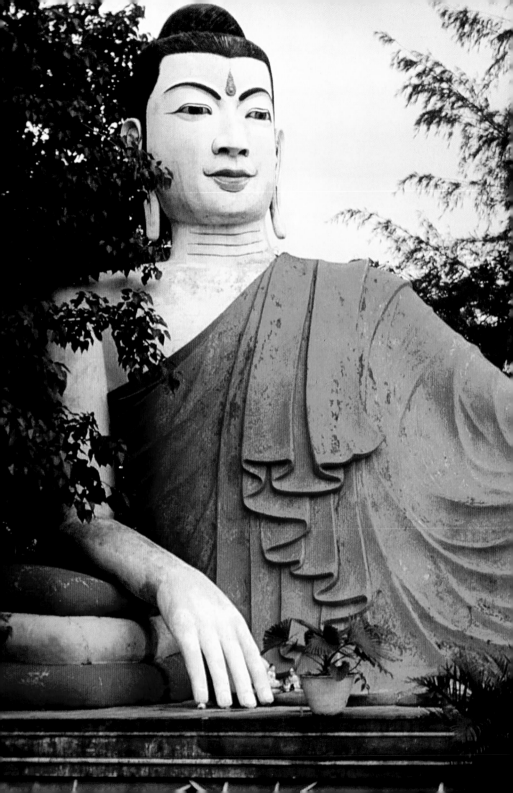

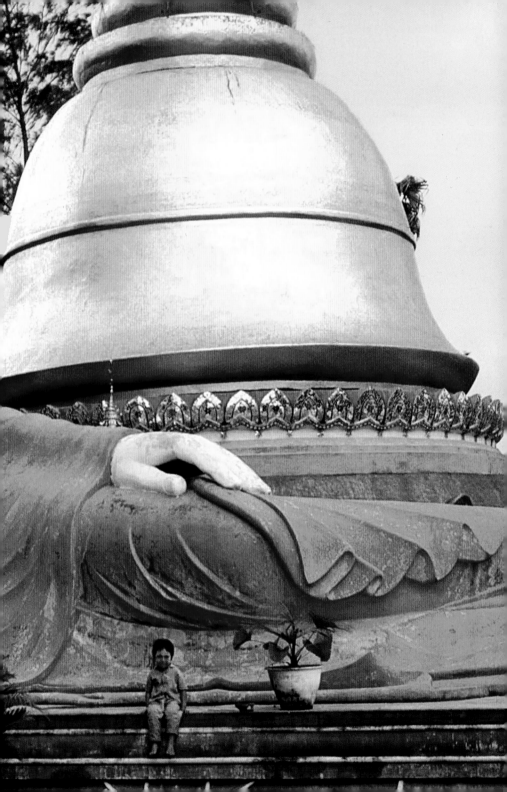

India

The Indian subcontinent is the birthplace of Buddhism. Shakyamuni began and ended his quest for enlightenment walking the highways and byways of the Himalayan foothills, and so it is appropriate that the art of the Buddha should have begun in India, or at least under Indian influence. The holy places of the Buddha, not surprisingly, are those where significant moments in his life and ministry took place and which he sanctified by his presence, often leaving them with the memory of miracles he had performed there. After his death his followers built domed shrines or *stupas* in his remembrance, as a focus for their ritual and for the teaching of *dharma*, the law or way towards perfection.

Right
Detail from a wall painting depicting the idea of a thousand manifestations of the Buddha. India, 5th–6th century CE.

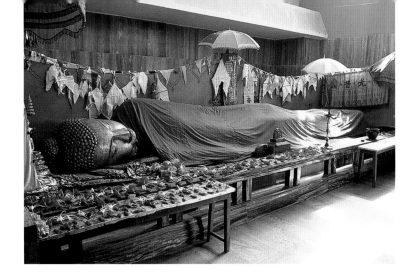

Above

Prayer flags and a traditional colourful umbrella, the Buddhist symbol of protection, raised over a figure of Gautama Buddha reclining at the moment of *parinirvana*. Kusinagara, deathplace of the Buddha, northern India.

Opposite

Tara, the female aspect of the *bodhisattva* of compassion, Avalokitesvara, according to myth created from Avalokitesvara's tears. Male figures present her with offerings and other images hover around her lotus nimbus. India, 10th century.

The first great monuments to the Buddhist faith grew up at four sites: Lumbini (also known as Kapilavastu), Gautama Siddharta's birthplace, which today falls within the borders of Nepal; Bodh Gaya in the Ganges basin, seat of his enlightenment; Sarnath, where he first taught *dharma*; and Kusinagara, where he died. These original shrines were then expanded to include Sravasti, where he lived for more than 20 years; Samkasya, where he descended from heaven to earth; Rajaghra, where he overcame several attempts on his life by the fallen disciple Devadatta and where he returned on several subsequent occasions as a retreat; and Vaisali, a city in which he once ended a great plague that had devastated the inhabitants. These became the Eight Great Wonders of Buddhism.

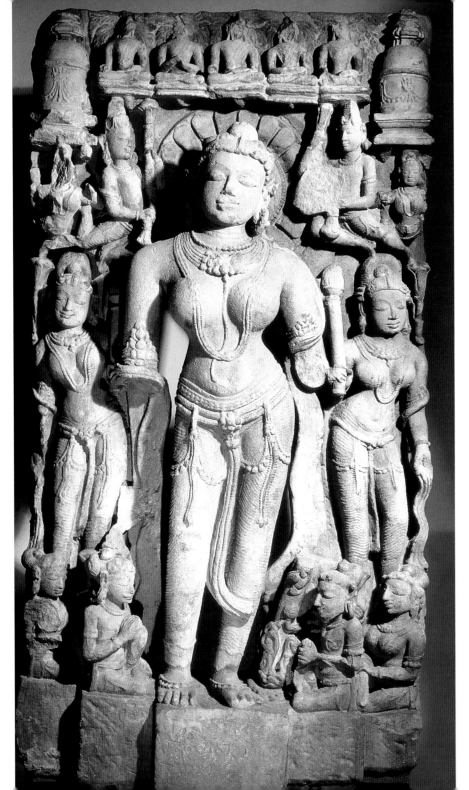

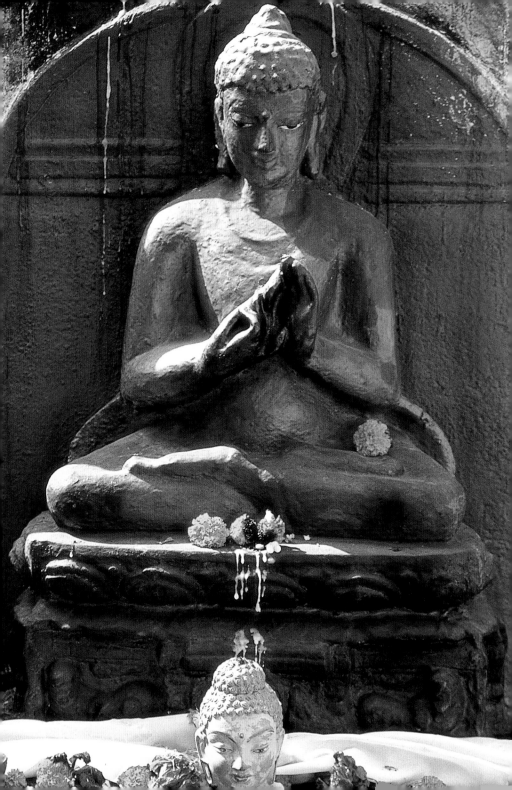

"All buddhas *dwell in the Palace of Extinction. There they have abandoned desire and endured much difficulty. Sentient beings in a myriad worlds endure ceaseless rebirth; they are trapped within the house of burning because they abandon neither desire nor lust."*

From the teaching of Zen master Won Hyo (Korean)

Left
Seated image of Gautama
Buddha in stone, with floral
offerings. Mahabodhi
temple, Bodh Gaya, site
of the Buddha's
enlightenment, Bihar
state, India.

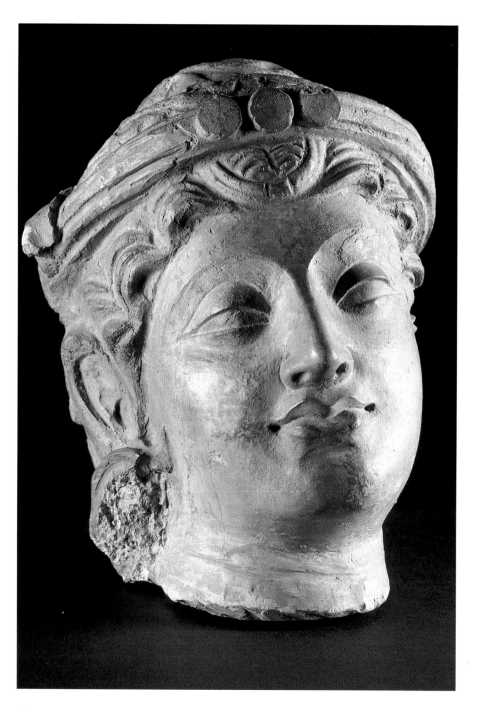

At such holy places pilgrims came in the wake of the teacher to renew their faith and to offer their devotions in his memory. The Buddha's doctrine seems to have attracted a good proportion of the intellectual elite in northern India. Increasingly some of his contemporaries had found dissatisfaction with the dominant Brahmanic culture, focused as it was on sacrifice and interpretation of the ancient Vedic texts, and were looking for less outmoded alternatives. The universality and modernity of Buddhism answered many of their needs. The Buddhist cause was also helped greatly by the devoted patronage of King Ashoka (273–232 BCE), whose empire of Magadha covered much of northern India.

Below
Bronze standing sculpture of Maitreya, the benevolent human *manusibuddha* of the future. Pallava, Madras, India, *c.*7th–9th century CE.

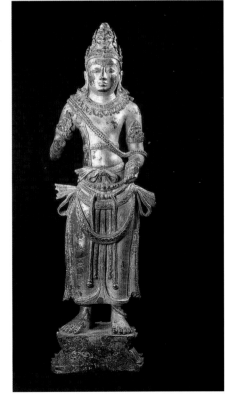

Left
Finely sculpted head of Gautama Buddha, revealing the strong Greek influence typical of the Gandhara art found in the northwest of the Indian subcontinent. National Museum, India.

Yet the security of Buddhist shrines was frequently threatened by the dominant Hindu majority, and after about a thousand years they began to fall into decay. From the eighth century CE onwards a resurgent Hindu militancy, aggravated by Muslim invasions from the north, encouraged the destruction of Buddhist monasteries and universities in India. By the end of the 12th century a large number had been sacked and abandoned. A Chinese pilgrim who visited Rajaghra as early as the fifth century CE tells how he found the place in ruins and abandoned, perhaps because it, like Vaisali, had suffered a visitation of the plague.

Some of the shrines became lost altogether, crumbling epitaphs to an abandoned and largely forgotten faith. Even the *bodhi* tree at Bodh Gaya, the central destination for Buddhist pilgrims, was repeatedly assaulted and probably had to be replaced on more than one occasion, though tradition has it that the original, a type of fig with the

botanical name *Ficus religiosa*, known as the pipal or *asvattha* tree, always survived because new shoots sprang from the ashes of the old.

Right
Detail of the extraordinary
penetrating stare in the
eyes on the painted face of
Gautama Buddha.
Sculpture at Tikse
monastery, Ladakh, India.

Overleaf

A Himalayan shrine containing a gold-covered image of a seated *buddha* draped with colourful fabric. In front is a prayer stone. Kunzang La pass, Spiti, Himachal Pradesh state, India.

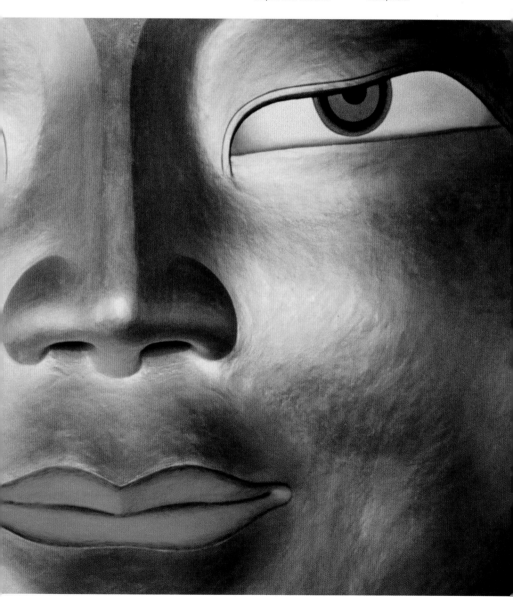

65

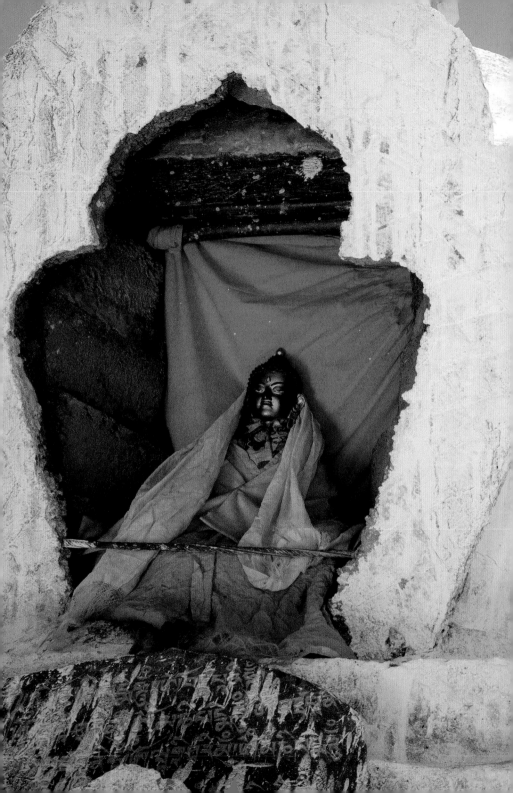

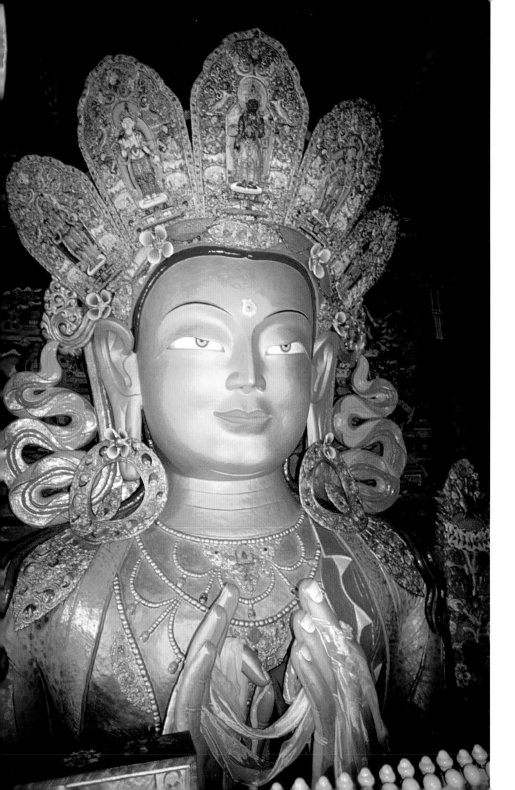

Today, however, the importance of the ancient Buddhist tradition in India has been recognized and there has been a resurgence of interest in preserving the Buddhist holy sites. Almost all were rediscovered during the 19th and 20th centuries, although not necessarily restored to their former glory. Bodh Gaya, for example, was still derelict as late as 1880, and it was only some time after 1945 that the Indian government formally recognized it as a major religious shrine. Today a massive sculpture of the seated Buddha commands the central chamber of the shrine and a "new" *bodhi* tree flourishes on the site of the old.

At first there was considerable reluctance to create images of the Buddha, because *buddha*-hood represents a transcendental state rather than an individual and there is no concept of worship in Buddhism. Early icons were more symbolic than representative of the man. Some of the oldest known examples include the footprints of Shakyamuni and the wheel or *cakra*, the symbolism of which became central to *dharma* teaching. It is normally drawn with eight spokes representing the Eightfold Path of Mahayana Buddhism, but there is also

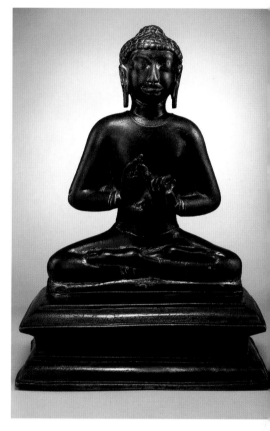

Opposite
Bust of a *buddha* wearing a gaudy crown and earrings, an ornate example of the Tibetan Buddhist art and culture that still thrives in the remote Himalayas of northern India. Tikse monastery, Ladakh, India.

Above
A seated Buddha in the "lotus position", made using the *cire perdue* or "lost wax" process. India, 5th century CE.

a thousand-spoked wheel representing the numbers in the Buddha's first sangha or commune. Sometimes his presence may also be indicated by an empty throne at the foot of the bodhi tree. Echoes of Judaism sound here with the representation of Jahweh in the form of the empty Mercy Seat flanked by guardian cherubim.

Buddha images were probably first sculpted during the second century CE, not in India itself but in its colonial provinces in Central Asia at the time of the Kushan empire, in the region known as Gandhara in what is now northern Pakistan and northeastern Afghanistan. Shortly afterwards, similar art began to appear in centres of Buddhist influence in northern India, where the earliest sculptures are thought to date from the second and third centuries CE. This resulted in two fairly distinct styles: artists in India, congregating largely at Mathura near Agra in the Ganges basin, produced relatively yogic figures, with thick-lipped, Indian-looking faces, while the Gandhara school revealed a considerable amount of classical Greek influence (see pages 86–91).

Both styles focused primarily on the way to enlightenment, portraying the acts of Gautama and the legends surrounding his life rather than focusing on the man himself or serving to inspire meditation. Some of the earliest images of his birth were discovered, predictably, in the ruins of Lumbini in the form of bas reliefs adorning the walls of a temple honouring his mother, Maya.

"In order to comprehend the nature of all the buddhas, past present and future, it is necessary to think of the nature of the universe as being created by the mind alone."

Chan chant (Chinese)

Right
Stone relief depicting a seated figure of a *buddha* with hands placed in the *dharmacakramudra* gesture. Cave temple in the Ajanta cave complex, Maharashtra state, India, 2nd century CE.

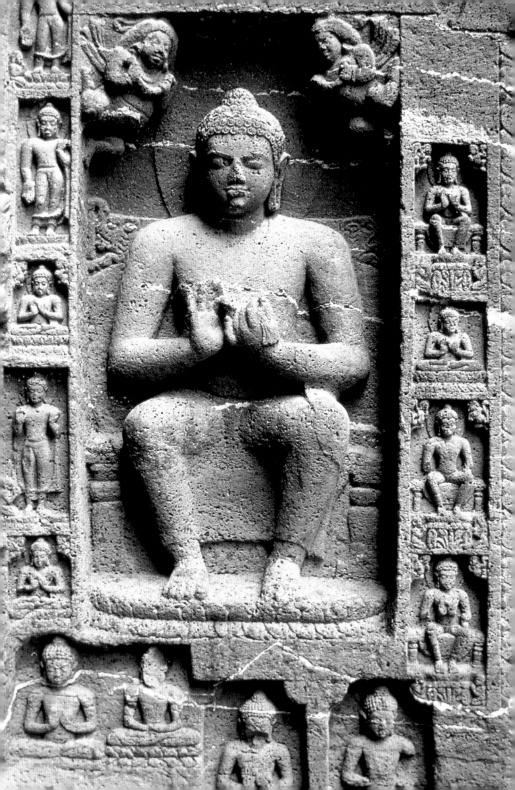

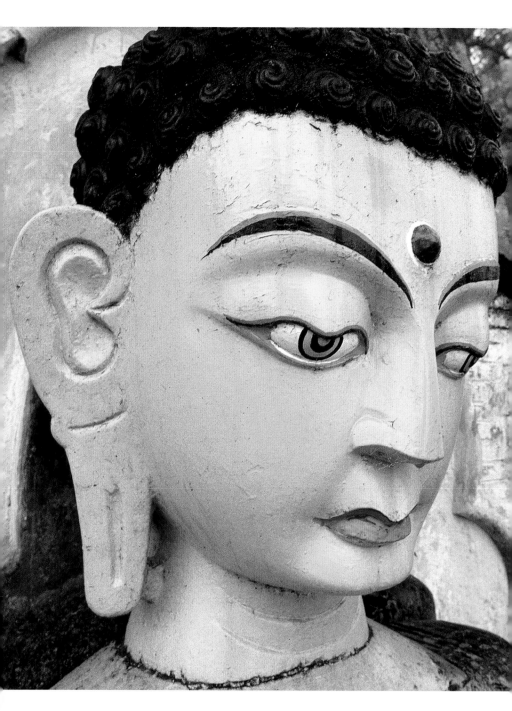

Nepal

In the Buddha's lifetime, Nepal was a meeting point for monks from India and Tibet; it is also said that the second-century Mahayana sage Nagarjuna taught there. Theravada Buddhism was not fully established in Nepal, however, until the fourth or fifth century CE.

Modern Nepal is predominantly Hindu, but many people mix Hinduism and Buddhism. Theravada is found in Kathmandu, while in the mountainous north – which, like the Indian region of Ladakh, is culturally close to Tibet – Mahayana dominates, and there are some 3,000 monasteries. The number of Buddhists in Nepal was swelled significantly by refugees from the 1950s Chinese communist takeover of Tibet.

Left

Painted statue of Buddha, with characteristic hair, ears and eyes. Swayambhunath temple, Kathmandu, Nepal.

Overleaf

Large stone sculpture of Gautama Buddha, flanked by diminutive attendants. Swayambhunath temple, Kathmandu, Nepal.

Page 76

Stone image of Gautama Buddha wearing a diaphanous robe, against the backdrop of a simple flaming *mandorla*. Kathmandu, Nepal.

Page 77

Richly decorated image of Gautama Buddha with the hands in the *vyakhyanamudra* "gesture of explanation" at the Bodnath *stupa*, Kathmandu, Nepal.

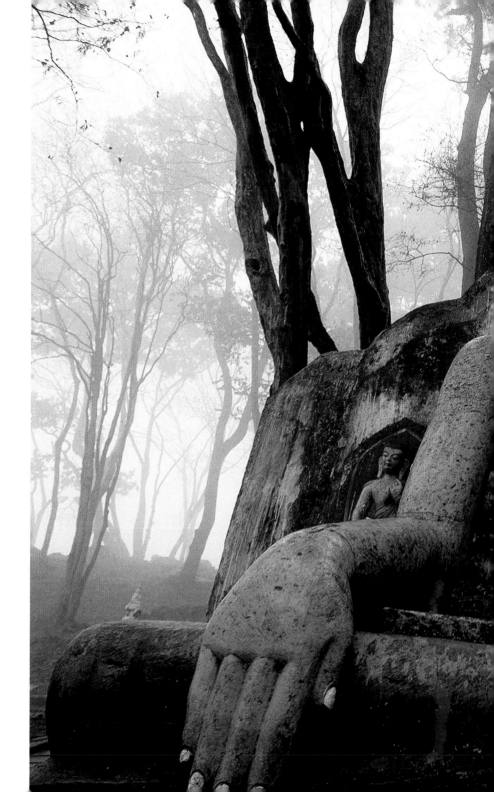

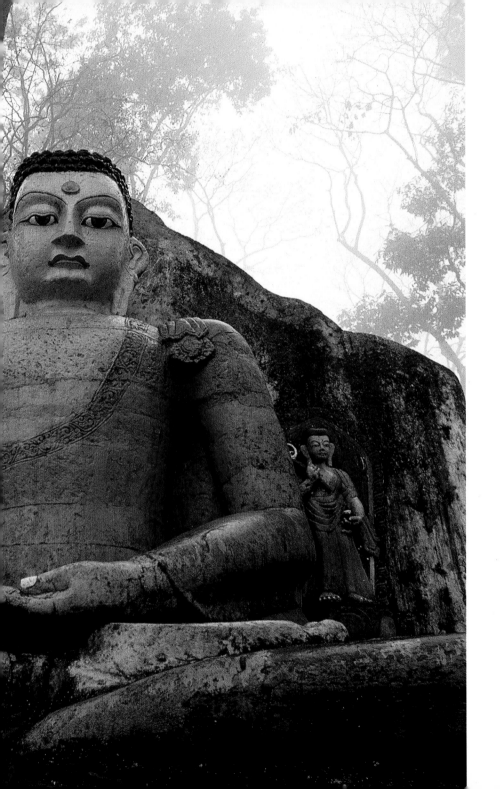

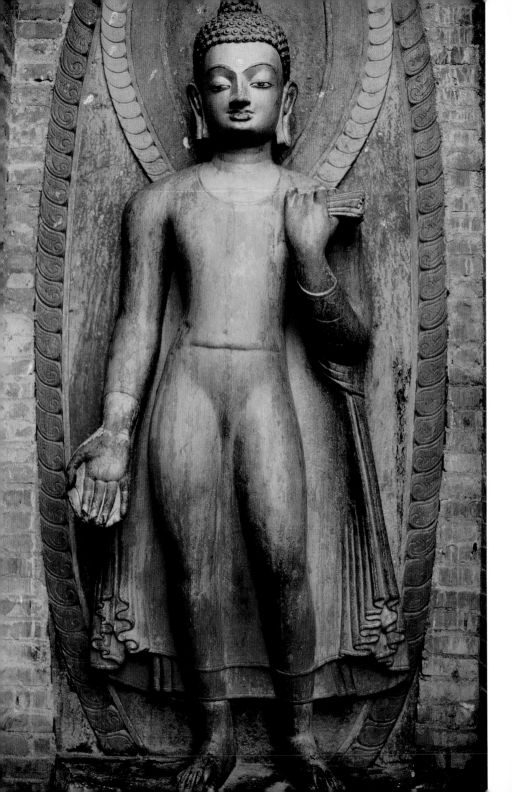

Sri Lanka

Buddhism took a firm early hold in
Sri Lanka, and as a consequence its
Sinhalese followers, the majority
population who colonized the island
from Bengal in the fifth century BCE,
were often demonized in classical Hindu
mythology. Legend has it that Mahinda,
one of the sons of King Ashoka
(273–232 BCE), brought Buddhism to
Sri Lanka in the third century BCE.
There is also a story that a daughter of
Ashoka took a branch of the *bodhi* tree
to Sri Lanka around 250 BCE and
planted it on a site that was to become
one of the great Buddhist monasteries,
the Mahavihara at Anuradhapura, the
ancient capital of the island.

Sacred writings including the
Mahavamsa describe how thirty
thousand devotees migrated to Sri
Lanka in the first century BCE and
established various other monastic
centres there. More probably the
dharma teaching was carried to the
island by pilgrims at a somewhat later
date. One of the most important among
these was a fifth-century-CE Chinese
scholar, Fa Hien, whose diaries amount
to one of the few first-hand accounts to
have survived from the period.

Above
Towering relatively modern
statue, 50 metres (165 feet)
high, of the meditative
Gautama Buddha. Dikwella,
Sri Lanka.

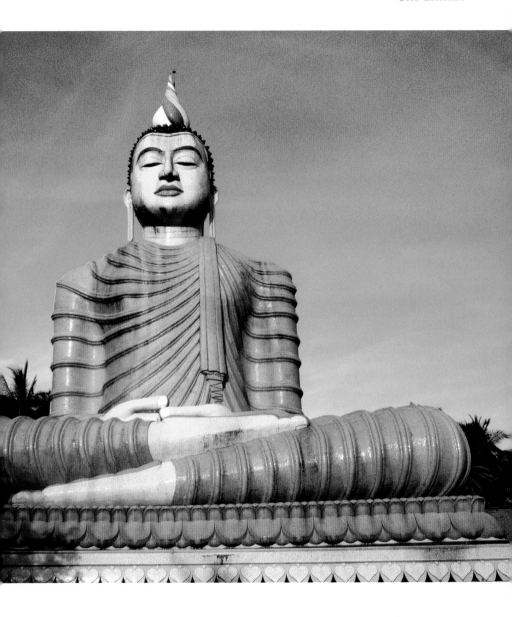

"From evil comes suffering;
Therefore day and night one should think and think again
About how to escape misery forever."

From the teachings of Gautama Buddha

Seated *buddha* in the "lotus position", with a nimbus emulating the sun's rays. Sri Lanka.

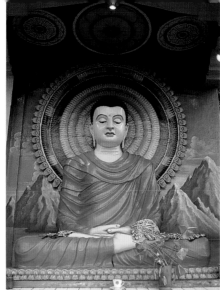

Below

Saffron-robed monks congregate before a massive stone sculpture, over 12 metres (40 feet) in length, of Gautama Buddha reclining at the moment of *parinirvana*. Gal Vihara rock shrine, Polonnaruwa, Sri Lanka, 12th century.

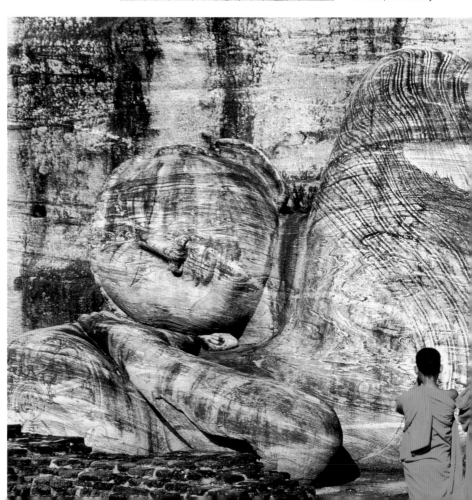

*"A special interchange, beyond the scriptures,
Not dependent on words and letters;
Pointing to the core of one's own mind;
Understanding one's own inner self."*

Saying on the subject of wall-gazing, attributed to the sage Bodhidharma (Chinese)

In any event, Theravada Buddhism prospered in Sri Lanka, and today some of the most resplendent sculptures of the Buddha can be found in its temples. The styles of art come from two major periods of history: Anuradhapura flourished between the third and tenth centuries as a centre of culture, and its early art closely followed styles found in northeast India; in the 13th century another school, artistically quite similar although this time centred in Polonnaruwa, became popular briefly, but shortly afterwards a catalogue of invasions and colonization sapped any further artistic inspiration.

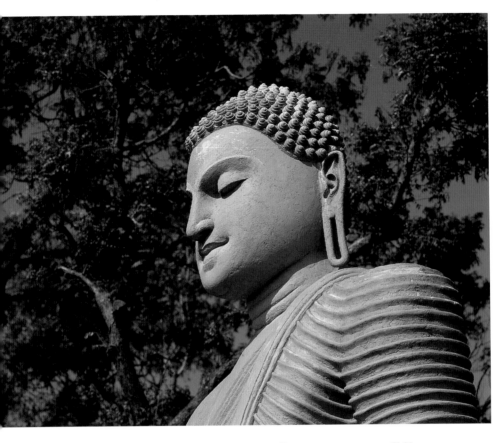

Above

Head of a *buddha* statue. Polonnaruwa, Sri Lanka.

Right

A devotee immortalized in stone stands reverentially with arms crossed beside the even more massive image of the reclining Gautama Buddha. Gal Vihara rock shrine, Polonnaruwa, Sri Lanka, 12th century.

"All men know how to satisfy their hunger with food But few have the wisdom to learn dharma *as a cure for ignorance."*

From the meditation teaching of
Zen master Won Hyo (Korean)

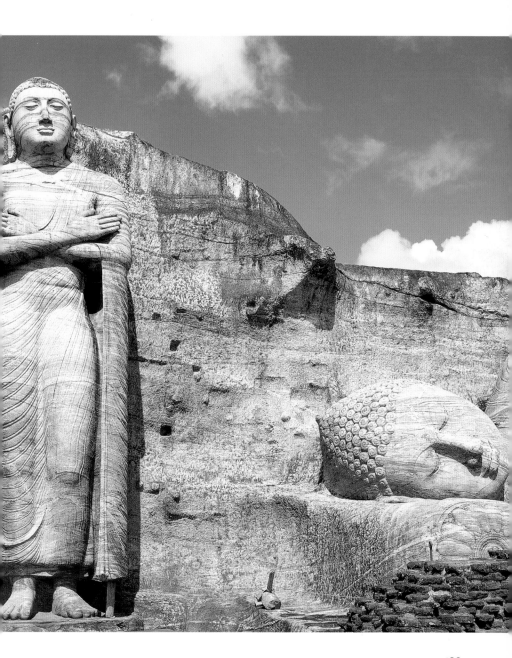

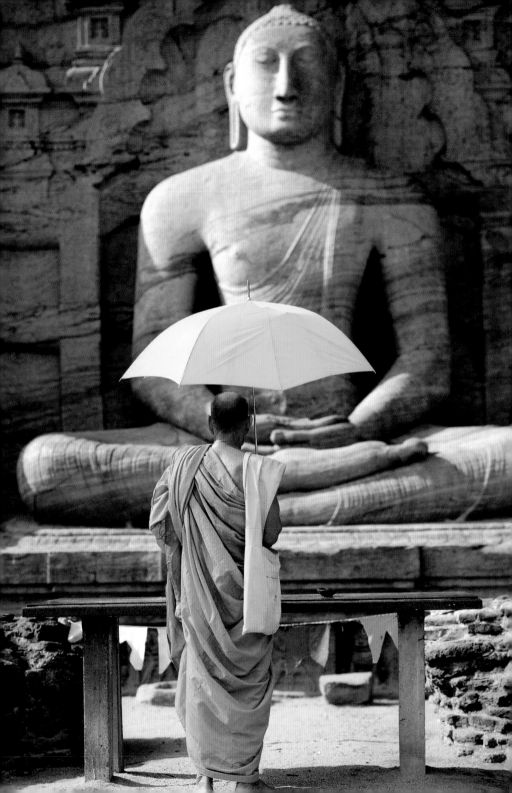

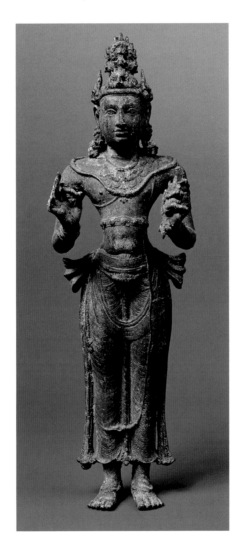

Left

The parasol or umbrella has become closely associated with images of *buddhas* and is often carried by monks. Originally an emblem of royalty in India, it now symbolizes protection of Gautama Buddha against the elements. Granite statue, Gal Vihara, Polonnaruwa, Sri Lanka, 12th century.

Above

This small stone sculpture of the human *manusibuddha* of the future, Maitreya, was discovered at Tiriyaya, Sri Lanka, and has been dated to the second period of Anuradhapura art in the 7th–8th century CE.

Afghanistan and Pakistan

Although Theravada Buddhism by and large took a southerly path, one exception was its introduction into Afghanistan. A distinct branch of the school, known as Mahasanghaka, became established in two kingdoms that lay along part of the major trade route to Central Asia, the so-called Silk Road: Oddiyana straddling the Khyber Pass and Bactria (modern Balkh) further to the north. According to romantic tradition, Buddhism came to Bactria as early as the sixth century BCE, brought by two merchant brothers, but more realistically it probably arrived in the fourth century BCE, shortly after the Mahasanghaka school split away from mainstream Theravada in 349 BCE. The Mahasanghaka school itself then split up in several minor disciplines, one of which became established in the valley of Bamiyan, a location that achieved notoriety in modern times when the Islamic fundamentalist Taliban blew up its giant Buddha images.

Eastern Afghanistan occupies what was once the old Indian region of Gandhara, where the earliest Buddha images in human form were crafted (see page 70), and Afghan Buddhist art

Right
A finely executed sculpture in grey slate depicting a seated Gautama Buddha, his face and garments reflecting the Greek influence found in the art of Gandhara. Northwest India/Pakistan, 2nd–3rd century CE.

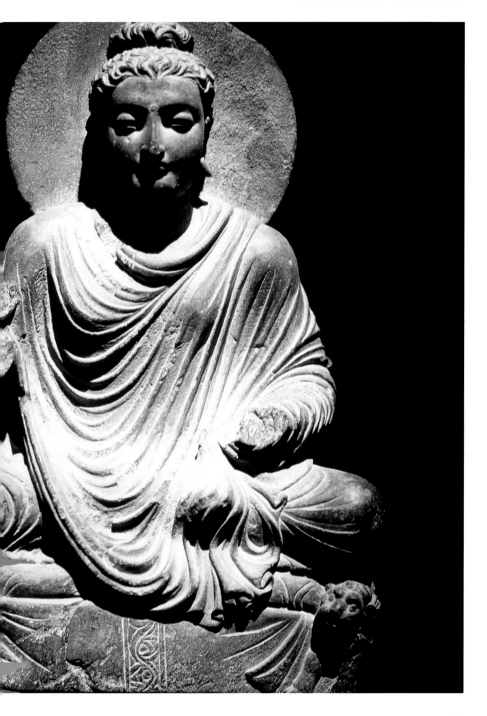

largely remained faithful to the Gandhara school. One of its more distinctive features is that many of the sculptures and paintings of Gautama Buddha and various *bodhisattvas* look more like classical Greek gods than Indian ascetics. The head, particularly the shape of features such as the eyes, nose and mouth, becomes distinctly European and the robes are reminiscent of those on Greek sculptures.

The culprit was Alexander the Great, who conquered most of the region, including Bactria and Oddiyana, in 330 BCE and established a Hellenic dynasty there for a brief period until 317 BCE, when India colonized the area. Among the ancient Indian empire's Mauryan-Dynasty rulers was King Ashoka (273–232 BCE), a strong supporter of Theravada. Hellenic influence was strengthened once more early in the second century BCE, when some of the local Greek-speaking warlords who had remained in the area rebelled against the Mauryans in Oddiyana and took control. They tolerated Theravada, and for a while it was actively supported under King Melandros (155–130 BCE).

Afghanistan is a country with a history of delivering boons and curses to Buddhism. On the plus side,

branches of the Silk Road passed through it en route to Tibet and China so Buddhist monks were coming and going frequently, spreading their message and founding monasteries. But on the other side of the coin, Afghanistan's strategic position in Central Asia meant that it was ripe for picking and a dizzying assortment of empire builders advanced and retreated over its soil down the centuries.

During the era of one of these, the Persian Sassanid Dynasty in the third century CE, members of the Lokkotaravada sect of Theravadan Buddhists commissioned the sculpting

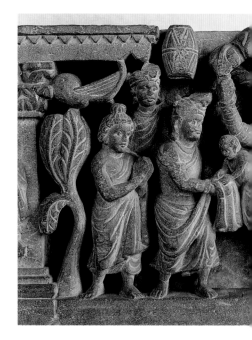

Right

Stone statue of the human *manusibuddha* of the future, Maitreya, seated on a throne unusually depicted as being crafted in woven cane. Pakistan, Kushan Period, 2nd–3rd century CE.

Below

Stone relief carving in the Gandhara style, anticipating the birth of the human *manusibuddha* of the future, Maitreya. Pakistan, Kushan Period, 3rd century CE.

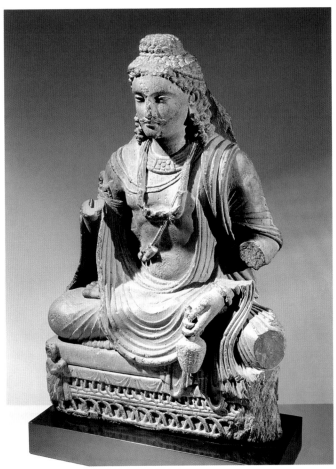

"The dharma *is devoid of words and appearances; yet it is not separate from words and appearances.*

From the teachings of Zen master Uichon (Korean)

of two giant statues of the Buddha on the face of a sandstone cliff at Bamiyan, a high valley in the mountains of the Hindu Kush about 230 kilometres (145 miles) northwest of Kabul. The huge task was carried out over a period between the third and fifth centuries CE, resulting in two immense statues, one 55 metres (180 feet) and the other 38 metres (125 feet) high. They must have presented a fabulous sight to travellers. It is known that when the sculptors had finished the main carving they used mud and straw to create facial expressions, hands and detailed folds in the robes. The figures were also painted, the larger image red and the smaller blue, with hands and faces decorated in gold.

Under a subsequent regime, the seventh-to-eighth-century Umayyad Dynasty of Arabs, Muslim expansion placed much of Afghan Buddhism into cold storage, but one positive effect was to accelerate the spread of Buddhist teaching as monks fled the region. Through these troubled centuries Buddhism remained popular among poorer peasants living in remote areas and was sustained in a limited number of monasteries. These were religious schools that the succession of occupying forces descending on

Afghanistan had left in peace, largely because the monks of those particular retreats had escaped the accusation of harbouring dissidents or inciting rebellion. In this way a distinct Afghan Buddhist artistic tradition was kept alive, at least for a while. The end came, however, in the 14th century under the Islamic khans, who effectively outlawed Buddhism in 1321. There is no historical record of the religion being actively followed in Afghanistan after that period.

Over the centuries the fine features of the Bamiyan *buddhas* were slowly defaced, either by the elements or more deliberately by invaders wishing to "remove their souls". It was not, however, until the power of modern high explosives was applied in 2001 that they finally succumbed to man's intolerance. Today moves are afoot to recreate the *buddhas* of Bamiyan bringing in the skills of Sri Lankan craftsmen.

Right
Before demolition by Islamic fundamentalists in 2001, one of a pair of huge standing images of Gautama Buddha, carved into the rock face of sandstone cliffs at Bamiyan in the Hindu Kush mountains, Afghanistan, c.3rd–5th century CE.

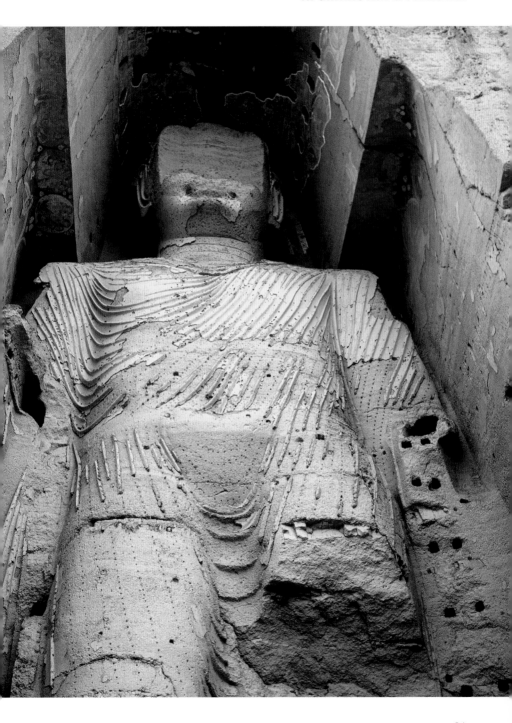

Myanmar (Burma)

South and eastwards beyond India, the main spread of Theravada Buddhism was into Burma, Thailand, Malaysia, Cambodia and Laos, the region known as Indo-China; lying between India and China, it has been culturally influenced for thousands of years by both. A profusion of Buddhist monasteries became established right across the region and these became centres for a great flowering of Buddhist art and architecture. Some of the most impressive and beautiful, and also some of the oldest of all sculptures of the Buddha are to be discovered in Southeast Asia. Much of the success of Buddhism in the region, as elsewhere, is explained by its tolerance of other local religious beliefs and its willingness to merge its own principles with theirs.

The earliest progress of Buddhist expansion was probably into Myanmar (known as Burma until 1989), because of its proximity to India. Myanmar is the meeting ground for India and Southeast Asia. Although the country is cosmopolitan in make-up, its people drawn from Khmer, Indian and Chinese

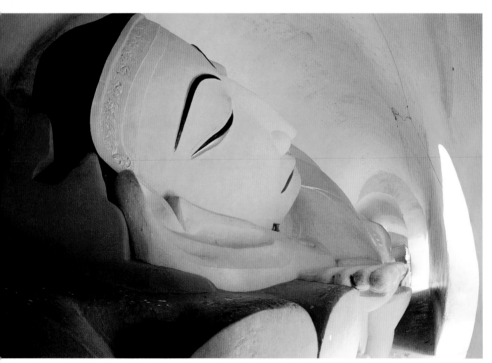

"*In the beginning there is no such thing as* buddha. *Out of necessity it is given a name. In the beginning there is no such thing as mind. To find enlightenment is to realize the 'One Thing'. Men say that the 'One Thing' is emptiness, yet it is not truly a void. Mind of no-mind is the true mind, as wisdom of no-wisdom is the true wisdom.*"

From the teaching of Zen master Hyechol (Korean)

Left
Modern reclining image
of Gautama Buddha in a
temple at Bagan (Pagan),
Myanmar.

"The dharma *and the* vinaya *that I have taught
 and established
shall be your master when I have departed
 this world.
Take the road to salvation with due care."*

From the *Sutta-Pitaka*

Below

A "cloned" assembly of painted *buddhas*, revealing enigmatic smiles, display the earth-touching *mudra*. Shwedagon pagoda, Yangon (Rangoon), Myanmar.

Right

Shweyattaw *buddha* on Mandalay Hill. Mandalay, Myanmar.

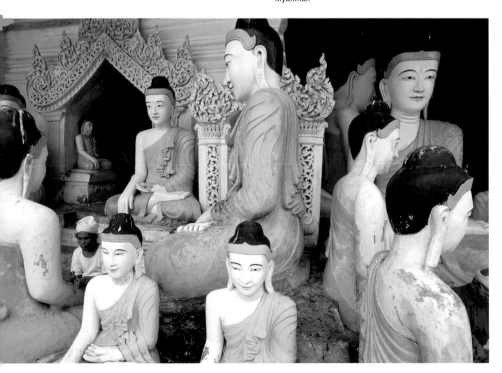

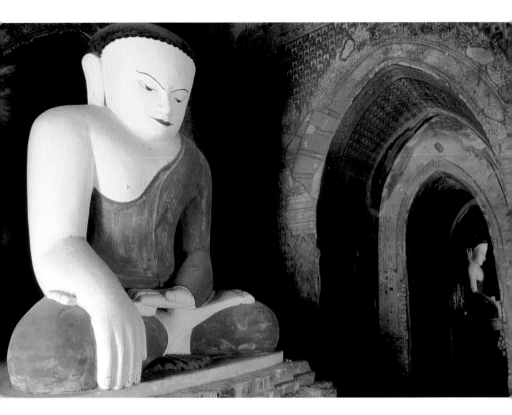

origins, today over 80 percent of the population is Buddhist, and the great majority follow the Theravada discipline.

One of the great Myanmar centres of Buddhist devotion in bygone centuries was Bagan (Pagan), founded in the 11th century on the banks of the Irrawaddy river in the middle of the country. For two hundred years, successive rulers of Burma built an impressive catalogue of temples in the vicinity; several hundred still survive, having outlived royal palaces long since crumbled to dust.

Above
An unusual modern sculpture of Gautama Buddha displaying the earth-touching *mudra* in the Paya Thonzu temple, Bagan (Pagan), Myanmar.

Right
An extraordinarily elaborate *buddha* sculpture in gold, attended by angelic figures, graces a plinth in the Shwedagon pagoda, Yangon (Rangoon), Myanmar.

"Like the bird that carries its
wings with it as it flies,
so the monk carries his robes and
his begging bowl as he travels;
his robes are sufficient for his body and his
begging bowl for his stomach."

From the *Sutta-Pitaka*

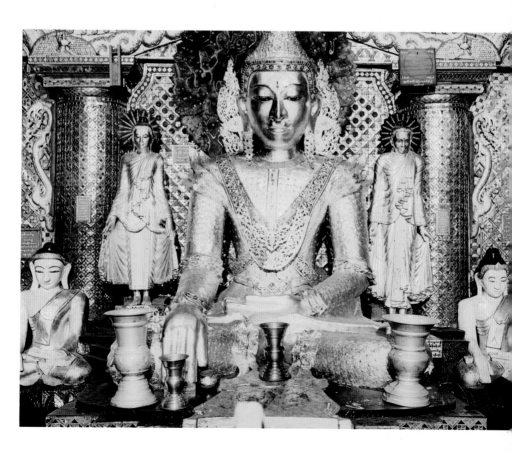

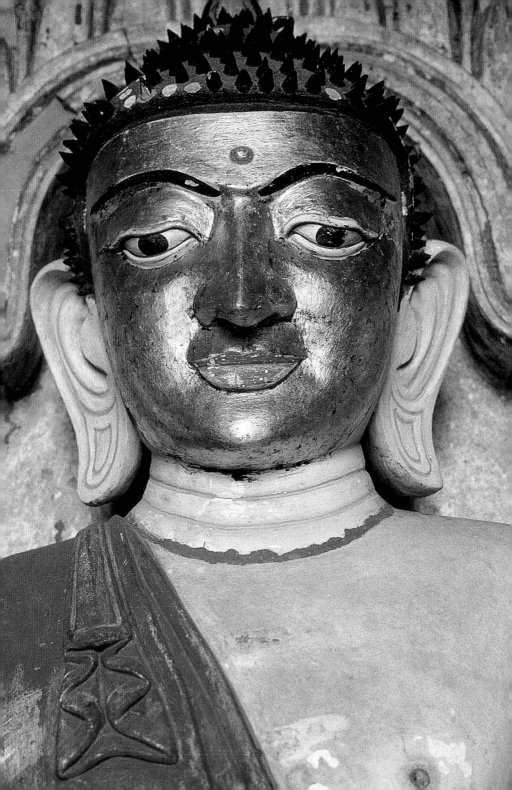

Left

Dramatic facial features distinguish a *buddha* statue at Bagan (Pagan), Myanmar. 12th century.

Right

A seated statue of the Buddha in stone embellishes these large ancient *stupas* at Bagan (Pagan), Myanmar. 11th–13th century.

"*The diligent monk must avoid two extremes. The one is a desire for sensual gratification. It is base, vulgar, worldly and ignoble. The other is self-mortification. It is painful, ignoble and brings no good.*"

From the sayings of Gautama Buddha

Below

An expressive, asexual face of the reclining Buddha is fashioned from wood covered in gold leaf. Myanmar, early 18th century.

Right

A standing *buddha* sculpted in gold and set in a temple niche at Bagan (Pagan), Myanmar.

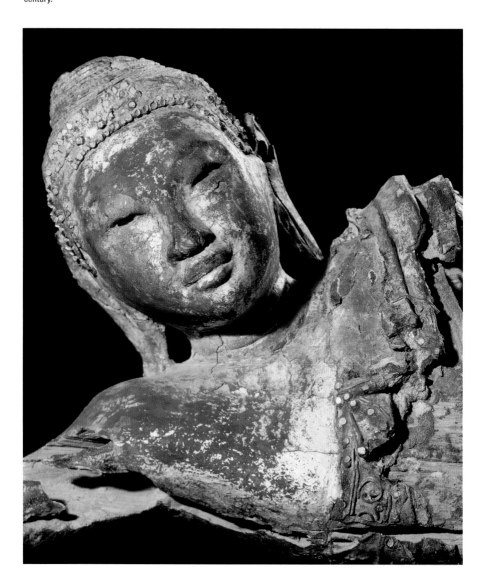

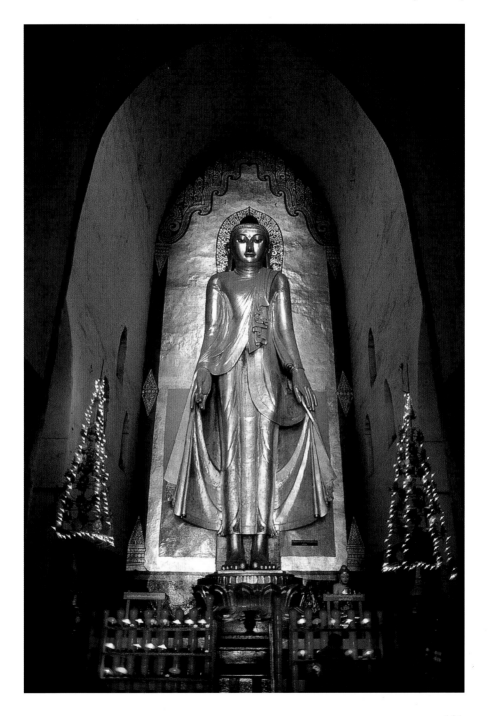

*"Human life, found but once,
Is more precious than the
wishing stone,
So easily lost and so hard to regain
It is short as a lightning flash.
Understanding this, cast off
worldly things
like the husks of the wheat,
and strive day and night to
find life's essence."*

From the teachings of Jey Rinpoche (Tibetan)

Right
The Mahamudi Buddha, an
ornate and richly clothed
seated sculpture of
Gautama Buddha, has been
distorted over the years by
layers of gold leaf applied
to every part except its
face. Mahamuni temple,
Mandalay, Myanmar,
11th century.

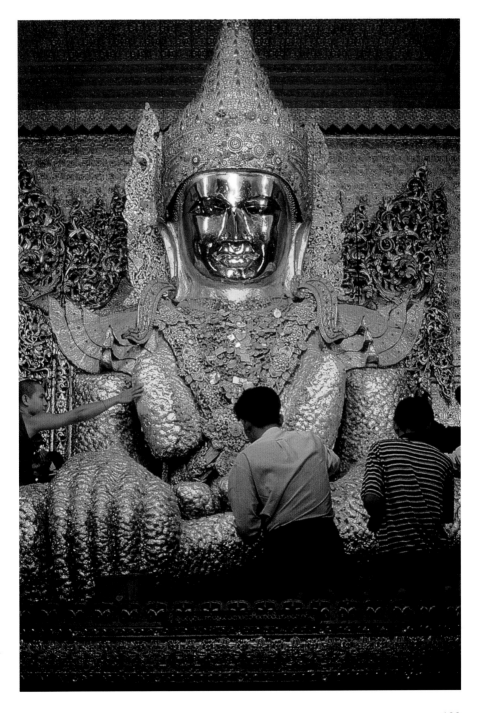

"Moon and stars may tumble to earth,
mountains and valleys may
crumble to dust,
even the sky above may vanish;
but thou, O Buddha, speak
nothing false.

From the *King of Absorption Sutra*

Below

Seated golden statue of
Gautama Buddha as the
ninth incarnation of the
Hindu creator god, Vishnu.
Mandalay, Myanmar.

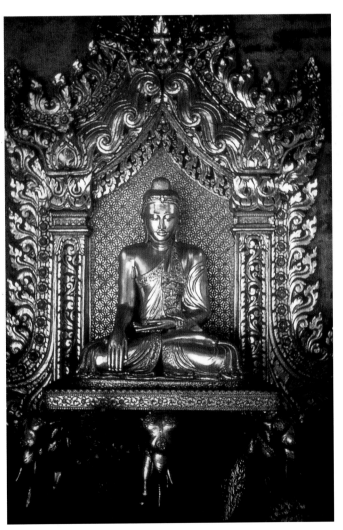

Above

A modern image of
Gautama Buddha framed
by a wheel into the spokes
of which devotees have
pushed offerings of money.
Myanmar.

Bagan is now a UNESCO world heritage site, and among the great Buddhist centres of Southeast Asia is probably equalled only by Angkor Wat in Cambodia (see pages 136–141).

Further north on the Irrawaddy is the fabled city of Mandalay, where the Mahamuni pagoda houses Burma's most venerated sculpture of the seated Buddha. Mandalay is also home to the Kuthodaw Pagoda, built by King Mindon (1814–78), in which visitors can find the entire Theravada scriptures carved on 729 marble slabs. Although not in bound form, this is claimed to constitute the world's "largest book". Known as the *Tipitaka*, it is inscribed in Pali, the ancient script of the first Buddhist communities in India; Pali is completely distinct from Sanskrit, the script used by Mahayana Buddhists.

A curiosity of the Mahamudi Buddha is its distortion (see picture on page 103). Countless generations of worshippers have paid homage by adding pieces of gold leaf to the image. So many layers of these have been deposited that the effect has been to disguise the lines of the original sculpture, and only the face now remains unaltered.

Further south, in the Irrawaddy delta, lies the capital of Myanmar, Yangon (Rangoon). The city boasts a profusion of impressive Buddha imagery, including the magnificent Shwedagon pagoda, where eight hairs of the Buddha repose as a sacred relic. Dating from the 11th century, the Shwedagon *stupa*, soaring to a height of 100 metres (330 feet), is clad with gold and its dome is tipped with precious stones.

Right
Quirky bespectacled head of Gautama Buddha, the glasses being cleaned during a monthly routine by staff at the Shwemyethman pagoda, Shwedaung, Myanmar.

"*Remember how animals suffer the
consequences of stupidity.
Abandon the* karma *of such misery
and cultivate the causes of joy.
Human life is a rare and precious thing.
Do not make it a source of pain.
Take heed; use life well.*"

From the teachings of Nagarjuna (Tibetan)

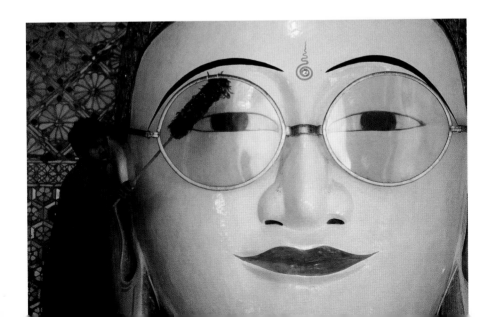

Thailand

According to tradition, Buddhism arrived
in Thailand in the third century BCE.
Buddhist monks introduced the religion
in the reign of the Indian King Ashoka,
establishing the first *sangha* community
of monks in the regional capital of
Nakhon Pathom. Theravada Buddhism
appears to have become the dominant
religious institution of the kingdom early
in the 14th century, reaching its pinnacle
of influence during the reign of Li Thai
(1347–68). Under his sponsorship,
various Buddhist religious works on
cosmology and the planes of existence
were studied and re-written into a single
volume known as the *Tribhumikatha*,
so called because it represents a
composite of 30 books. It is the earliest
literary work of Buddhist teachings to
have been composed in Thailand.

Today some 95 percent of the Thai
population is Buddhist. It is normal for

Right
One of many superb
statues of *buddhas* in
the *wats* or temples of
Sukhothai, Thailand.

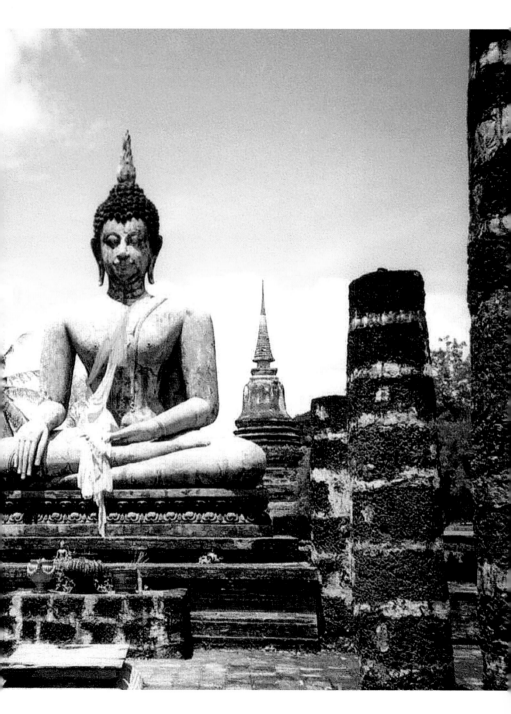

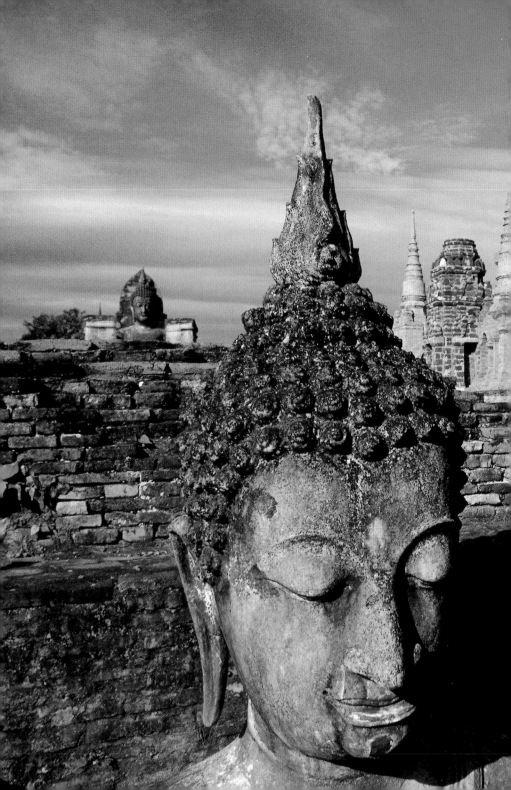

Previous page
Massively sculpted head of a *buddha* rising among the pillars and temple spires of Wat Mahathat, Sukhothai, Thailand.

every Buddhist male over the age of 20 to take temporary vows as a monk, and the country boasts in the region of 27,000 Theravada temples or *wats*, most of them scattered in the countryside. The constitution decrees that all Thai rulers must be Buddhist and the *sangha* effectively endorses their legitimacy. There exists a small Mahayana Buddhist population in Thailand, but it is largely confined to ethnic Chinese and Vietnamese and is easily distinguished by the standard dress of orange jacket and trousers.

The *Tribhumikatha* has had a profound effect on Buddhist culture in Thailand and one tangible

Left
A finely sculpted head of a *buddha* in gilded bronze. Thailand, 14th–15th century.

Right
The gold mosaic covering this statue has been intricately worked to show typical *buddha* features such as folds in the chin and neck and a suggestion of slits in the earlobes. Thailand.

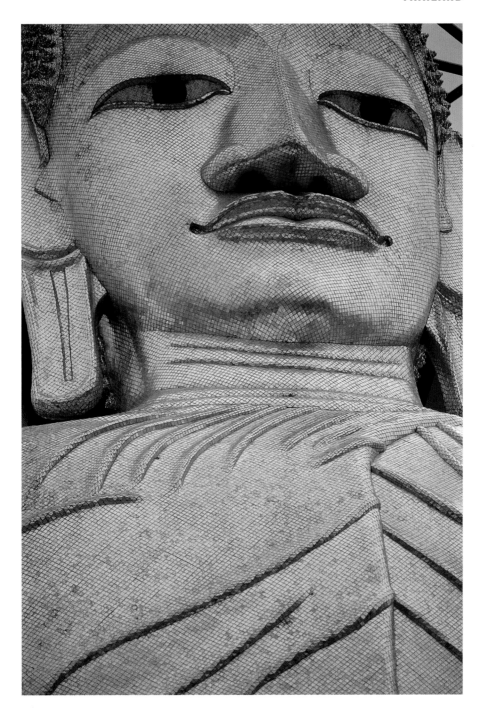

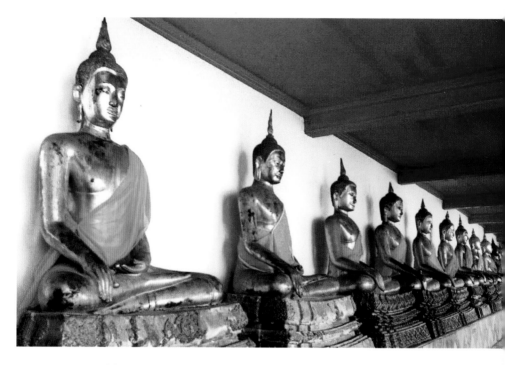

consequence, aside from the profusion of *wats*, has been the tremendous outpouring of Buddhist art down the centuries. Few countries may claim to have created as many images of *buddhas* in painting and sculpture. Amulets depicting *buddhas* are particularly popular for wearing around the neck, and although they do not appear in Theravadan scriptures, they serve as personal talismans bringing protection and good fortune.

Among the most impressive of the large *buddha* sculptures of Thailand are the Big Buddha of Ko Tao island and

Opposite
Buddha painting with gold leaf at Wat Chakrawat, Bangkok, Thailand.

Above
A row of seated and gilded *buddhas* line the walls of the temple of Wat Suthat in serene repose. Bangkok, Thailand.

"I am free from bonds,
both human and divine.
So also are you from bonds
human and divine.
Travel the roads for the good of others,
for the happiness of others,
out of compassion for the world."

From the *Mahavagga*

the colossal reclining *buddha* in Bangkok's Wat Pho. At 46 metres (150 feet) in length and 15 metres (50 feet) high, the latter is modelled in plaster around a brick core and finished in gold leaf with the eyes fashioned in mother-of-pearl inlay.

The seemingly limitless profusion of smaller icons includes some extraordinarily beautiful sculptures that display a fascinating blend of Indian and oriental in their features. Foremost for the sheer brilliance of its craftsmanship, and with a flaming *mandorla* serving as a backdrop, must surely be the seated golden *buddha* of Bangkok's Wat Benchamabophit, a temple built by King Rama V at the beginning of the 20th century; beneath the *buddha* are interred the King's ashes.

Right
Seated *buddhas* rest on plinths at the base of this intricately carved *stupa* at Wat Chai Watthanaram, Bangkok, Thailand.

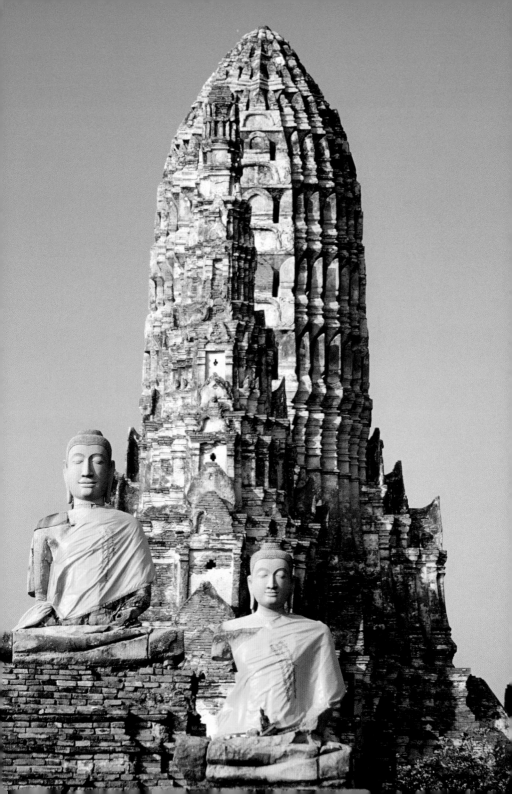

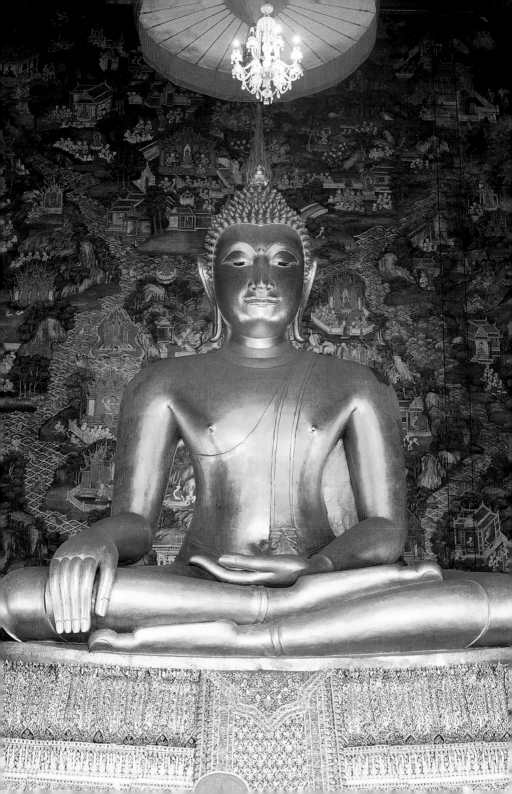

"If one who aspires to enlightenment wishes to make the germ of enlightenment grow and illumine the world with brightness, he must consider the true nature of things. The truth is not born nor is it extinguished. It is neither one nor many, neither coming nor going."

From the *Brahmajala Sutra* (Mahayana)

Left

A gilded *budda* whose face shows a blend of Indian and Chinese influences sits serenely before an ornate backdrop in a Bangkok temple, Thailand.

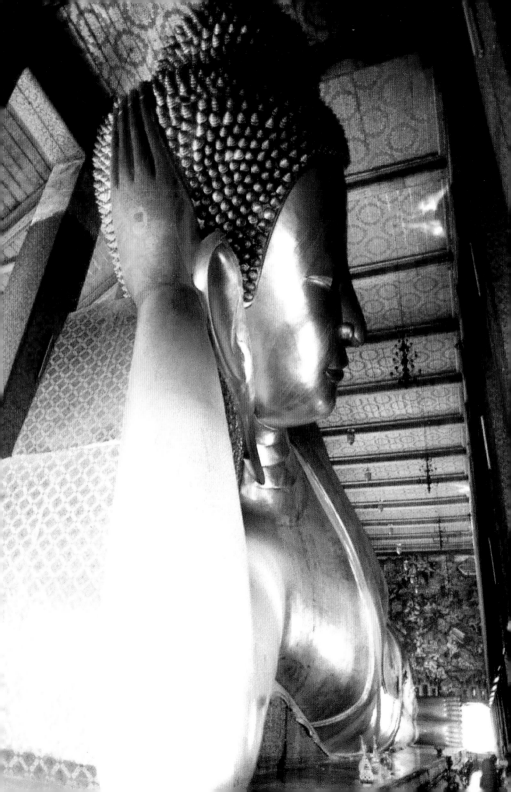

*"Do not do evil things but perform good deeds;
purify your thoughts.
This is the way of all the* buddhas.*"*

From the *Nirvana Sutra* (Mahayana)

Left and below

At 46 metres (152 feet),
the gold-leaf-covered
reclining *buddha* at Wat
Pho is the longest in the
land. Bangkok, Thailand,
19th century.

Overleaf

The massive and gently
smiling head of Gautama
Buddha in repose stands
before an elaborately built
stupa. The accentuated
line of the lips is a
characteristic of Buddhist
art in the region.
Ayutthaya, Thailand.

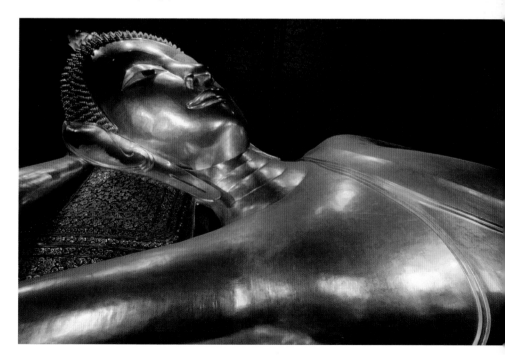

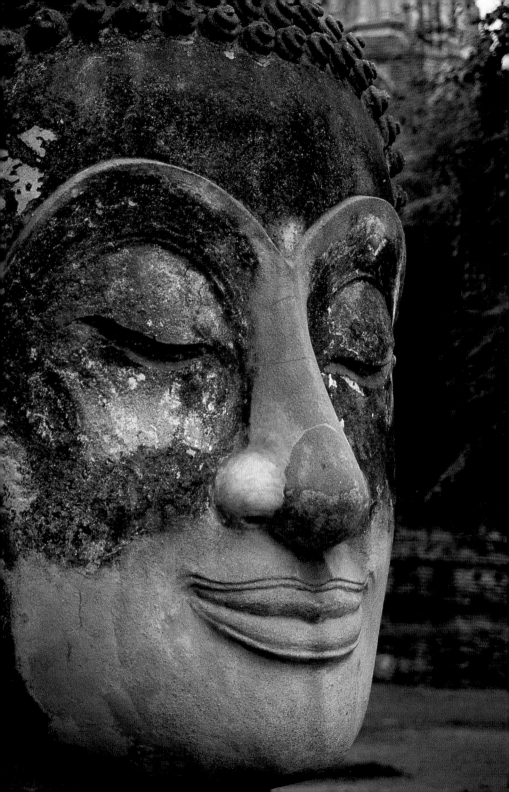

"The true nature and form of all things are permanent. They are unchanging."

From the *Avatamsaka Sutra* (Mahayana)

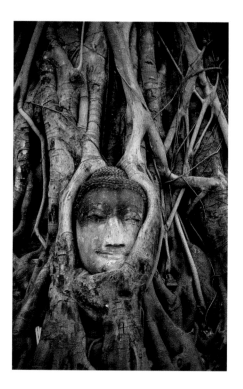

Above

A sculpted head of a *buddha*, apparently of considerable age, peers from amid tree roots. Ayutthaya, Thailand.

Right

The appearance of this sculpted head of a *buddha* borders on the grotesque, its gold surface so bright that it reflects surrounding scenery. Wat Yai Chai Mongkhon, Ayutthaya, Thailand.

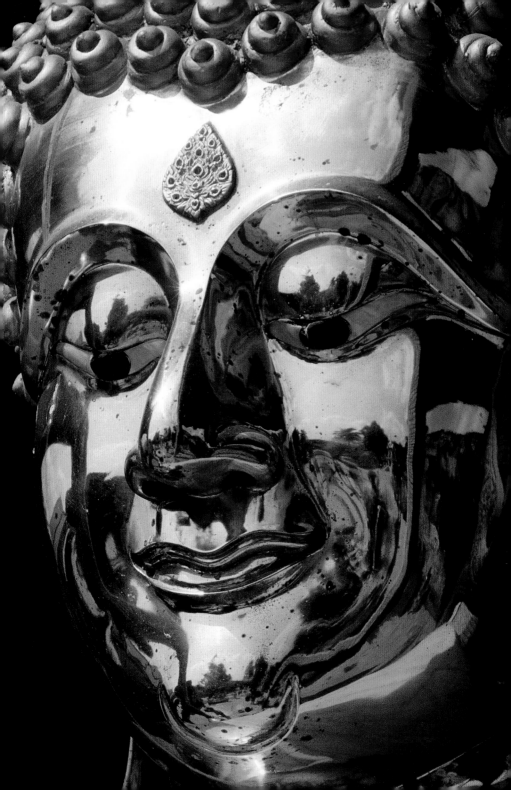

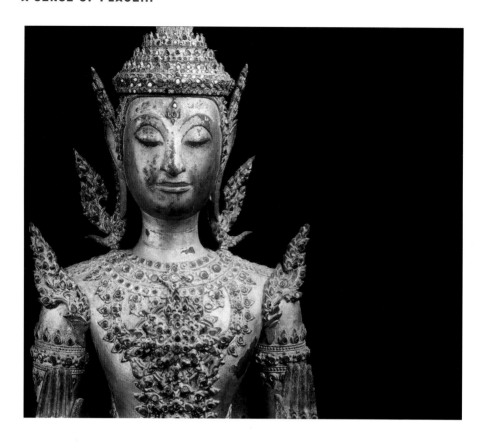

Above

The richly adorned head and torso of a golden *buddha*, symbolic flames arising from the head and shoulders. Bangkok, Thailand.

Right

A head of a buddha in serene repose, the hair arranged in meticulous curls. Bangkok, Thailand, late 14th century.

Overleaf

The blue of the sky provides a striking backdrop to this immense sculpture of a seated buddha. The brilliant white stone is interrupted only by the colour of the deeply hooded eyes. The Tha Ton, northern Thailand.

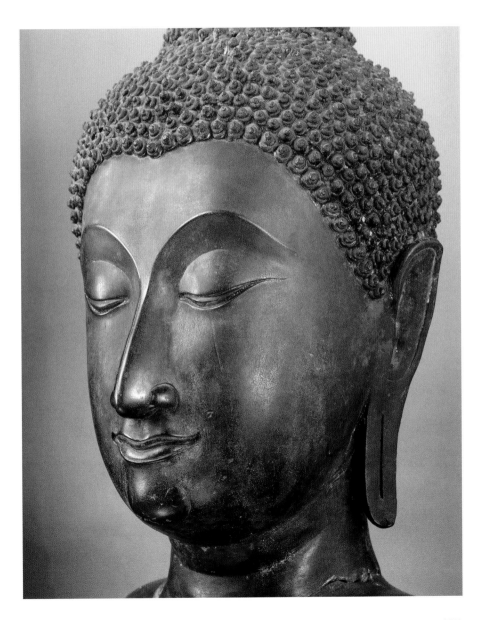

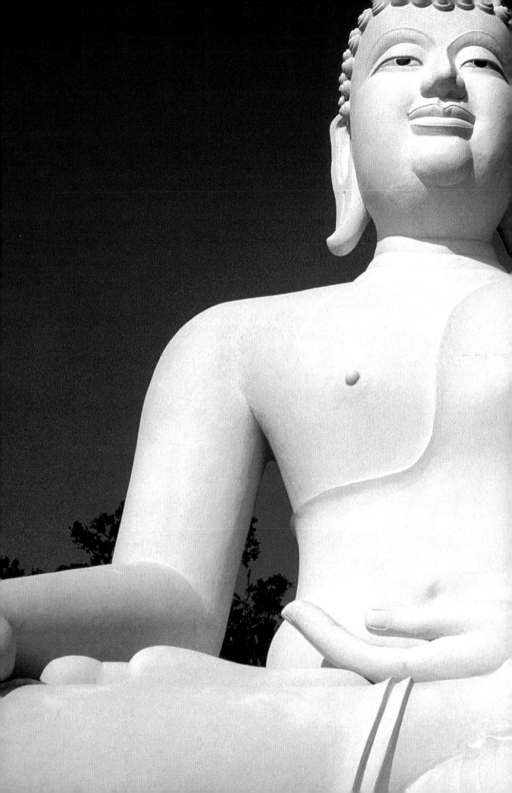

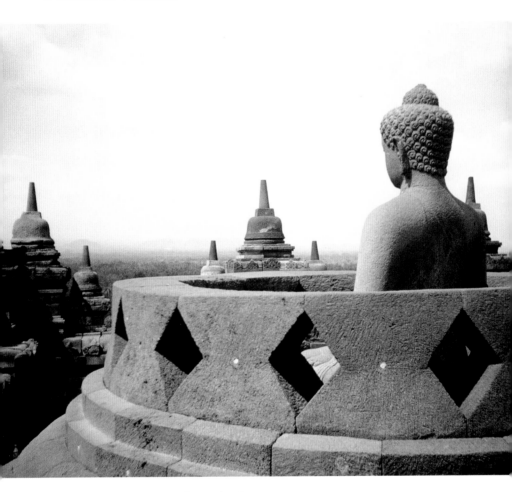

"When the mind is disturbed
 turmoil of many things is produced.
When the mind is stilled this
 multiplicity disappears.
Though sullied the mind is eternal.
It is clear and pure and cannot
 be transformed."

From the *Kishin-ron* (Mahayana)

Above

A Gautama Buddha in stone gazes out over the landscape of ancient *stupas* from its high vantage point at the temple complex of Borobudur, Java, Indonesia, 8th–9th century CE.

Indonesia

A sprawling archipelago of some 17,000 islands, Indonesia stretches from the Malay Peninsula in the northwest towards Australia in the south. Not surprisingly, given its geography, it is a nation of very diverse culture, but the expansion of Islam resulted in both Hinduism and Buddhism falling into steep decline in Indonesia from about the 15th century. In the 1930s, however, a Theravada Buddhist revival was staged, sparked by the visit of a Sri Lankan monk, Nerada Thera. But notwithstanding his evangelical mission, today Buddhism is strictly a minority religion, some 87 percent of the Indonesian population being staunchly Muslim, with a small additional Christian community.

Buddhism arrived in Indonesia in about the fourth or fifth century CE, several hundred years after Hinduism had become *established* and had served largely to replace the old localized tribal cults of the islands. For centuries rival Buddhist and Hindu empires then challenged each other for supremacy in two of the four principal islands of Indonesia: Buddhism flourished most strongly in Sumatra,

while Hinduism found its power base in the neighbouring island of Java.

During the eighth and ninth centuries the Mataran kingdom of the Sailendra Dynasty that ruled central southern Java promoted a mix of Hinduism and Buddhism, and the Sailendra kings commissioned a sizeable numbers of temples or *candis*, the most famous of which is Borobudur in the centre of the island. Built between 750 and 850 CE, the *candi* of Borobudur is constructed on a massive scale that almost matches that of Angkor Wat in Cambodia and it is classed as one of the seven man-made wonders of the world. The Borobudur complex covers some 55,000 square metres (590,000 square feet).

Borobudur follows the requirements of a *mandala* (see pages 302–305). Standing on a hugely constructed base of larval rock, the temple is designed in the shape of a lotus, and there is some archaeological evidence that the area was once flooded, which would have given the impression that the temple was indeed a vast lotus bud floating on a serene lake.

Six rectangular terraces in the lower part of the monument are topped by three circular upper tiers. In a blend of

Hindu and Buddhist traditions, the Borobudur *candi* is said to represent three aspects or levels of the cosmos. In the lowest of these, man's world of desire is influenced by negative impulses. In the middle level, man has achieved control over his negative impulses and uses only the positive. At the highest level, the world of humankind is finally liberated from all forms of the physical and worldly desire with which it has been burdened since the beginning. The whole edifice is surmounted by a glorious *stupa*, representing the concept of emptiness or *sunyata* in which there is neither existence nor non-existence.

In this way Borobudur symbolizes in stone the ten levels that a *buddha*-to-be, a *bodhisattva*, must achieve before he can become *buddha*. Monks come to the monument and walk around the various tiers, always clockwise, with the heart of the temple on their right side. As they climb to the summit they make the symbolic journey from the material world towards perfect awareness.

At the highest level of the monument, and in keeping with the symbolic imagery, there are no decorations or bas reliefs, but facing in every direction are 92 sculptures of

Above
The head of a Buddha sculpture becomes silhouetted provocatively against the evening skyline at Borobudur, Java, Indonesia, 8th–9th century CE.

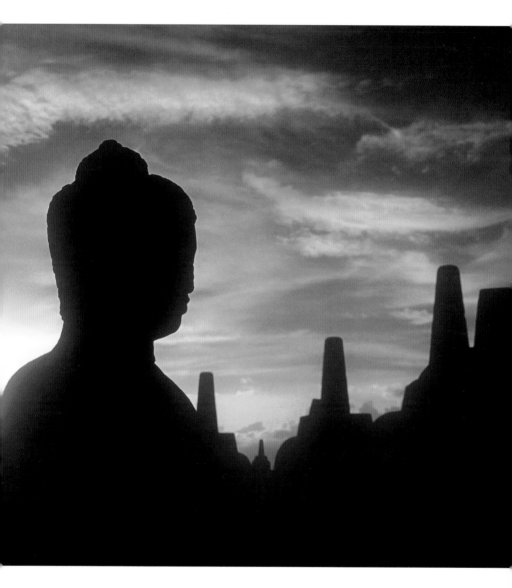

"The ignorant man is enmeshed by the five desires.
He allows the evil one to carry him away, mind and body,
just as the monkey is carried away
on the shoulder of the hunter."

From the *Nirvana Sutra* (Mahayana)

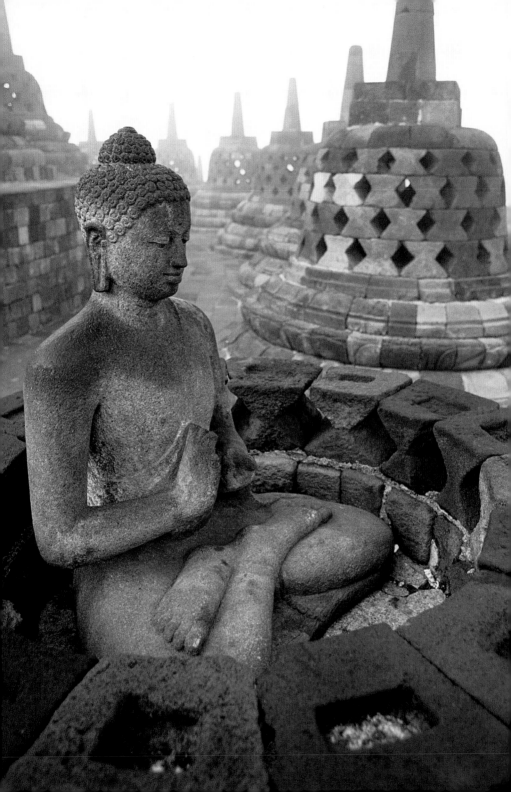

"When enlightenment becomes complete and perfect
the bodhisattva *is freed from his bondage in all things.*
Yet he does not strive for deliverance from all things.
He neither hates samsara *nor loves* nirvana.
The light of perfection is neither bondage nor deliverance."

From the *Purnabuddha Sutra* (Mahayana)

dhyanibuddhas (see page 39). In each of the compass quarters the sculptures' hand positions or *mudras* (see pages 246–267) are all of a type. The images facing east display the *bhumisparsamudra*, the gesture of calling the earth to witness when the fingers of the right hand touch the ground. To the south, the left hand is lowered, palm out, in the *varadamudra*, the position of blessing. In the western quarter, the *buddhas* display the *dhyanamudra*, the gesture of meditation, while those in the north reveal the *abhayamudra* of fearlessness. The images at the centre of the monument show the *vyakhyanamudra*, the hand position related to teaching.

Java claims three major Buddhist *candis*, all dating from the eighth and ninth centuries. Aside from Borobudur, there are at Kalasan and Sari; while not on the same scale as Borobudur, at each of these sites there survives a rich collection of *buddha* images. The Kalasan and Sari temples were also commissioned during the Sailendra era and combine Hindu and Buddhist motifs. Probably all three were built as Mahayana rather than Theravada places of worship, although in the more recent revival it was the Theravada school that became the more popular among Indonesian Buddhists.

Left
Gautama Buddha revealed
seated in contemplative
repose among the *stupas*
in the remarkable
Buddhist architecture of
Borobudur, Java,
Indonesia, 8th–9th
century CE.

Cambodia

Straddling the lower reaches of the
Mekong river, Cambodia is a land where
Theravada Buddhism predominates.
When the communists took over the
running of the country in 1975 under
the regime of Pol Pot and the Khmer
Rouge, however, they all but destroyed
the Buddhist heritage and culture.
Virtually all monks were either executed
or driven to flee into exile and their

Below and right
Huge heads of the Buddha
in time-weathered stone
set the mood for visitors
to the Angkor Wat
archaeological park at
Angkor Thom, Cambodia,
9th–13th century.

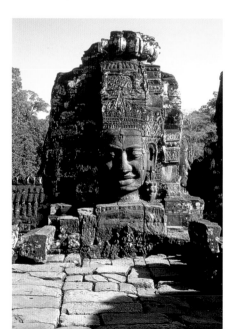

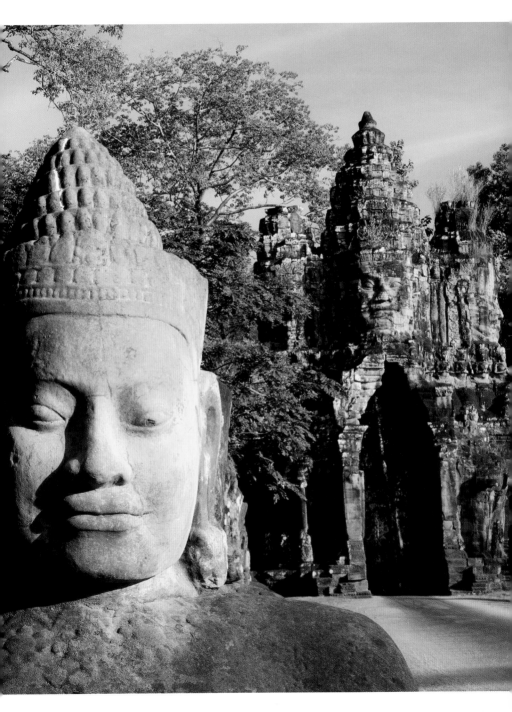

monasteries bulldozed. Such temples and art as remain, including the world-famous Angkor Wat, are largely in a ruined or semi-ruined state.

Cambodian Buddhism can be traced back to the turn of the sixth century CE and even, if tradition is believed, to the first century CE. However, it represented a mix of Brahmanical Hinduism and Mahayana Buddhism until the 13th century, when Theravada Buddhism was introduced into Cambodia and became the dominant branch of the religion. It is unclear exactly who brought Theravada to the country, but one possible contender for the accolade is Tamalinda Mahathera, who was perhaps a son of King Jayavarman VII (1181–1218) and who had studied at a monastic school in Sri Lanka.

When one thinks of Cambodian Buddhism the mind's eye is instinctively drawn to that extraordinary monument

"The foolish and the ignorant pursue careless lives, the clever person treats knowledge as a precious possession."

From the *Dhammapada*

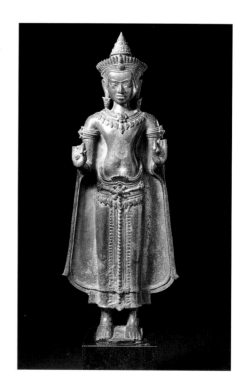

Right

This small and delicate statue of a standing *buddha* has been dated to the 12th century. Cambodia.

Opposite

The faces of stone statues of *buddhas* are caught in a shaft of sunlight streaming down through an aperture at Angkor Wat, Angkor Thom, Cambodia, 9th–13th century.

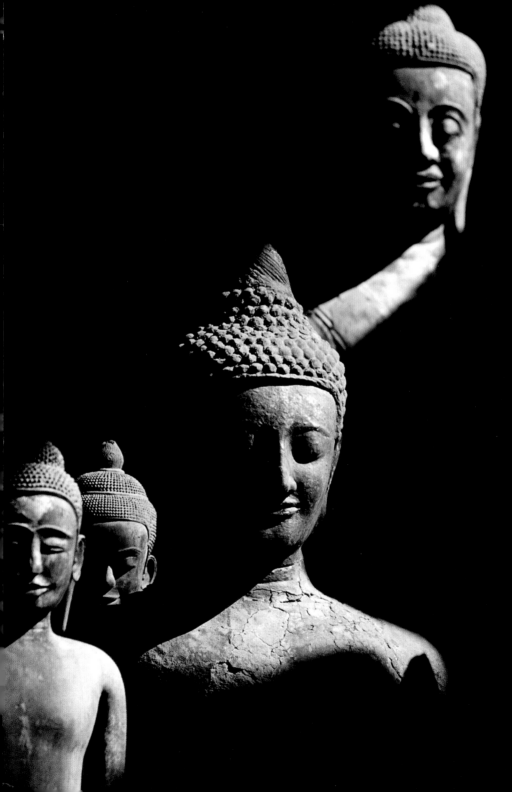

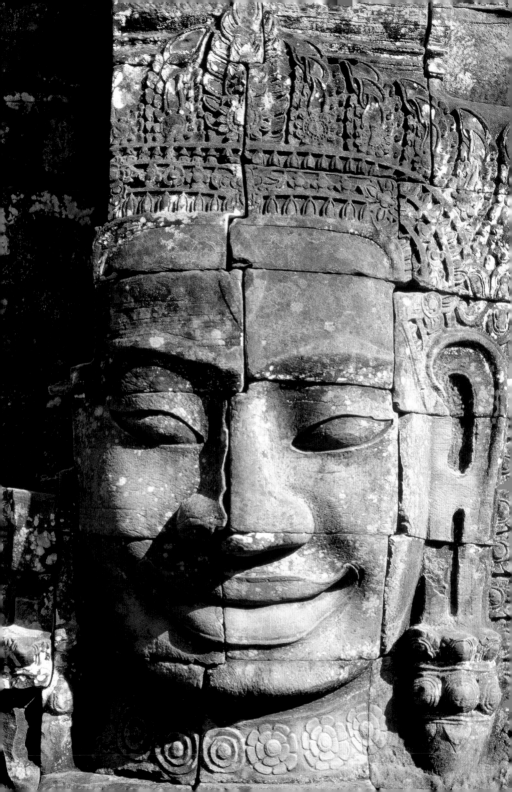

to Buddhist and Hindu faiths hidden deep in the jungle, Angkor Wat. Covering some 400 square kilometres (155 square miles), the awesome collection of now ruined temples was built between the ninth and 13th centuries but fell into disuse from the 14th century when the power of the Khmer kings declined and the town became a regional backwater, and was only rediscovered by French explorers in the 1860s. The most extraordinary of the Angkor temples was constructed during the reign of King Suryavarman II (1113–50 CE) and lays claim to being the largest religious monument in the world. Spared from the ravages of the Khmer Rouge, the temple itself extends over 200 hectares (500 acres) and is constructed in three massive terraces. Above the uppermost soars the great central tower, which is shaped like a lotus bud and is meant to symbolize Mount Meru, the mystical centre of the Hindu universe.

The Bayon temple at Angkor Wat, built in the 12th century, is a mass of ruined towers, from the walls of which gaze more than 200 sculpted faces of King Jayavarman VII.

"Soon my corpse will be lying on the ground, abandoned and inanimate, like a useless piece of flotsam."

From the *Dhammapada*

Left
Relief of a smiling *buddha*, crafted from assembled blocks of stone, revealing a characteristic style that is almost geometric in nature. Angkor Wat, Angkor Thom, Cambodia, 9th–13th century.

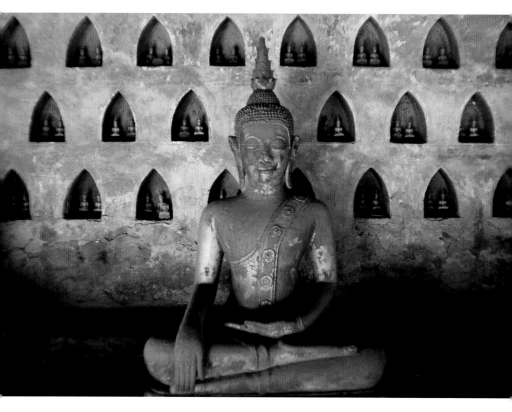

"*In truth the person who knows his own ignorance is wise, but an ignorant person who thinks themselves wise is truly a fool.*"

From the *Dhammapada*

Above
A seated image of Gautama Buddha rests before a wall containing dozens of niches sheltering small *buddha* images in the Pagoda of One Thousand Buddhas at the monastery of Wat Si Saket, Vientiane, Laos.

Laos

Sandwiched between Thailand and Vietnam lies the small, landlocked state of Laos, which also shares shorter borders with Myanmar and Cambodia. The country, which has widely been seen as the poor relation in Indo-China, was established in the mid-14th century, when the main power base of the region, Angkor (see Cambodia, pages 136–141), was going through a weakened political era, and a renegade Thai prince named Fa Ngum took the opportunity to set up a separate kingdom in Laos. Strongly influenced by the teaching of a Theravada monk he had met while staying at Angkor, Fa Ngum introduced Theravada Buddhism as the national religion and it has remained thus to the present day.

There is some justification to the claim that Theravada Buddhism has succeeded in bonding the various scattered ethnic groups of Laos in the face of perennially weak government and, latterly, under the communists who took over in 1975. Unlike the experience of neighbouring Cambodia under the regime of Pol Pot, communism was introduced into Laos under the Pathet Lao in a comparatively gentle manner

and Buddhism was not subject to any draconian suppression. In fact, the communist government went so far as to imply that communism and Buddhism were on similar "wavelengths". The most required of the monks has been to instil a patriotic and communist version of Laotian history into their teaching.

The first capital of Laos was Luang Prabang, in the north of the country, and today this is the site of some of the finest Buddhist art in Southeast Asia. The most distinctive of the Laotian *buddhas* were sculpted between the 16th and 18th centuries and one of the most famous religious icons of the nation is an exquisite emerald *buddha*, the Phra Keo. The statue, however, was forcibly removed by a Thai invasion force in 1778 and now rests in the Wat Phra Keo in Bangkok, where it remains the focus of simmering resentment between Thailand and Laos. Another *buddha*, the magnificent Phra Bang, was returned to the country briefly by the Thais in 1782 under a Vietnamese puppet government, but subsequently found itself back in Thailand.

In one of the most distinctive styles of Laotian *buddhas*, the hands are spread at the sides in what has become tagged the "calling for rain" posture. At

143

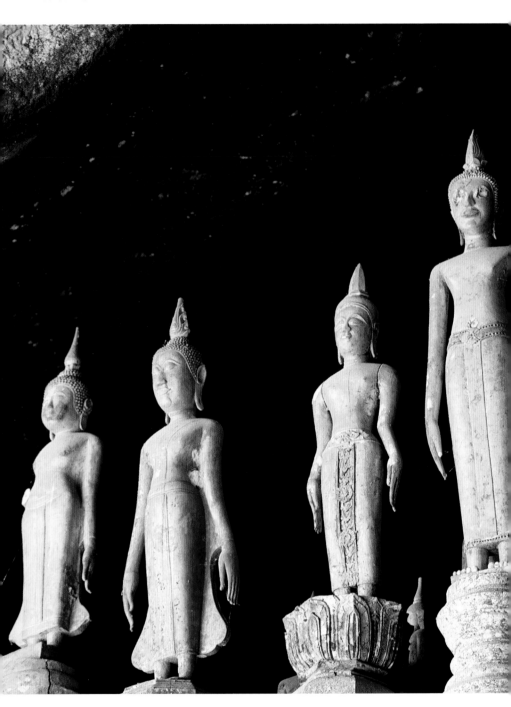

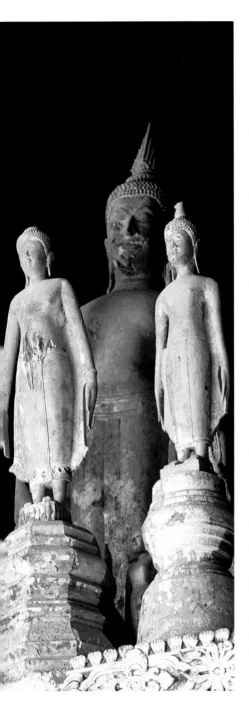

the end of the dry season Laotians have traditionally sought the monsoon rains by letting off rockets, and this unusual posture of the *buddhas* echoes the desire. A number of such buddhas stand in the main temple of the city, the Wat Xieng Thong, which houses a large assembly of wooden images, many covered in gold leaf. More, in similar posture, are to be found in one of the oldest Luang Prabang temples, the Wat Wisunalat. Some of the oldest of all surviving Laotian *buddha* images, around 2,500 sculptures from the early 1700s, rest in the Pak Ou caves, for much of the time in total darkness.

The modern Laotian capital is Vientiane (Vien Chan), founded in the 18th century. There one can explore the Pagoda of One Thousand Buddhas at the monastery of Wat Si Saket, so called because at one time it did indeed

Left

These rows of *buddha* statues with their arms at their sides reveal a gesture that has become known as "calling for rain". They are traditionally invoked to help farmers at the end of the dry season. Pak Ou caves, Luang Prabang, Laos, early 18th century.

house a thousand images, many of them sheltered in little wall niches. Over the years, however, the original sculptures have been largely depleted and replaced by other artworks.

Repeated Thai aggression has been at considerable cost to Buddhist art in Laos. The Thai forces destroyed many of the religious shrines in Vientiane when they sacked the city in 1862, but the Wat Si Saket was spared, apparently because it was built in the "Bangkok style". Less fortunate was the old royal monastery of Wat Phra Keo that stood nearby, the rightful home of the Emerald Buddha. The Thais razed the original building during their attack on the city but the monastery was carefully rebuilt in the 1930s and it contains many of the smashed images of *buddhas* as a lasting reminder of the destruction that took place.

It is, however, the vast Buddhist sculpture park near Vientiane, the construction of which started in 1958, that particularly captures the attention. The garden is home not only to a large assortment of Buddhist figures but also to images from the Hindu pantheon. A massive and strikingly spectacular Buddha, reclining in stone, dominates the landscape of the park.

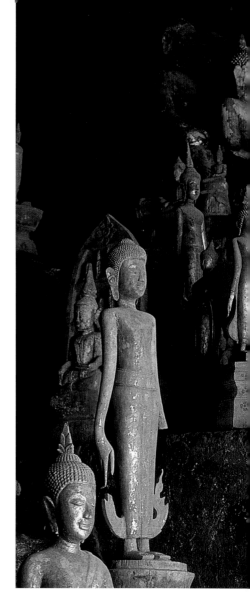

Above
Some of the collection of 2,500 sculptures of *buddhas* mostly dating from the early 1700s. Pak Ou caves, Luang Prabang, Laos.

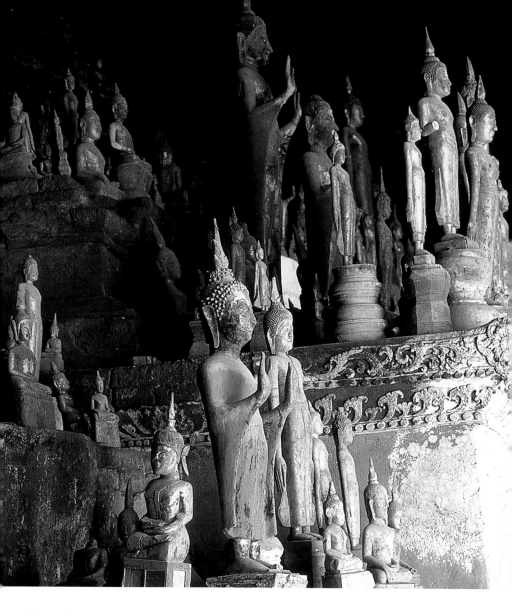

"As a house with a leaking roof lets in the rain,
 so desire enters a mind that has not been practising meditation.
But a house with a good roof keeps dry
 and desire is kept from a mind that meditates."

From the *Dhammapada*

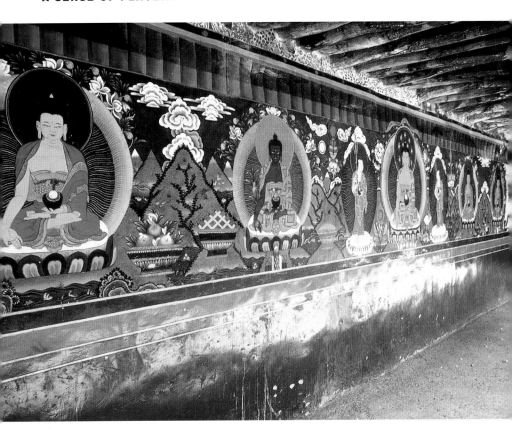

*"In struggling to break free from
temptation, the mind wriggles like a fish
pulled from its home to dry land."*

From the *Dhammapada*

Tibet

Many centuries after its export to Sri Lanka, Buddhism began its spread northwards and became established in the Himalayan fastness of Tibet. Monks carried it there in the seventh century CE, and at first met with strong opposition from more conservative elements loyal to the ancient Tibetan religion of Bon. The Bon shamans had been conducting their magical rituals since time immemorial and were resistant to any dilution of their authority. The ideals of Buddhism appealed, however, to the Tibetan King Songsten Gampo (617–650 CE), who became a staunch convert. Nevertheless the real credit for a peaceful blending of the principles of Buddhist and Bon cultures goes to an eighth-century-CE Buddhist missionary named Padmasambhava. It was he who was largely responsible for the founding of the first Buddhist monastery in Tibet at Samye.

Padmasambhava had brought with him a distinct form of Mahayana Buddhism (see page 53) known as Vajrayana. One of the more liberal disciplines, Vajrayana leaned towards ritual and the magic of Tantrism and was happy to permit an unusual degree of

Opposite

Mural paintings of Buddhist scenes decorate the walls of Shalu monastery, Shigatse, Tibet.

Below

A gilt bronze statue of the *dhyanibuddha* Amitayus, "He of Infinite Life", an aspect of Amitbha, holds the vase of longevity while seated in meditative repose at a monastery in Tibet.

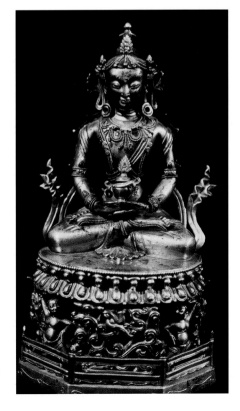

sexual licence among the members of its *sangha* community of monks. The object of the Tantra, a series of Hindu ritual and magical writings used by the Buddha for the evocation of divinities, is to reach into the subconscious mind and draw out the spiritual and mystical powers immersed in its depths.

To complicate matters, two forms of Tantrism exist within Buddhist practice, the Right Hand and Left Hand. Left-Hand Tantrism focuses on the female aspects of the *dhyanibuddhas* or spiritual *buddhas* (see page 39) and in particular on that of the *bodhisattva*

Right

Traditionally dressed Tibetans in front of a giant sculpture of Gautama Buddha holding a begging bowl, hewn from the living rock of a cliff face. Lhasa, Tibet.

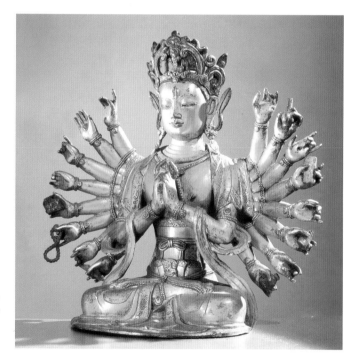

Right

The tutelary deity of Tibet, the *bodhisattva* Avalokitesvara, "the Merciful Lord", depicted with 18 arms, two of which hold a rosary. One of the most popular figures of Mahayana Buddhism, he demonstrates the blend between Buddhism and the more ancient Tibetan belief in gods and goddesses. Tibet, 17th century.

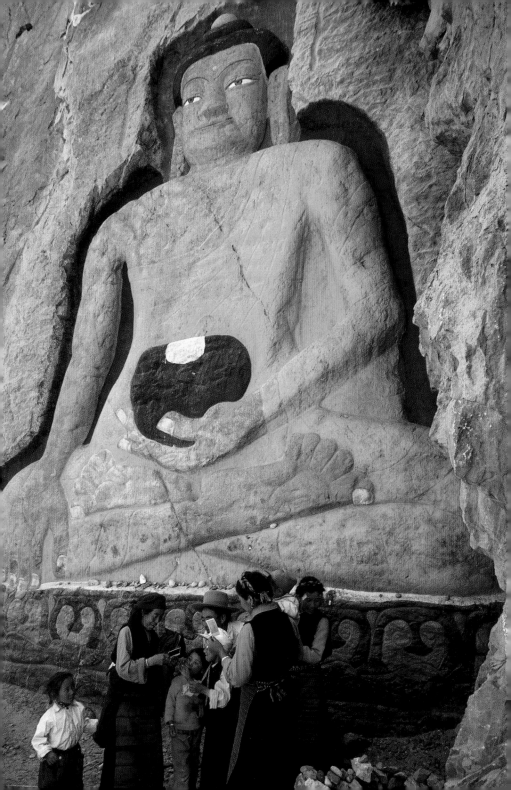

Avalokitesvara. He is revered as a special kind of *dhyanibuddha* concerned with the practice of meditation. Avalokitesvara is especially important in Tibetan Buddhist iconography: he became the patron deity of Tibet and his evolution reflects the blend between Buddhism and the theistic belief in gods and goddesses. It has been this tolerance shown by Buddhism, allowing it to merge with other religions, that has accounted for much of its successful spread.

In Tibet, Buddhism has remained a fundamental part of local culture, closely integrated into daily life. But the Chinese communist takeover in the 1950s brought major efforts at suppression: numerous monasteries were destroyed and key religious figures, including the Dalai Lama, emigrated to India, Nepal and elsewhere, setting up Tibetan Buddhist *sanghas* abroad.

Overleaf
A painting of Gautama Buddha executed on a rock face stares out over town and countryside from its vantage point below the Sera monastery, near Lhasa, Tibet.

Left
This faded fresco depicts the legend of Gautama Buddha's first sermon before his disciples. Tibet, 17th century.

Right
A 23-centimetre-high (9-inch) finely wrought statue of the seated *dhyanibuddha* Amitayus (an aspect of Amitbha) wears a silver crown, revealing the influence of theism in Tibetan Buddhism. Central Tibet, 13th century.

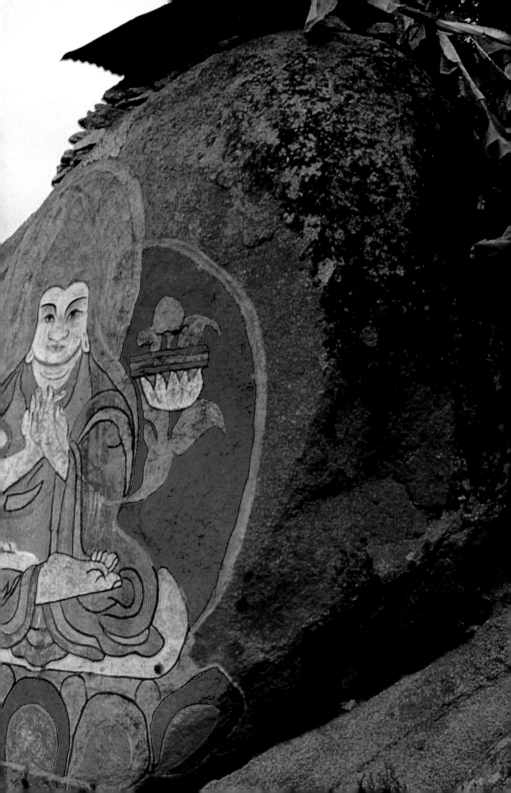

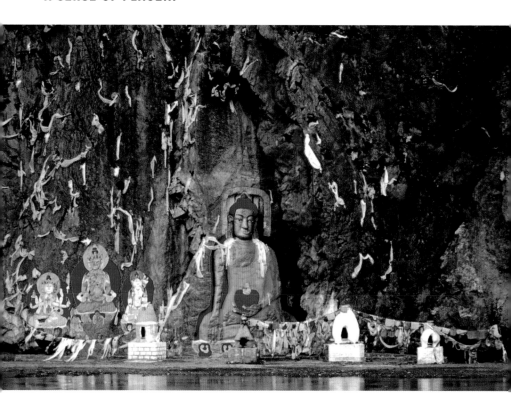

"To the feet of the accomplished masters,
embodiment of the Three Jewels,
profoundly I turn for spiritual inspiration;
bestow upon me your
transforming powers."

From the teachings of the Third Dalai Lama (Tibetan)

Left

Carvings and paintings of *buddhas* on a cliff face. Lhasa, Tibet.

Below

Depiction of Gautama Buddha at the moment when he renounced his princely life and the material world by the symbolic cutting of his hair at a single stroke. Tibet, 18th century.

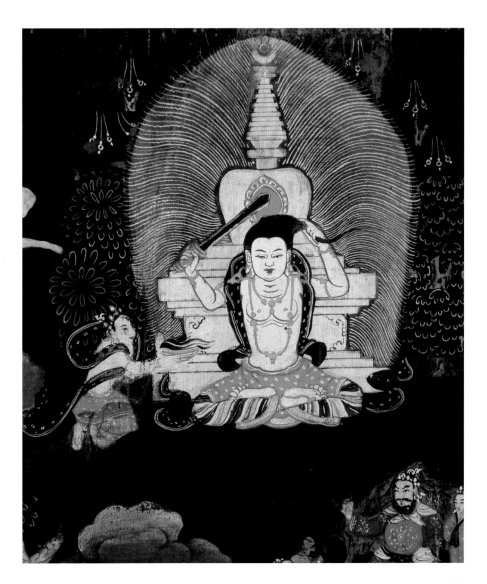

China

Sometime during the first century BCE, Mahayana Buddhist monks are claimed to have made the hazardous trek across the mountains to China by way of Nepal and Tibet and established the first Chinese *sanghas*. Other historians argue that the monks did not reach China until the second century CE. Around the same time, from the first century CE onwards, there was much activity along the network of east–west trade routes known collectively as the Silk Road, and monks also travelled these paths across mountain and desert, taking Buddhism, predominantly in Theravada form, from Gandhara in Afghanistan through Chinese Central Asia (the modern Chinese province of Xinjiang) into China itself.

Whatever their origins, the monks brought with them to China images of Gautama Buddha and a heavenly retinue comprising *bodhisattvas*,

"Sorrow comes from pleasure, so too does fear. The person who is freed from pleasure experiences neither sorrow nor fear."

From the *Dhammapada*

Opposite
The 34-metre (112-foot) seated bronze image of the Tian Tan Buddha looms over the surrounding rooftops of Po Lin monastery on Lantau island, Hong Kong, 1983–93.

Right
A painting of Gautama Buddha attended by monks. Shikshin monastery, Karashar, Xinjiang province, China, 9th–10th century CE.

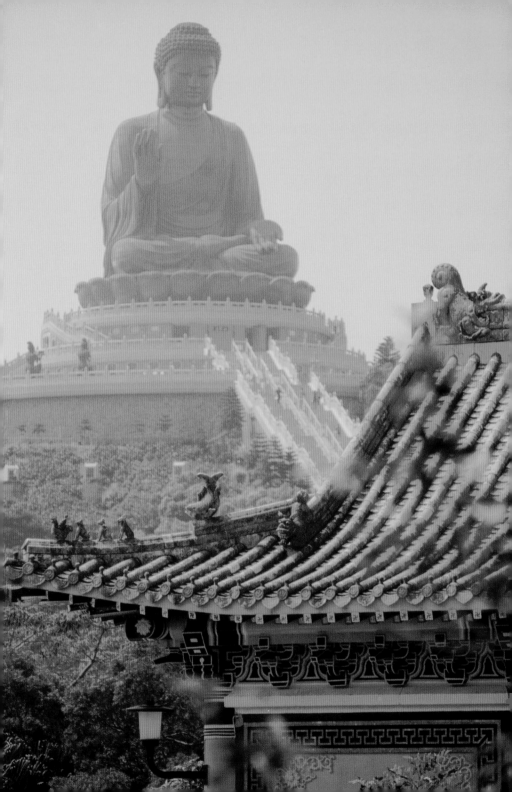

Below

A damaged sculpture of the Buddha seated serenely on a lotus throne decorated with two layers of petals. The right hand may once have been raised in the *abhayamudra*, while the left is lowered in the *varadamudra*. China.

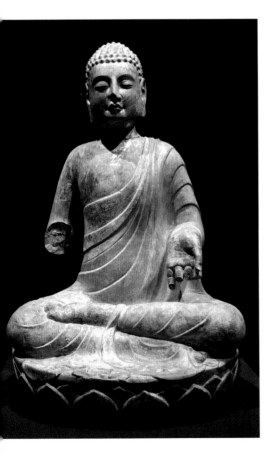

dhyanibuddhas *(see page 39)* and other figures from Buddhist scriptures. They found much in common between local faiths and the ideals of Buddhism, including a parallel belief in the notion of *sunyata*, the perfect state of emptiness needed to achieve *nirvana*, echoed in the traditional Chinese Taoist concept of *wu* or nothingness.

On the other hand, they also encountered strong contrasts, such as attitudes towards celibacy: the monks had brought from India a celibate lifestyle that went against the deep-rooted Chinese character of maintaining family ties and working for a living. The Mahayana schools struck a greater chord with the Chinese than did Theravada, but nonetheless for several hundred years Buddhism and Chinese religions existed side-by-side in an atmosphere of mutual tolerance rather than amalgamating.

Right

Sculpted in terracotta, a bust of Siddharta as a young man before becoming an ascetic, wearing princely garments and displaying an elaborate hairstyle. Tumshug, China, 6th–7th century CE.

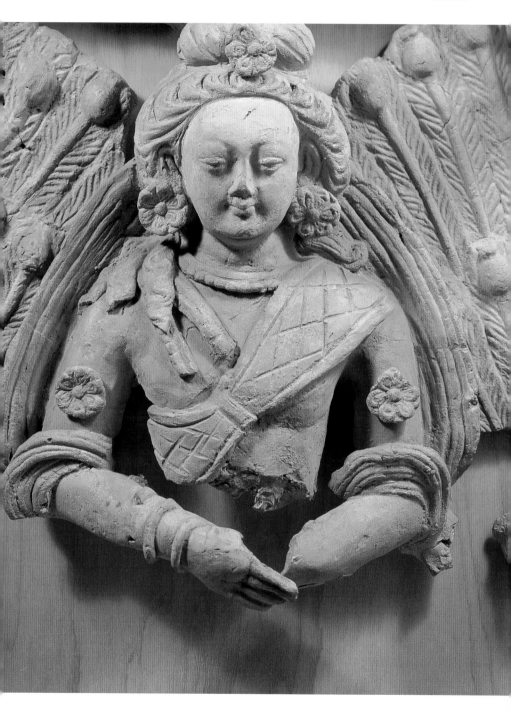

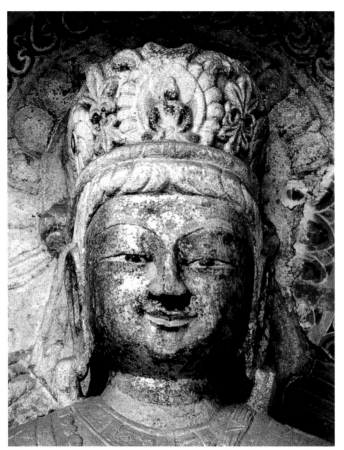

Left

An ornately crowned head of a *buddha*, carved in semi-relief, in the cave temples known as the Yungang grottoes, on the southern slopes of the Wuzhou Mountains. Yungang caves, Datong, Shanxi province, China, late 5th century.

Right

Intricate wall carvings of *buddhas* and scenes from Buddhist tradition decorate the interior of the Yungang grottoes. The art here retains much original Indian and Gandharan character. Yungang caves, Datong, Shanxi province, China, late 5th century.

"The wise find solace in Truth, like a deep, clear and tranquil lake."

From the *Dhammapada*

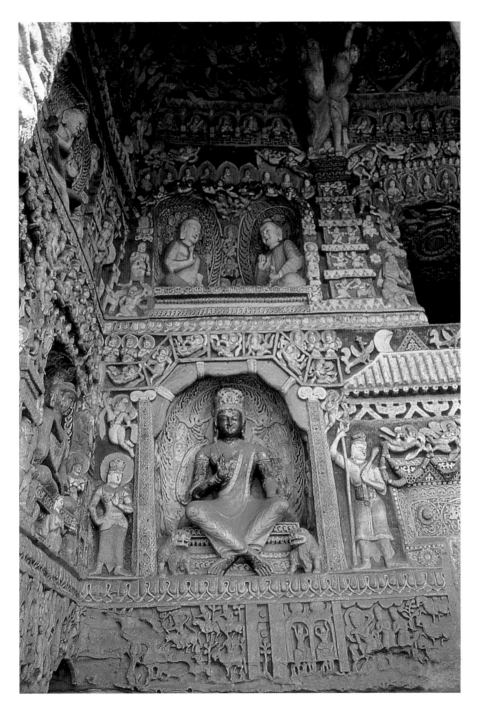

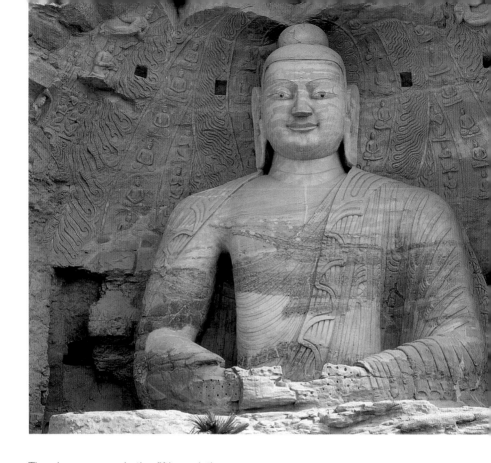

The change came in the fifth or sixth
century, when, according to tradition, a
monk named Bodhidharma arrived in
China from India accompanied by a new
sectarian, inward-looking form of the
meditative life, later to become known
as Zen. Bodhidharma was almost
certainly a figure of mythology but he is
credited with having introduced the Zen
technique of "wall-gazing" in order to
clear the mind of material thoughts. By
the seventh century Zen Buddhism had
become established in China, where it

Above
Perhaps the oldest known
rock carving of a seated
buddha, 14 metres
(46 feet) high and with
distinctly Gandharan
facial features, with a
bodhisattva in attendance.
Cave 20, Yungang caves,
Datong, Shanxi province,
China, 460–494 CE.

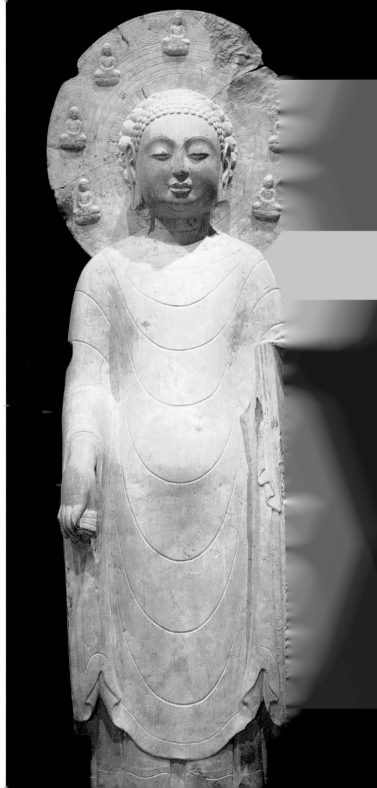

Right

A standing Gautama Buddha with a notably Chinese face. The seven small images sculpted on the nimbus behind the Buddha's head may indicate his ability to manifest himself in a variety of forms. China.

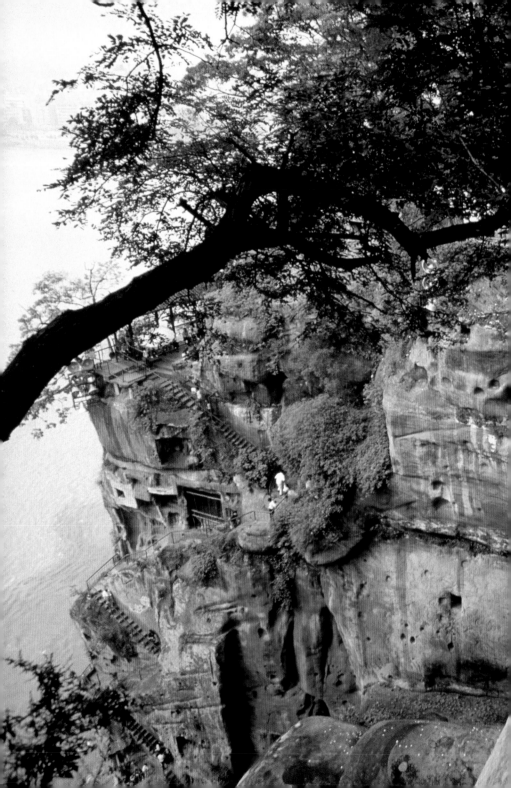

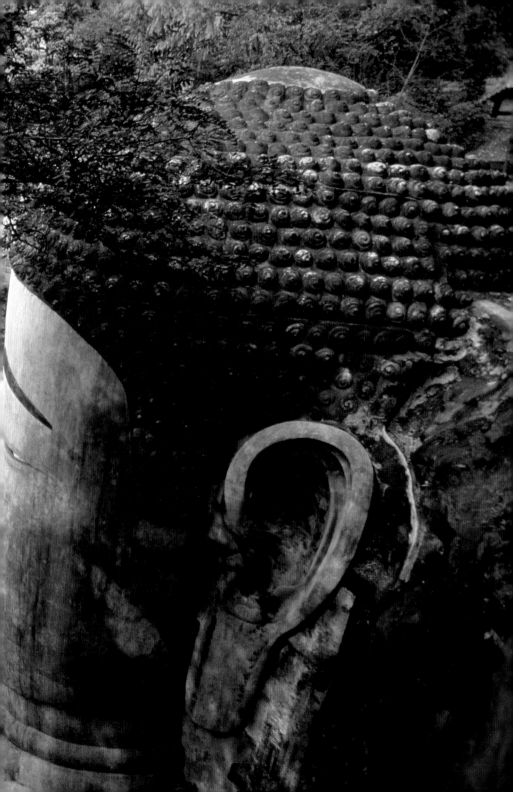

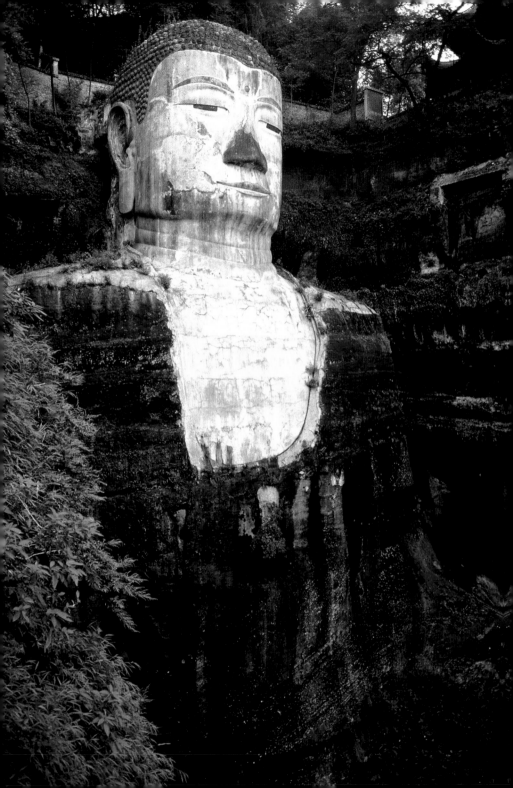

"I have been humiliated, violated, beaten, robbed! Anger feeds in those who keep such thoughts. I have been humiliated, violated, beaten, robbed! Anger starves in those who discard such thoughts."

From the *Dhammapada*

was known as Chan. One of its most eminent champions was the Sixth Zen Patriarch, Hui Neng, born in 638 CE. He and others of like mind saw the attraction in Mahayana mysticism and arrived at an eclectic combination that brought together the influence of Indian culture with the needs of the Chinese mind, but also incorporated practical elements of Confucian philosophy.

The true joining of religious forces, however, began with the Tang Dynasty in the eighth century, and was probably complete by the 11th century. Much of the Taoist concept of immortality gained from pills and potions and the endless quest for mortal longevity had lost its

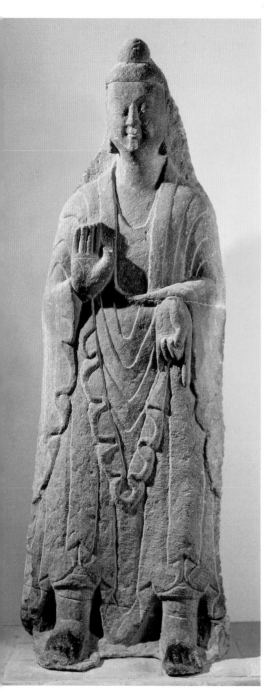

appeal, and it was increasingly fashionable to look for alternatives. The result was an eruption of Zen Buddhist schools practising a blend of meditative *dharma* techniques and Zen metaphysics. Within their cloisters Buddhist scriptures were increasingly translated into Chinese tongues. Hui Neng died a recluse, somewhere in southern China, in about 713 CE. True to the last to his discipline, he is said to have passed away seated in the lotus position. The schools established by Hui Neng and other masters expanded and rivalled one another until the period of the Five Dynasties (907–960 CE), when they became streamlined into the Five Houses of Zen philosophy.

Zen was not the only school to flourish in China. During the Song Dynasty (960–1279 CE) other forms of Buddhism appeared, including Tiantai and Ching Tu. Tiantai focuses on the Buddhist teachings contained in the *Lotus Sutra*, a scripture that stresses

Left

A standing and elaborately robed *buddha* carved in grey limestone. From Cave 26, Yungang caves, Datong, Shanxi province, China, Northern Wei Dynasty, *c.*490–505 CE.

Right

Standing images of *buddhas* with relatively rounded Chinese faces, carved in stone at the Longmen caves, Luoyang, Henan province, China, 5th–10th century.

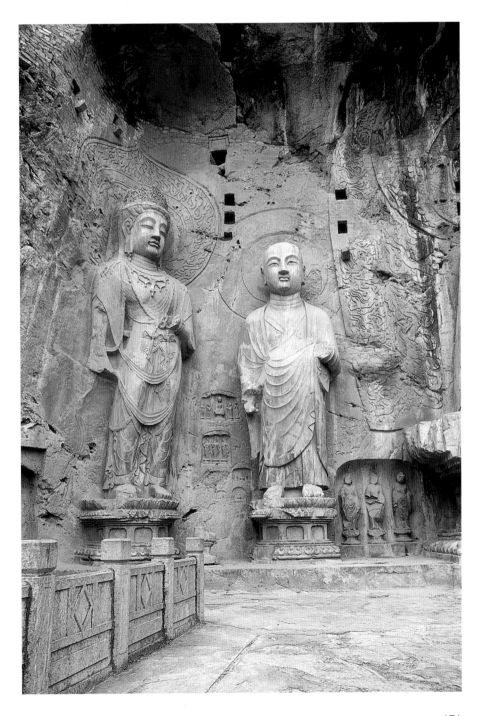

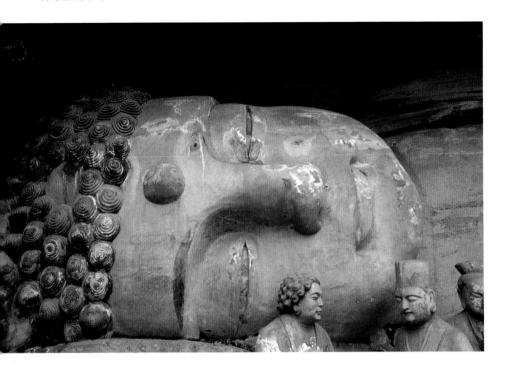

"Better than a thousand pointless words is a single saying that brings peace."

From the *Dhammapada*

Above

Detail of the head of Gautama Buddha reclining at the moment of entering *nirvana*, carved in stone. In front are smaller statues of people bearing gifts. Dazu, Sichuan province, China, 9th–13th century.

Right

A mass of distinctly Chinese buddhas and Buddhist scenes carved in stone relief decorate the exterior of a cave temple at Dazu, Sichuan province, China, 9th–13th century.

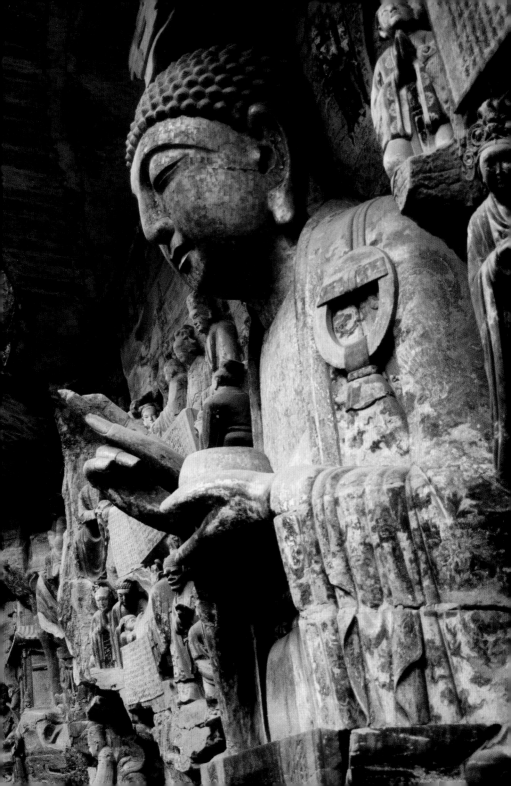

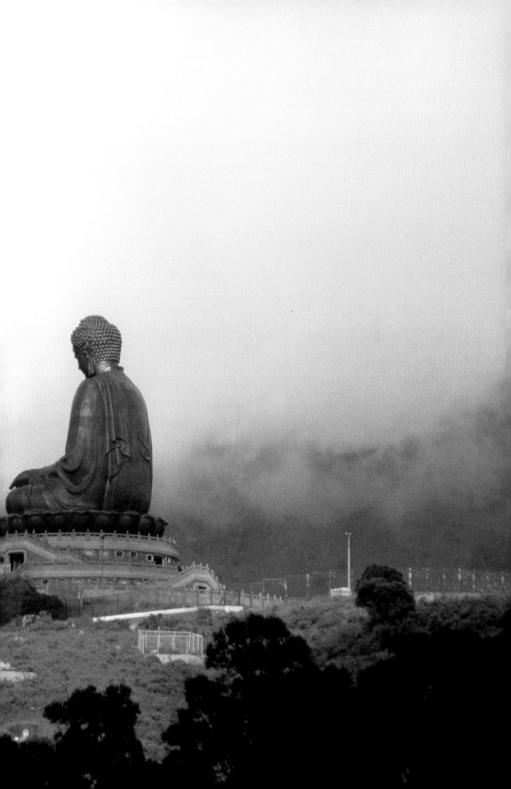

"Many are those who are blinded by this world and few are those who see the truth. Many are like birds trapped in a net and few are those who reach paradise."

From the *Dhammapada*

the importance of emptiness as well as morality and compassion, and incorporates a high level of Tantric mysticism along with more familiar techniques of meditation. Ching Tu, which is closely allied to Zen, focuses on the Amitabha *dhyanibuddha* as the main object of worship through which to reach paradise and generally tends to be more popular with lay people, not least because it rejects monastic life and celibacy.

In China the art of the Buddha gradually lost its Indian character. The voluptuousness of Indian-inspired icons was replaced – sometimes by a different kind of ornateness, distinctively Chinese in its delicate and flowing lines,

sometimes by a more austere imagery. And only in China and Japan can one discover fat, laughing *buddhas* with strongly oriental features, sometimes placed in cosy domestic shrines as talismans of good fortune.

Many Chinese painters and sculptors convey the flavour of Zen, the mind emptied of all thoughts. This

Previous page
Claimed to be the largest outdoor seated bronze *buddha* statue in the world, this 34-metre (112-foot) image of the seated Gautama Buddha dominates the dramatic skyline of Lantau island. Hong Kong, 20th century.

Right
A Buddhist statue stands silhouetted dramatically against the sun near the huge Buddha at Po Lin monastery, Lantau island, Hong Kong, 20th century.

176

Right

This jolly, laughing *buddha* with its hugely corpulent features may have evolved from the *manusibuddha* Maitreya, but has lost any trace of Indian influence and follows a purely Chinese tradition. Sculpted from a living rock formation in the grounds of Lingyin-si temple, Hangzhou, Zhejiang province, China.

"I do not eat in the evening and thus I am in good health. I am not overweight, I have energy and I live comfortably. The monk should also avoid eating in the evening in order to have good health."

From the sayings of Gautama Buddha

austerity can be summed up in the features of the colossal seated Buddha carved into the living rock of the mountainside at Leshan in Sichuan province of southwest China. Sculpted in the eighth century, its serene face, almost surreal, gazes out through half-closed eyelids over the confluence of three rivers from its lofty vantage point. At 71 metres (234 feet) in height, it is the largest *buddha* in the world, dwarfing the nearby buildings of the temple. The statue exudes the aura of great age, partly because of weathering of the rock but also thanks to ferns and other plants that have taken hold in cracks and crannies of the stone.

Buddhist art in China can never be described simply as "Chinese",

Right
An austere and distinctly Chinese image of the seated Buddha. Zhangpei temple, Sichuan province, China.

however. Because of the vast geographical size of the country and its differing traditions, there is immense variety. Particularly around the remoter fringes, neighbouring influence is felt and examples of past splendour are also more likely to have escaped mainstream changes of emphasis. Depending on the locality and era in which they were crafted, images of *buddhas* may be distinctly Indian or Central Asian in appearance, or may display Tibetan, Mongolian or Southeast Asian influence.

Some of the finest examples of Chinese Buddhist art to have survived the ravages of time and communism, the latter peaking in the Maoist Cultural Revolution of the 1960s, are found today in the cave temples of Dunhuang in Gansu province (both Indo-Gandharan and more purely Chinese style, dating from the fourth to 14th centuries), Yungang in Shanxi province (Indo-Gandharan-influenced work from the late fifth century) and Longmen in Henan province (mainly Chinese style, from the sixth to tenth century).

"To live a good life, to deny evil, and to purify the mind thoroughly, this is the teaching of all the buddhas."

From the *Dhammapada*

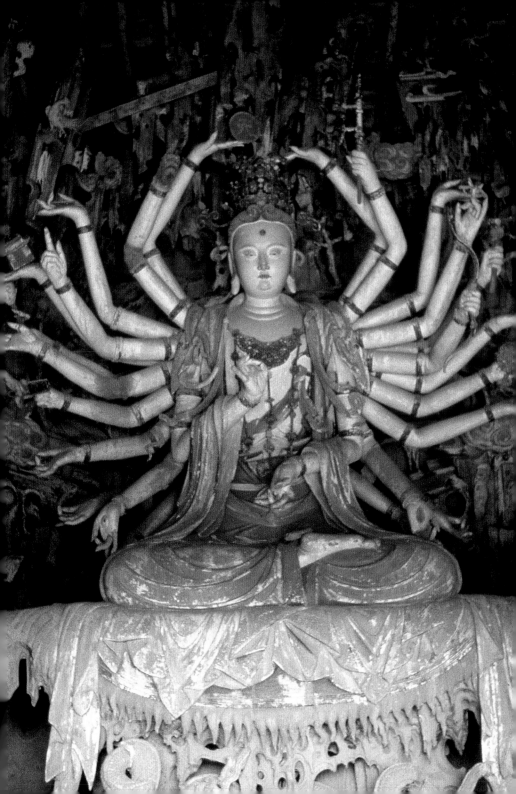

Opposite
Seated in the lotus
position, this many-armed
image of the *bodhisattva*
Avalokitesvara has
changed sex and become
female as Guanyin, the
Buddhist goddess of mercy
in Chinese tradition. In a
monastery at Mount Wutai,
Shanxi province, China.

Left
An unusual depiction of a
richly robed and
bejewelled *buddha*,
moulded from yak butter
by Tibetan monks at
Ta'er-si (or Kumbum in
Tibetan) monastery, Xining,
Qinghai province, China.

*"He who refreshes his spirit with the
Truth will live happily and in peace.
A wise person feeds on the Truth taught
by the holy ones."*

From the *Dhammapada*

Vietnam

Buddhism came to Vietnam by two routes: from India and China. The earliest school, probably arriving in the second or third century CE, was Theravada from India. One of the first monasteries in Vietnam, at Luy-Lau, the old capital, was often visited by Buddhist monks from India en route to China. However, the proximity to China, which has twice annexed Vietnam, meant that Mahayana Buddhism spilled across the border and took over as the dominant Vietnamese school. With it came traditions of Chan, Chinese Tantrism and Pure Land Buddhism.

Today Buddhist *dharma* literature in Vietnamese comes from both the Pali Canon originating in India and the *Agamas* and a collection of Mahayana *sutras* from China. Among the most important Buddhist centres in the land is the pagoda of Thien Mu, completed

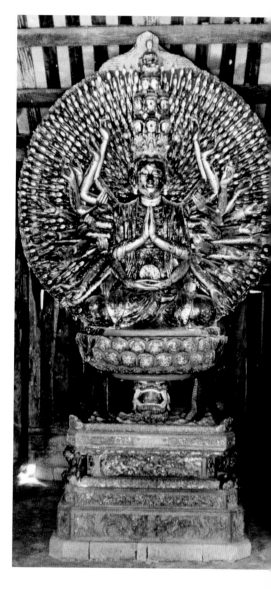

Left
Painted an unusual green, this large seated Buddha exudes natural calm and repose. Vietnam.

Right
The eyes of *buddhas* are said to be all-seeing. This striking sculpture of Guanyin (Avalokitesvara), seated on a lotus throne, is surrounded by a *mandorla* of eyes. Vietnam, 15th–16th century.

under Emperor Thieu Tri in 1844. The magnificent pagoda is 20 metres (66 feet) high; each of its seven levels once contained a golden *buddha*, but sadly these were stolen in the 20th century.

Korea

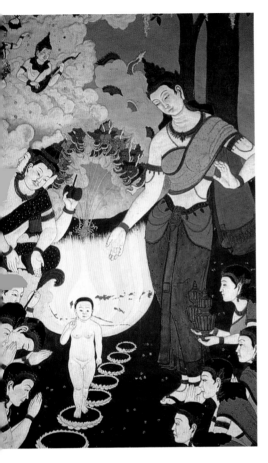

Chinese Buddhist monks carried Zen Buddhism to the Korean peninsula sometime during the fourth century CE, but for hundreds of years afterwards the religion was developed and largely conducted away from the eyes of the outside world. In recent times, South Korean temples have become more open to foreign visitors, but the present repressive political climate of North Korea and the South Korean focus on modernization have taken their toll.

Yet for a thousand years Buddhism enjoyed a dominant position as the state religion of Korea, maintaining its supremacy until the start of the 15th century when Confucianism, favoured by the powerful Yi Dynasty (1392–1910), largely replaced it. Korean Zen, or Son, developed from the early Chan school in China but quickly began to take on its own unique character, distinct not only from Chinese Buddhism but also from that of Japan. It is much less formal than Japanese Zen, harking back to the original rustic style of Chan. Different schools tend to be combined under one roof in larger Buddhist centres, while in small mountain temples, off the beaten track, individual traditions prevail.

Above

The infant Siddharta takes his first seven symbolic steps surrounded by disciples in this old *thanka* (painting) decorating the great hall of Chogye-sa temple, Seoul, South Korea, 20th century.

Opposite

Gautama Buddha seated at the base of the *bodhi* tree where he found enlightenment. Disciples listen to his teaching and display the *dharmamudra* gesture. From a mural on the outside wall of Chogye-sa temple, Seoul, South Korea, 20th century.

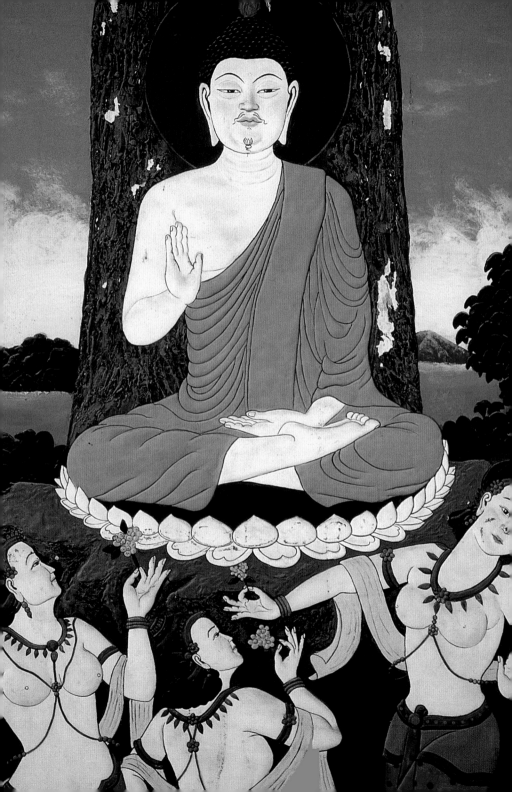

In spite of the centuries of repression, Korea is not short of surprises in the diversity of Buddhist temples and the art they protect. Nine Mountain Schools of Korean Zen have survived the passage of time, mostly dating from the ninth century CE, and some unusual examples of *buddhas* can be found. Korean Buddhist art is as much about painting as sculpture.

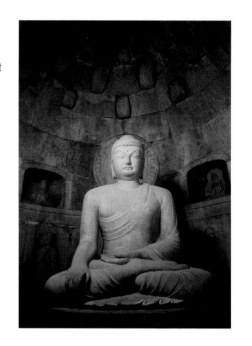

Not surprisingly, given that it took its lead from China, the emphasis is on Mahayana Buddhism. Aside from depiction of Shakyamuni and his life, the *buddha* image most frequently depicted, as in China, is the *dhyanibuddha* (see page 39) Amitabha, although Avalokitesvara and the future *buddha*, Maitreya, also feature strongly.

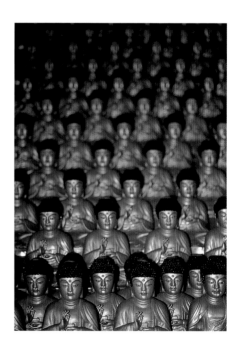

Right, top
Seated granite Shakyamuni Buddha at the moment of enlightenment in the "Cave of the Stone Buddha", Sokkuram grotto, Kyongju, South Korea, 8th century CE.

Opposite
A richly gilded statue of the Buddha stands before a painted depiction, both displaying the *dharmamudra* gesture. Taejo-sa temple, South Korea.

Right, bottom
Massed ranks of 1,000 *buddha* images, reflecting the idea of a thousand manifestations, are assembled in the temple of Pongwon-sa, South Korea.

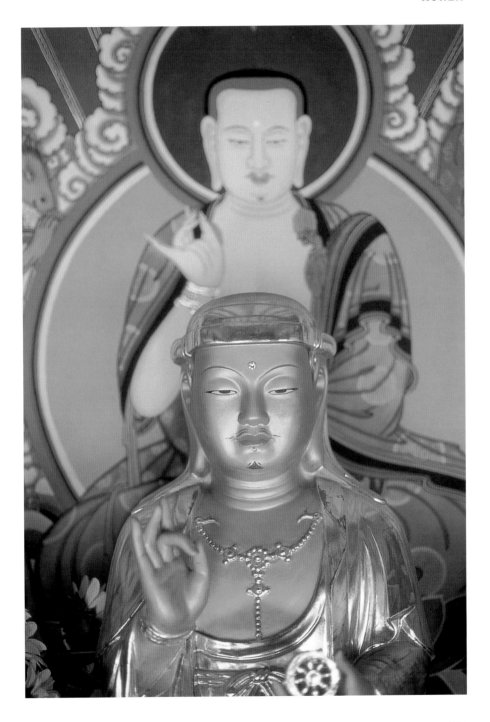

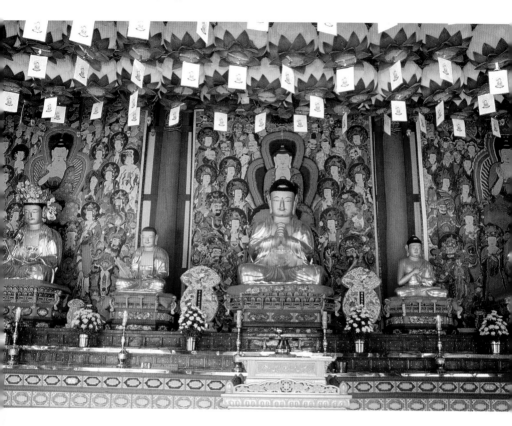

Above

Gold-covered *buddha* sculptures stand in front of myriad *buddha* paintings embellishing the walls of the Haein temple complex near Taegu, South Korea, 9th century CE.

Today the most important school is Chogye, whose Chogye-sa temple – built in 1910 and named after the mountain where the Sixth Patriarch, Hui Neng (see page 169), lived – is the only major temple within the old city walls of Seoul. Shilluk-sa temple, near Seoul on the Namhan (South Han) river, is home to the largest Zen sect in Korea, its main hall honouring Amitabha. Built in the 13th century, the centre fell into decay after being ransacked during the Japanese invasions of the 17th century

and was only restored to its former glory in 1928. As with Chogye-sa, the temple houses a wealth of Buddhist paintings.

Many of the finest temples are sited on mountaintops. Pomo-sa, on Kumjong-san peak above the city of Pusan, is thought to have been built in the seventh century CE. It is home to a famous painting of the oldest and first of the *dhyanibuddhas*, Vairocana.

Some impressive images of the *bodhisattva* Avalokitesvara can be discovered at the Naksan-sa temple on a mountain overlooking the East Sea. Here, true to the ideals of Avalokitesvara, or Kuan Yin as he becomes, compassion and mercy are the dominant themes. Founded in 671 CE, the centre is home to a glorious sculpture of Avalokitesvara and dozens of smaller images of the *bodhisattva* in a range of styles that show off the skills of Korean woodcarvers.

Overleaf
A trio of golden *buddhas* seated on a lotus thrones display a variety of hand *mudras* as they dominate the ornate hall of Sonun-sa temple near Kochang, South Korea.

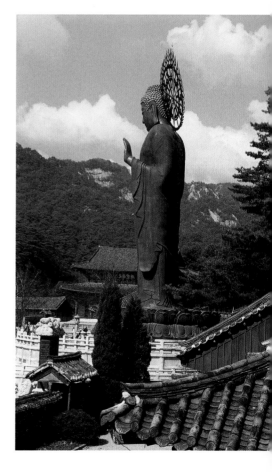

Right
A standing image of the Buddha in stone before an elaborately fretted metal nimbus rears up above the rooftops of Popchu-sa temple, Taejon, South Korea.

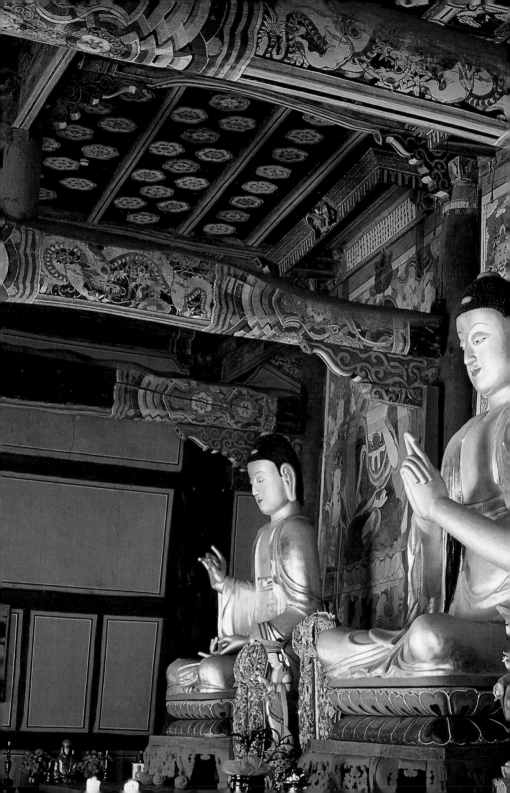

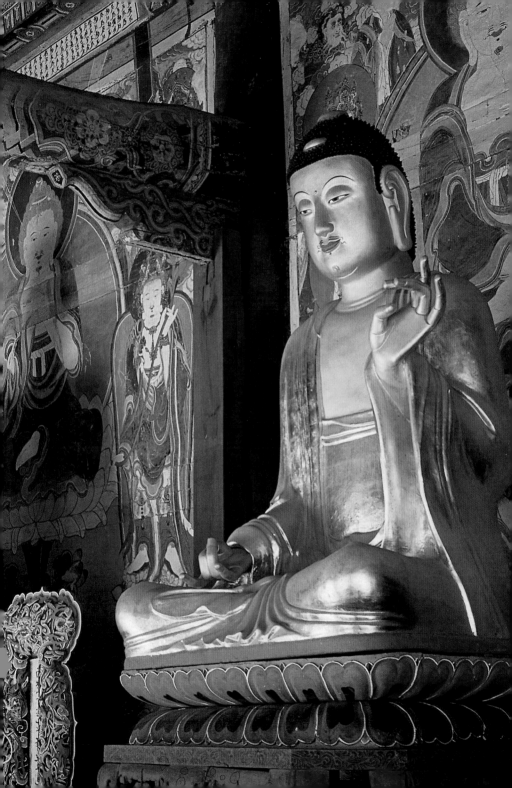

Japan

The last stopping place for Buddhism in its blossoming spread across the Asian continent was Japan. Thinking of the geography, it is not hard to see why the religion, which was always carried on foot by monks and sages, often over extremely inhospitable terrain, took a particularly long time to reach these offshore islands in the Pacific from its birthplace in northern India.

Below

The Daibutsu (Great Buddha), a 16-metre-tall (53-foot) bronze statue of the *dhyanibuddha* Vairocana, is the world's largest bronze *buddha*. Its head has been replaced several times after fires and earthquakes. Todai-ji temple, Nara, Japan; body of statue 8th century, current head 1692.

Right

Snow-covered *buddha* statue at the atmospheric Shingon-sect monastery on Mount Koya. Mt Koya, Wakayama prefecture, Japan.

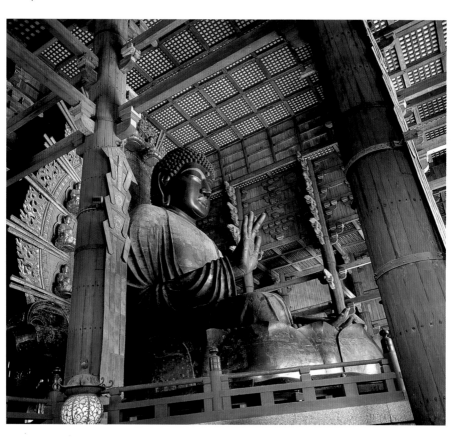

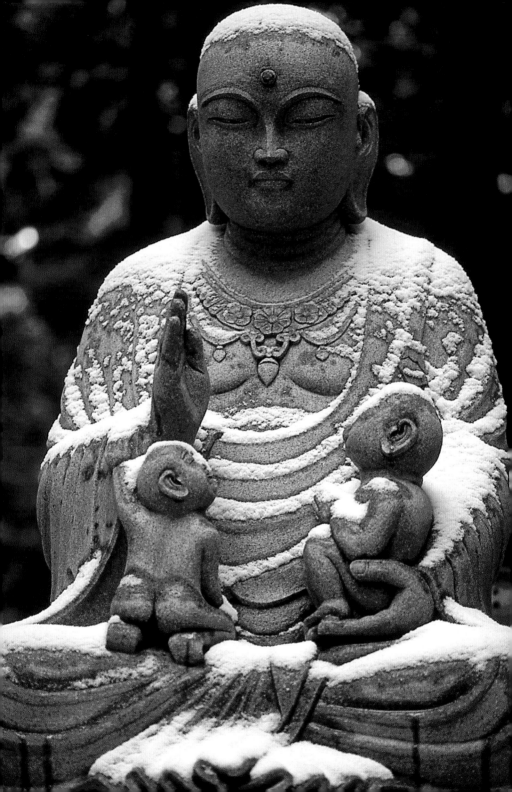

Japan discovered Mahayana Buddhism from two principal sources, China and Korea. As had been the experience in China, the indigenous and imported faiths proved reasonably tolerant of one another's beliefs, although there has never been a complete merging. Japan's original religion, Shinto, featured a time-honoured trust in the invocation of gods and goddesses that had much in common with the practices of Chinese Wu and Taoism, but all three were based on a round of festivals and rites without any clear moralistic doctrine. Buddhism was to change that.

One of the guarantees of Buddhist success in Japan was the liberal attitude of Buddhist monks towards Shinto shrines. They also promoted the vote-winning idea that Buddhist bodhisattvas (bosatsu in Japanese) to all intents and purposes shared the same identity as Shinto deities or kami. In practice, Buddhist temples include elements of Shinto shrines and vice versa, while Japanese homes frequently include Shinto and Buddhist sacred objects and statuettes side by side.

According to one tradition, Buddhism probably arrived in Japan in the sixth or seventh century CE, under

Opposite

An unmistakably Japanese style is evident in this painted wooden *buddha*, wearing the traditional plumed hat of a person of high rank and holding a fan. Japan, Muromachi Period, 1392–1568.

Above

A delightful *netsuke* (toggle) figure of a small seated *buddha* carved in ivory, the work of sculptor Masatoshi. Japan, 20th century.

the auspices of Shotoku Taishi (Prince Shotoku, 572–621 CE). He is said to have persuaded many of the traditional Shinto followers to convert or at least adapt and embrace Buddhist thinking. Another possible scenario is described in the Japanese chronicles of the *Nihongi*, which report that Buddhist schools were introduced from Korea in 552 CE. Less a matter of conjecture is the fact that Korean Buddhist monks first taught the Japanese to read the Buddhist scriptures, the *sutras*, in Chinese. The convention of using Chinese as the basis for Buddhist terminology, albeit with Japanese phonetic equivalents, became established and persists to this day.

Various different Buddhist schools arose, each focused on interpretation of different *sutras* as they arrived from India. One of the earliest was Kegon, a philosophical movement based on the teachings of a *sutra* known as the *Avatamsaka* and related to the Chinese Fa Yen. Tantric or esoteric Buddhism also found a willing home in the Japanese mind, and one of its foremost exponents, Kukai, posthumously known as Kobo Daishi ("Great Saint" Kobo, 774–835 CE), was responsible for founding the Shingon sect. Its spiritual

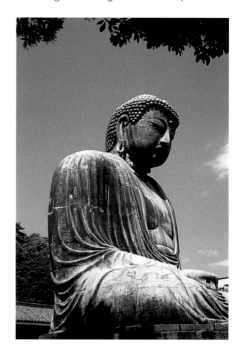

Right and opposite
The giant bronze statue of Amida Buddha (Amitabha) known as the Daibutsu or Great Buddha in Kamakura, near Tokyo, is 11.3 metres (37 feet) tall excluding its stone plinth. Kamakura, Japan, 1252.

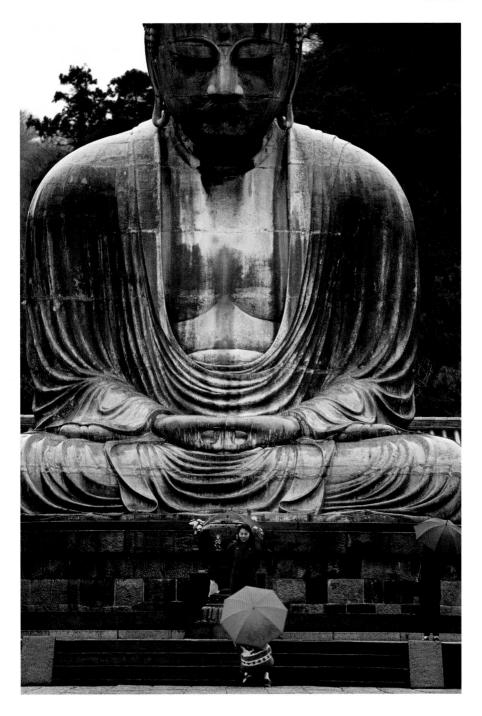

heart is on Mount Koya in Wakayama prefecture, where Kobo Daishi is buried.

Several major branches of the religion grew out of the Chinese Tiantai school (see page 170), known in Japan as Tendai. These include Jodo, the "Pure Land" sect, which gained its Japanese popularity under the guidance of a monk named Shinran (1173–1262). It is devoted to the Amida *buddha* (the *dhyanibuddha* Amitabha, see page 39), through whose spiritual power the Jodo follower finds rebirth of his or her soul in the Pure Land. The Nichiren sect (also known as Hokke-shu) was founded by a monk named Nichiren who lived in 1222–82. His teachings are based on the *Lotus Sutra*.

Japanese interest in Zen Buddhism did not take off until the Kamakura Period, between 1185 and 1336. Primarily a monastic tradition, Zen eventually appealed to the Japanese mind and during the medieval period it spread through two main sects, Rinzai and Soto. Founded by the sage Eisai, who learned Zen techniques in China late in the 12th century, the Rinzai school appealed to intellectuals in Japan. It became established in the region of Kyoto, where five monasteries were built, known as the "Five

Above

A *tsuba* or sword-guard as a figure of a *buddha*. Japan, 18th century.

Right

The seated figure of Amida Buddha (the *dhyanibuddha* Amitabha) resting against a massive fiery *mandorla* upon a multi-layered lotus throne is some 3 metres (10 feet) in height, carved in wood and gilded and lacquered. Byodo-in temple, Uji, near Kyoto, Japan, 1053.

Mountains". Although it claimed more modest beginnings, the Soto school presented a broader-based appeal and overtook Rinzai in terms of popularity. From their main headquarters and temple in Yokohama, the Soto masters teach meditation techniques requiring the devotee to adopt a difficult and painful posture for long periods of time as a means of freeing the mind.

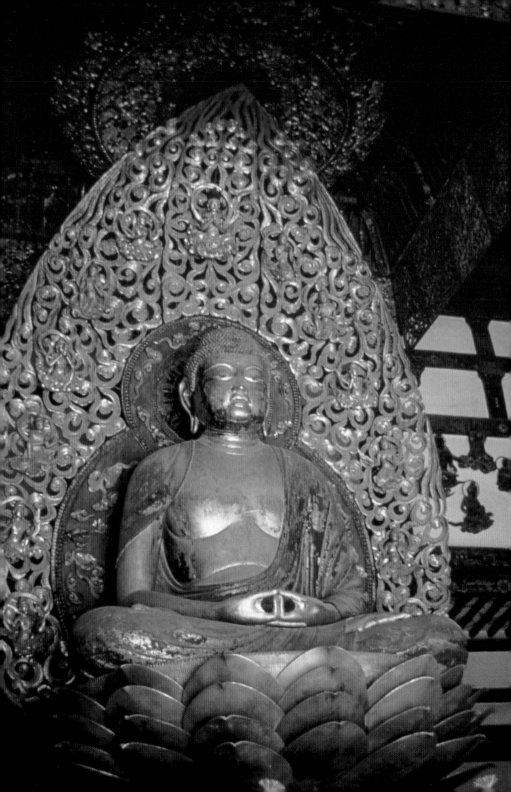

Left

A small sculpture of Yakushi Buddha (the *manusibuddha* Bhaisajyaguru), the healing or medicine *buddha*, displays the *abhayamudra* gesture with his right hand and holds a medicine pot in his left. Japan, mid-12th century.

Right

This modern gilded statue of the Buddha is to be found in the Japanese Peace Pagoda beside the River Thames, built by Buddhist monks and nuns to commemorate the Hiroshima atom bomb. Battersea Park, London, England, 1985.

Japanese Zen also includes a third, less influential school, Obaku, which did not arrive from China until the 17th century. Its main school is at Uji, near Kyoto.

Today Japan is a land of religious sects like no other. It has been calculated that more than 180,000 of them are registered throughout the islands, ranging from small, insignificant cells with a few hundred members to organizations claiming membership of millions. Many are Buddhist or display Buddhist leanings. The major Buddhist sects have developed their own styles not only of worship but also of religious art, which varies considerably from place to place as well as depending on the era in which the work was created. Much emphasis, however, is placed on techniques of meditation and this, more often than not, is reflected in relevant images of the *buddhas*.

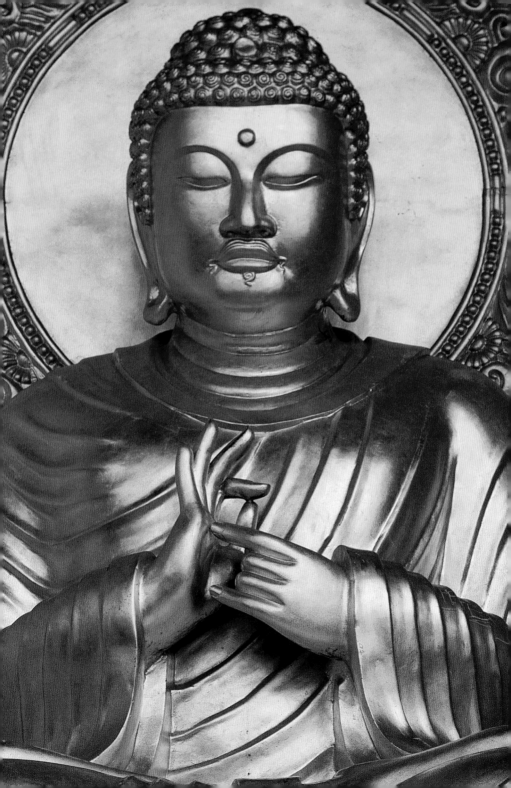

*"A person who is well disciplined
is best able to train others.
But it is oneself who is hard to train."*

From the *Dhammapada*

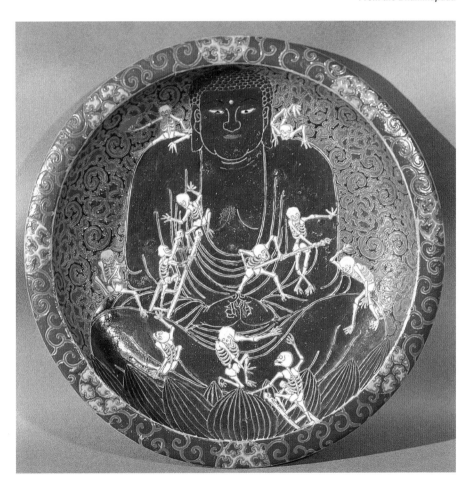

Left

Snow-covered statue of the *bodhisattva* Jizo (Kshitigarbha), protector of children, sufferers and travellers, often shown wearing a red bib. Japan.

Above

Decorated plate depicting a seated *buddha* on which ten human skeletons appear in various postures depicting the fate of those who adhere to the values of the material world. Japan, 18th century.

205

...and Time

Today Buddhism is alive and well in its traditional oriental homelands, and is becoming increasingly popular in the Western world. Its adaptability has stood it in good stead and ensured enduring relevance.

Few modern images of faith can be more powerful than those of an elderly Buddhist monk named Thich Quang Duc sitting down in a Saigon street in June 1963, pouring petrol over himself and, with utter tranquillity, immolating himself. His moment of nemesis, shown on TV screens around the world, did much not only to underline the sufferings of the Vietnamese people but also to demonstrate Buddhist thinking.

It may be difficult to appreciate that one of the oldest living religions was virtually unknown in the West until about 150 years ago. During the 20th century its most tireless evangelists included the

Right
This modern and strikingly executed sculpture of the seated Gautama Buddha provides an arresting spectacle on Ko Samui island, Thailand, 20th century.

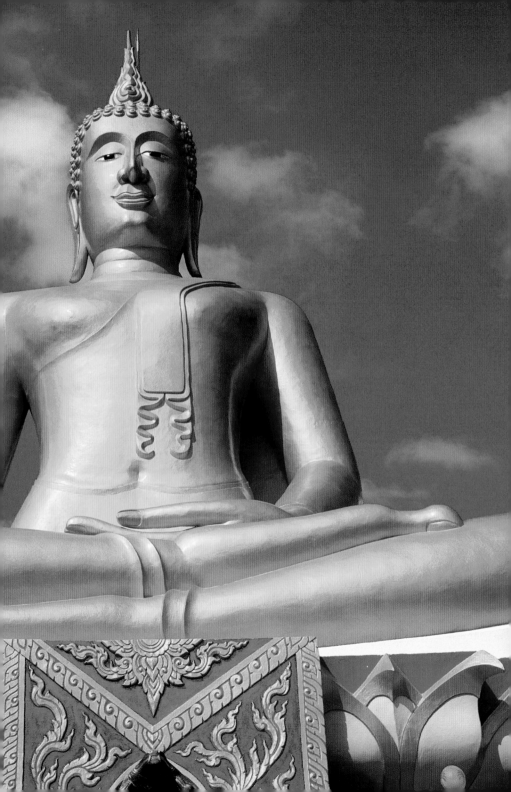

Tibetan Dilgo Khyentse Rinpoche, a leading figure in the spread of Buddhism in Europe until his death in 1991. Another Tibetan monk, Kenpo Karthar Rinpoche, escaped the Chinese purges in Tibet in 1959, travelling first to India and then, in 1978, to the United States, where he taught *dharma*. These two men played a major part in acquainting the West with the true message of Buddhist faith, as did the leader of Tibetan Buddhism, the 14th Dalai Lama.

The Dalai Lama's words, from his acceptance speech after winning the Nobel Peace Prize in 1989, explain much of why Buddhism has today become the world's fastest-growing religion: "If you have inner peace, the external problems do not affect your deep sense of peace and tranquillity. In this state of mind you can deal with situations with calmness and reason."

Below
An unusual and original idea of sculpting the Buddha in sand is the inspiration of an artist in the resort of Benidorm, Spain, 20th century.

Right
Simulation of a giant *buddha* statue under construction, which, when finished, is expected to be the largest *buddha* in the world. India, 21st century.

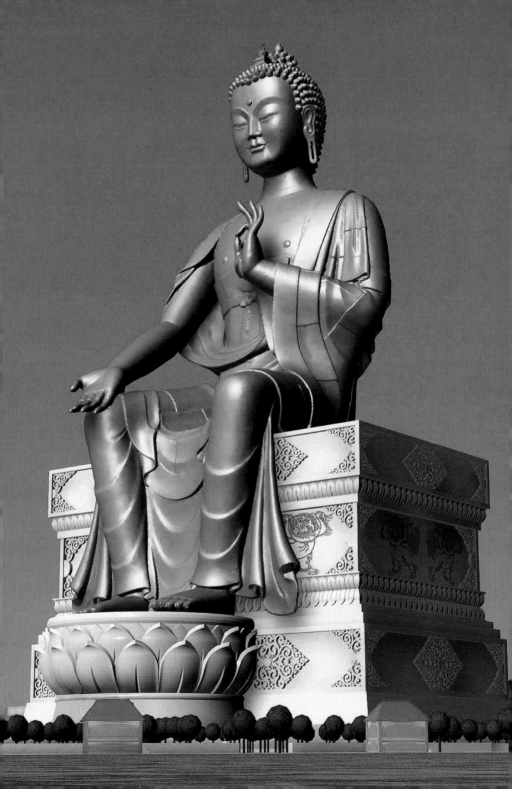

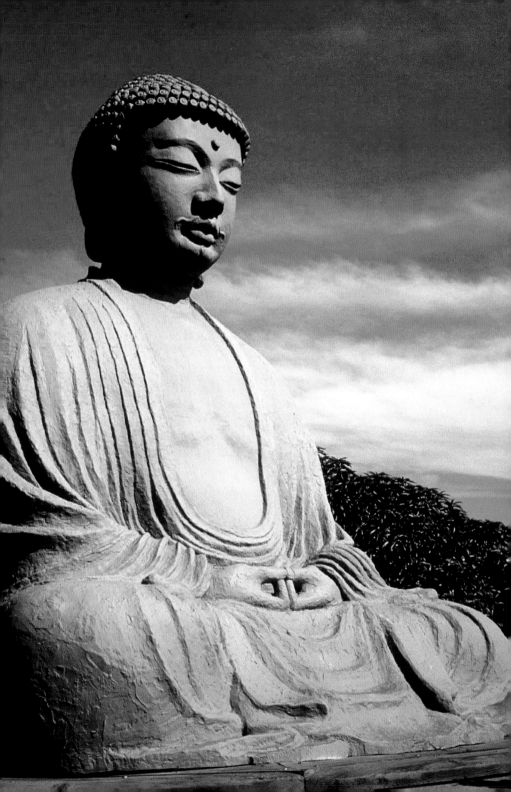

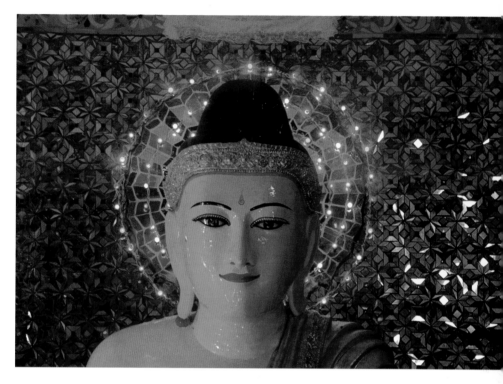

Previous page

Perhaps a claimant for the title of most bizarre piece of Buddhist art, this interpretation of a *buddha,* created entirely from food cartons, was the inspiration of Anthony Key. Its hands form the *dhyanamudra* (see pages 260–262). Walcott Chapel, Bath, England, 2002.

Left

A modern sculpted image of Gautama Buddha, seated in repose, at a Buddhist temple in Hawaii, USA, 20th century.

Above

The creator of this ceramic sculpture of a *buddha* has added a nimbus equipped with modern lighting. Yangon (Rangoon), Myanmar (Burma), 20th century.

"Keep the mind free from likes and dislikes. To be denied what one likes is painful and so is the presence of what one dislikes."

From the *Dhammapada*

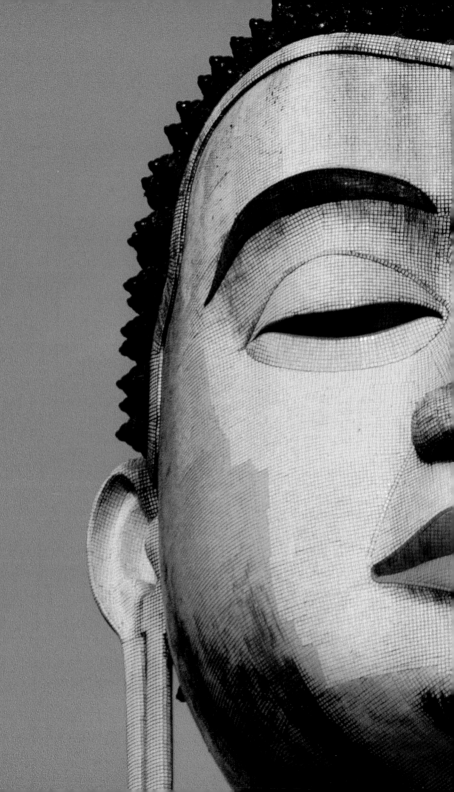

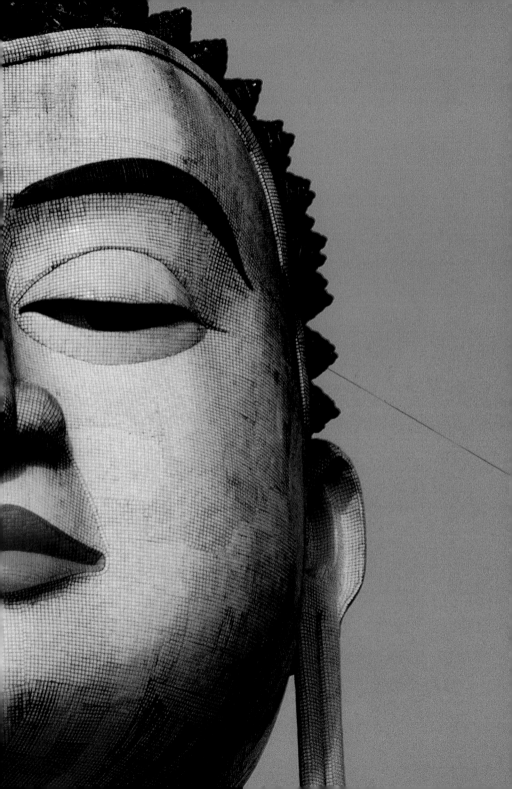

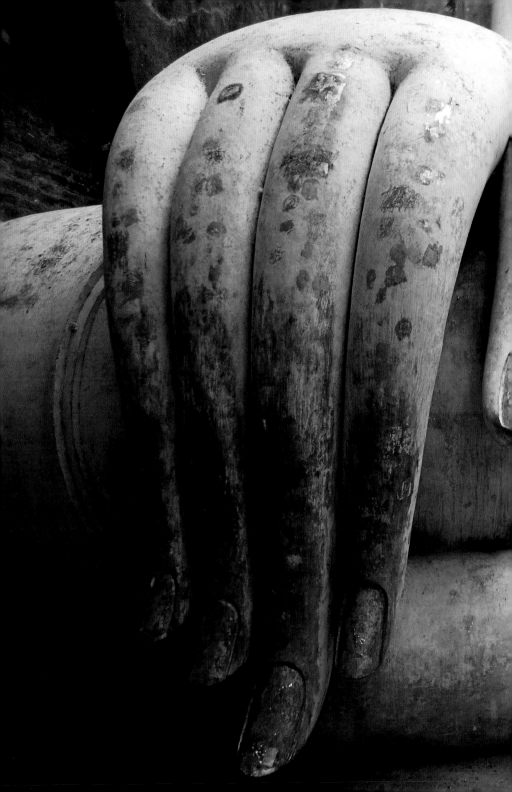

3
All in
the Detail

Each stance of the Buddha that an artist displays, whether seated, standing, walking or reclining, reflects some aspect or incident of Gautama (Shakyamuni) Buddha's life. The symbolism of Buddhist art relies on the details of gestures, bodily features and even the paraphernalia associated with the main image as important artistic devices signifying the presence of the Buddha as subject and conveying significant information about him.

According to the scriptures of Theravada Buddhism, great spiritual figures such as Gautama Buddha are to be recognized by certain details in their actions and physical appearance. The so-called Great Marks of a *buddha* or,

in Sanskrit, the *mahapurusalaksana*, are said to number 32.

The first of the marks focuses on the fact that Gautama Buddha "sets his foot down squarely", and that he has "a thousand-spoked wheel on the soles of his feet" (see page 33). So, not surprisingly, the footprints of the Buddha or *paduka* have become popular symbols for artists to use as their subjects. Highly schematized, the toes of the Buddha's foot are usually drawn of equal length. The mystical wheel or *cakra* is also widely depicted in art since it is central to *dharma*, the Buddha's teaching of the law. The wheel may be superimposed on the soles of the feet but also appears on

Right
The footprints of Gautama Buddha carved in relief on part of the Great Stupa built by King Ashoka in the ancient middle Indian kingdom of Avanti. These footprints are super-imposed with symbols of the thousand-spoked *cakra* wheel and the toes are characteristically of more-or-less equal length. Sanchi, India, 3rd century BCE.

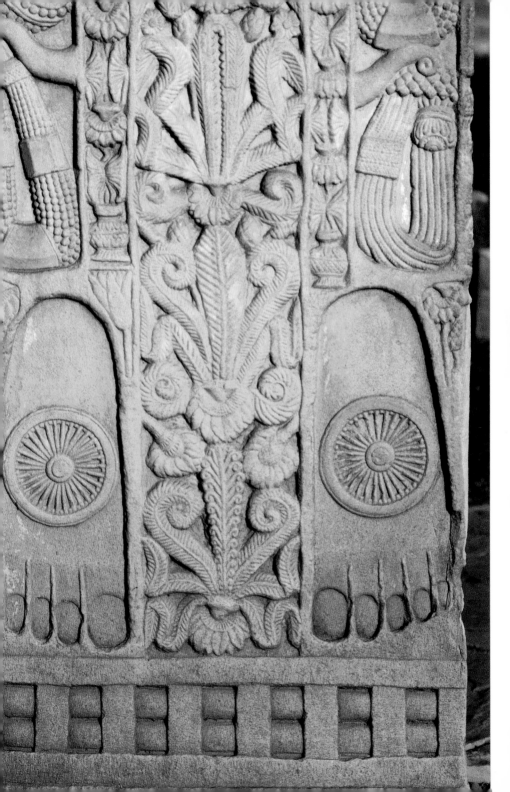

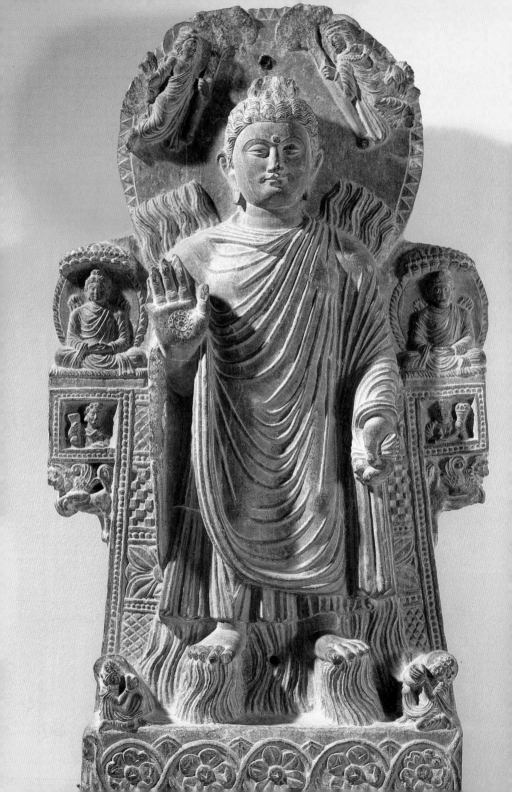

*"When these grey bones
are cast aside like gourds in autumn,
what pleasure will be gained
from looking at them?"*

From the *Dhammapada*

Left

Images of a *buddha*
typically include a number
of identifying Great Marks,
such as the thousand-
spoked *cakra* wheel, here
seen on the palm of the
hand. As well as showing
buddha features, the
statue, carved from a
slab of schist, reveals
marked Greek influence.
Pattava, Afghanistan,
3rd–4th century CE.

the palms of the hands. The last detail
in the list of 32 *buddha* features tells us
that "his head is shaped like a turban",
and this has given rise to some highly
stylized conventions concerning the
depiction of the Buddha's coiffure.
Although not all of the 32 features will
be included in any single painting or
sculpture, each provides a classic
reference point confirming to Buddhist
devotees that they are in the presence
of the likeness of a *buddha*.

Hair

More-or-less all *buddha* images include a common feature, the bun or topknot on the crown of the head that conforms with the description of the 32nd Great Mark. In the princely circles in which Siddharta moved before becoming an ascetic (see page 22), men wore their hair fashionably long and frequently had it wound up into such a coiffure. This would have been especially necessary when wearing a turban, and in the oldest Vedic Hindu culture it actually appears as a kind of turban, known as an *ushnisha*. The term appears confusing because in Sanskrit its literal meaning is a row of small curls fringing the forehead. In Buddhist art, however, the *ushnisha* becomes a raised bump on the top of the Buddha's head.

Despite having originated as a secular fashion, this bump came to symbolize the Buddha's sublime knowledge and his extraordinary consciousness. The topknot also became an emblem of those who had achieved or were ready to achieve *nirvana*, and for this reason it was favoured by artists when depicting any of the ranks of *buddhas* and *bodhisattvas*.

Right
The precise arrangement of small, tight curls in the coiffure of the Buddha is well drawn on this gold statue. Po Lin monastery, Lantau island, Hong Kong, 20th century.

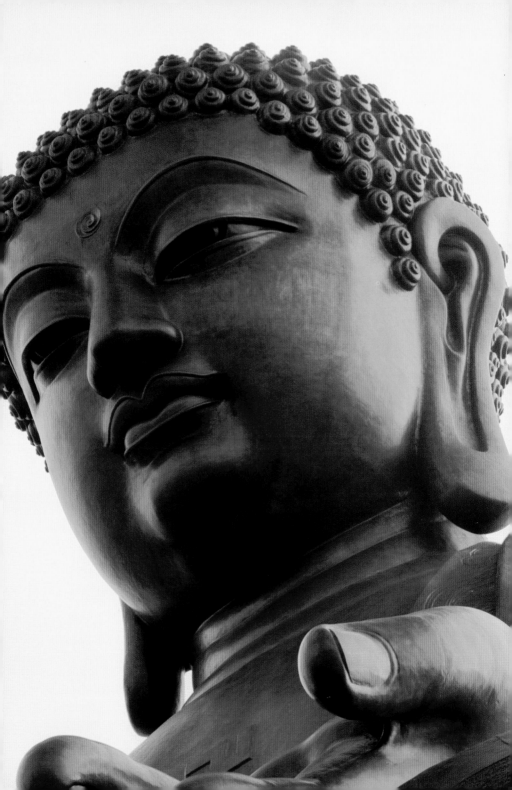

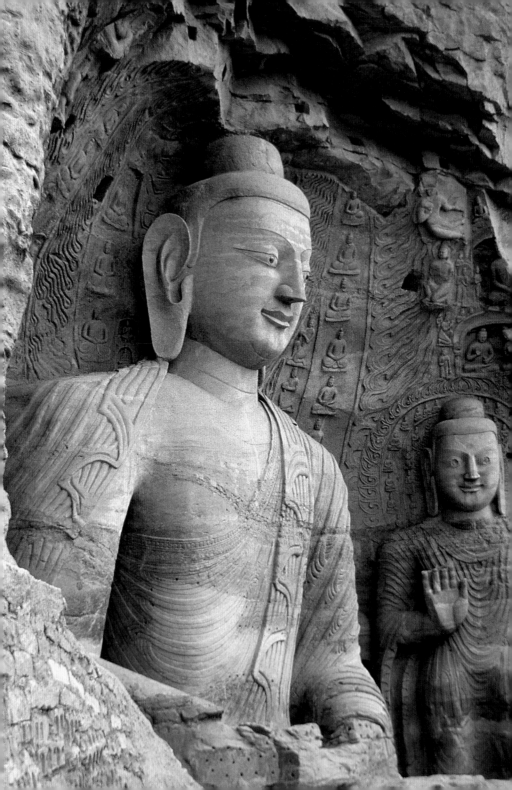

The *ushnisha* is usually covered in small, tight curls of hair, almost invariably turning clockwise. Why the curls? Nobody has any definite answers, but one of the more likely explanations is that they grew after the *cudakarana* ceremony of hair cutting. When Siddharta cast off his old life, tradition has it that he also dispensed with his long hair at a single stroke and the stubble that was left became naturally curly. The fact that the curls turn to the right means that they follow a direction regarded as auspicious in all Indian religions. Sometimes the Buddha is depicted with his head completely shaved, but generally he has hair in one style or another.

The rather plain rounded topknot is sometimes elaborated into a slightly lopsided coil like a snail shell, but it can also be extended into a long point or peak reminiscent of a flame. This elaboration may have been developed for distinct reasons among different Buddhist cultures. In the southern part of India, Sri Lanka and Indonesia, it probably traces back to the sacrificial flame of the Hindu fire god Agni. The Hindu scriptures explain that fire is an annihilator of many things, including ignorance. By this token it becomes a symbol of knowledge, and this clearly was the attraction to incorporating a flame-like peak of hair rising from the crown of the Buddha's head.

In other parts of the Buddhist world, including Tibet and Thailand, the extension of the hair into a point seems to have originated more as an ornament fixed on top of the simple rounded *ushnisha*. Known as a *cintamani*, in romantic Hindu tradition "a jewel that grants all desires", it takes the classical

Left
When the hair is not depicted in curls, it is most commonly drawn as a plain, rounded topknot, an emblem traditionally associated with those who have achieved *nirvana*. Yungang caves, Datong, China, late 5th century CE.

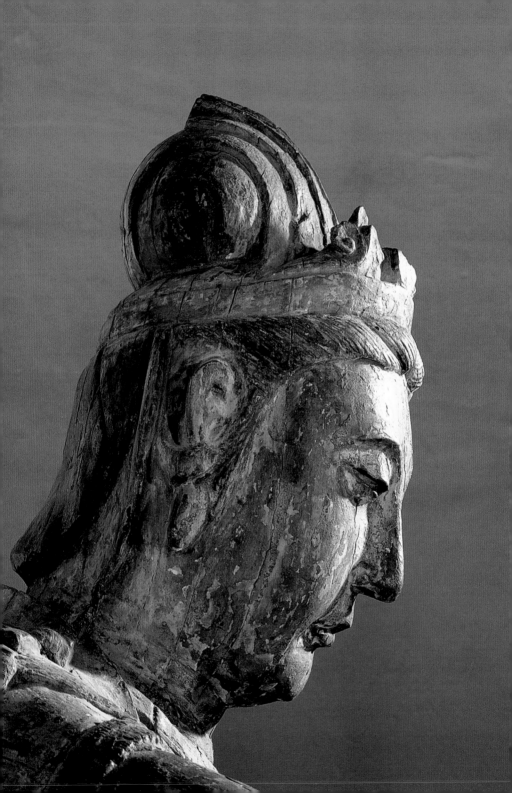

"A wrongdoer is like ivy, suffocating the tree over which it climbs. Such an immoral person does to themselves much that an enemy would wish upon them."

From the *Dhammapada*

Left
In some artistic traditions the hair of Gautama Buddha may be worked into a coil not unlike a slightly lopsided snail shell. In this wooden image, still bearing traces of pigment, it is combined with a small tiara. China, late Song/early Yuan dynasties, 13th century.

form of a pearl surrounded with flames. In some sculptures the high hair crown surmounted by a flaming ornament is quite distinct.

Not infrequently, artists in the traditions of mainstream Mahayana Buddhism (see pages 50–53) adopt the apparently curious convention of placing a small image of the Buddha, known as a *buddhabimba*, either in his hands or on his topknot instead of a jewelled ornament. This manikin is envisaged as being the spiritual "core", the

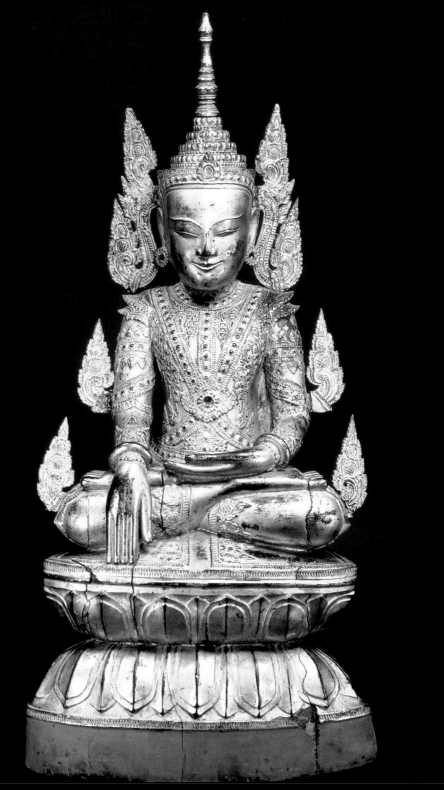

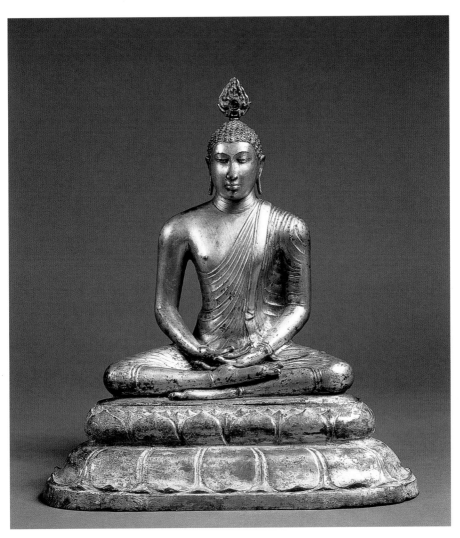

Left

On this elaborately decorated *buddha* the rounded topknot is extended upwards into a long point or peak, supposed to be reminiscent of a flame. Gilded and lacquered image, Myanmar (Burma).

Above

The flame-like peak of the topknot may sometimes be quite rounded, as in this less ornate example from Sri Lanka.

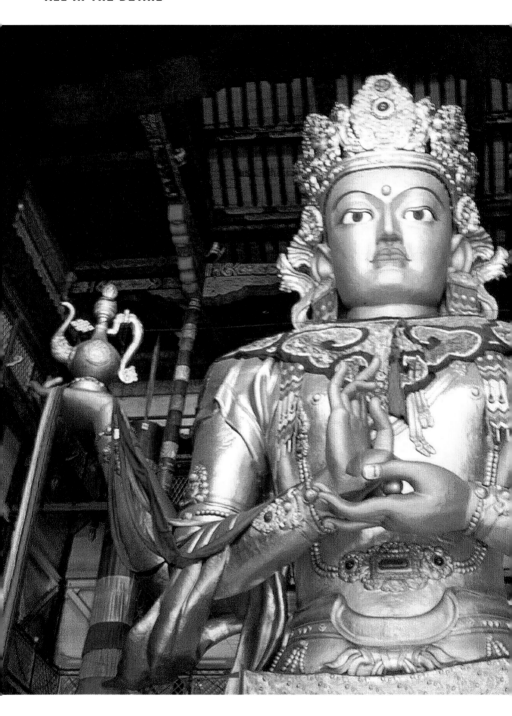

dhyanibuddha (see page 39), of which the Shakyamuni Buddha is merely an outward physical manifestation.

A *bodhisattva* or *buddha*-in-waiting can also be seen wearing a crown or diadem, but the crown is not conventionally associated with any of the true *buddhas* such as Gautama Buddha. The only exception is a "crowned Buddha" or *mukutadharin*, who wears a crown and other royal ornaments, although the symbolism is not clearly explained in the scriptures.

Left

Images of *bodhisattvas* or *buddhas*-in-waiting are frequently adorned with a crown, although decoration is rare on actual *buddhas*. Such ornamentation is particularly common in the Tibetan Buddhist tradition, as evidenced in this large statue from Mongolia.

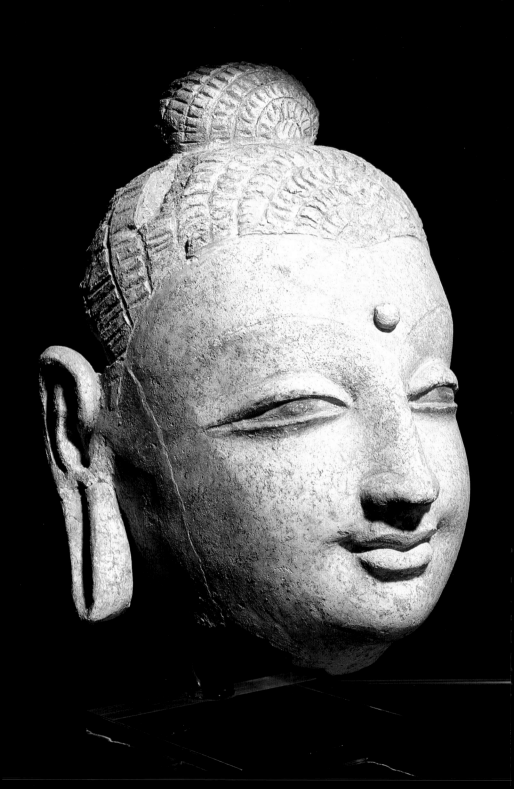

Urna

Another favoured artistic tradition among the 32 auspicious symbols of Gautama Buddha and other *buddhas* and *bodhisattvas* is the *urna* in the centre of the forehead. This takes the form, in most cases, of a round mark or protuberance and, as with so many such symbols of spiritual greatness, appears to have originated as a sign of nobility in secular Hinduism. Made with a coloured paste, this secular mark, called a *tilaka*, may be applied for special occasions such as wedding betrothals and before important journeys. It has also come to distinguish different Hindu castes and sects.

In Buddhist art the more specific *urna* applied to Gautama Buddha may sometimes be in the form of a jewel, the *catulatilakamani*. In some of the early depictions it alternatively appears as a whorl of hair between the eyebrows, and a similar curl of hair known as a *srivatsa* may be drawn on the breast, in which case it symbolizes the source of the natural world.

Opposite

The *urna* in the centre of the forehead is generally depicted as a round mark or protuberance. On many older statues the bump has fallen off, leaving a hollow, but on this example it has survived the centuries. Graeco-Buddhist style, Afghanistan, 1st–4th century CE.

Above

This four-headed Buddha derives from a myth concerning the Hindu god Brahma, whose multiple faces allowed him to gaze on his daughter Satarupa as she circled around him. Each head sports a jewelled urna and crown. Po Fook Hill, Hong Kong.

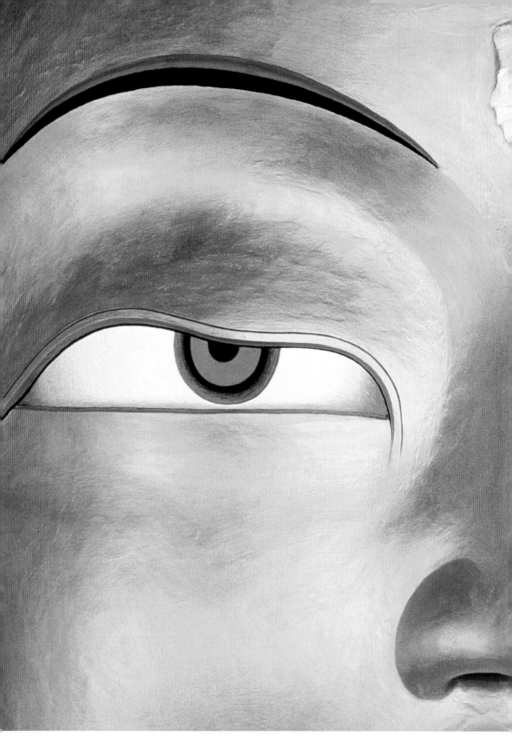

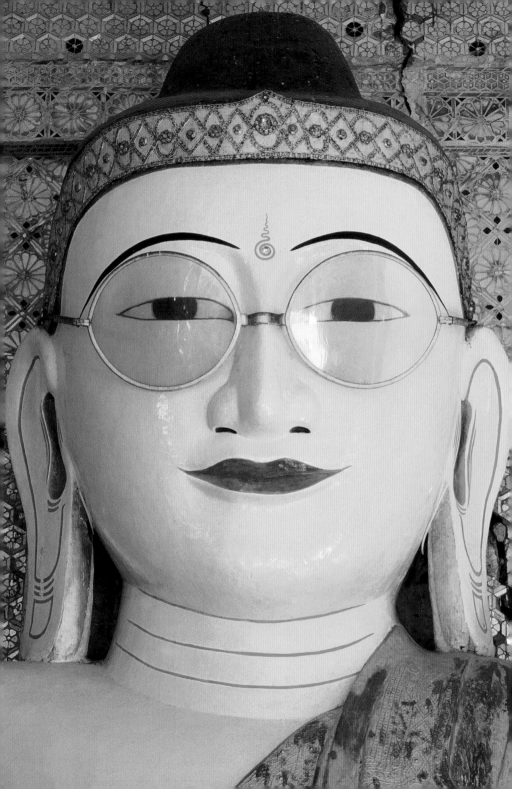

"When a person has done good things, they should not cease but be willing to continue. The store of good brings true happiness."

From the *Dhammapada*

Opposite

In some of the earliest depictions of Gautama Buddha, the *urna* was drawn as a whorl of hair between the eyebrows. The tradition has been continued in this bizarre modern sculpture. Shwemyethman Pagoda, Shwedaung, Myanmar (Burma).

Previous page

The *urna* may be drawn in a variety of styles, including a heart shape or, as in this remarkable golden sculpture where the eyes dominate, a conch shell. India.

Eyes

Irrespective of culture, the eyes are
perhaps one of the least distinctive
features of *buddha* images, although
the precise way in which they are drawn
constitutes one of the 32 marks of
greatness. By and large, the eyes are
characteristically half closed and looking
slightly downwards in a manner known
as *nimilita*. Unlike images of deities in
religions like Hinduism in which gods
and goddesses are worshipped, the
eyes of *buddhas* and *bodhisattvas* are
generally not wide open, staring
confidently over the heads of ordinary
human beings, but downcast and
withdrawn to emphasize the humility
and contemplative nature of the religion.

Right
The eyes of the Buddha
are most often depicted
either deeply hooded, to
emphasize contemplation,
or half closed and looking
downwards in a gesture of
humility. Head in bronze
with green patina, in the
style of the Ayuthya
School, Thailand,
17th century.

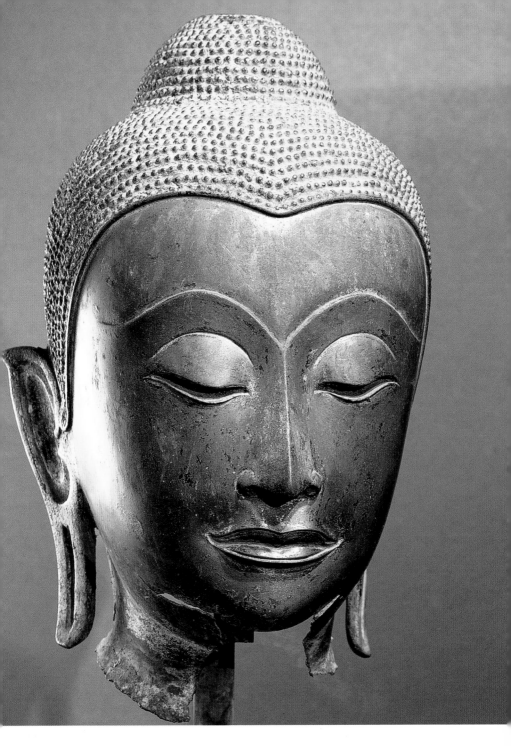

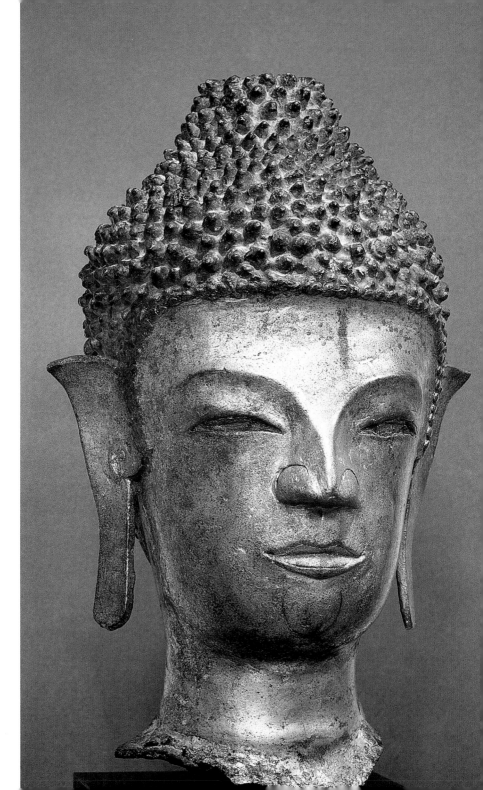

Ears

Left

This *buddha*'s extended earlobes reflect the fact that in Siddharta's early years, before he abandoned his life of comfort and affluence, he would have worn heavy ear ornaments. Head in the style of the Lan Na School, Thailand, 17th century.

In almost all depictions of the Buddha, his earlobes are distended to a considerable length. This stylistic distortion harks back to the life of indulgence he enjoyed before abandoning his princely birthright, leaving his family and becoming an ascetic. It was the practice of high-born individuals in India to wear heavy pendants on the ears, indicating their aristocratic status. These ornaments can be in the form of rings called *karnika* or may be styled as long pendulous leaves, often heavily encrusted with precious stones adding to the weight. Other possibilities include the *sinhakundala*, fashioned in the shape of lion's heads to give the wearer an impression of strength and fighting prowess. Many *buddha* images go so far as to show a realistic slit in the earlobe, indicating how the original piercing may have been stretched by the weight of heavy jewellery.

Overleaf left

Ears of *buddhas* may be adorned with jewellery, as in this Nepalese-influenced image of Vairocana, one of the five *dhyanibuddhas*. Brass with turquoise and gemstone. Tibet, early 15th century.

Overleaf right

The earlobes are frequently sculpted with long slits, reinforcing the tradition that Siddharta wore heavy ornaments in the ears, causing the original piercing to stretch.

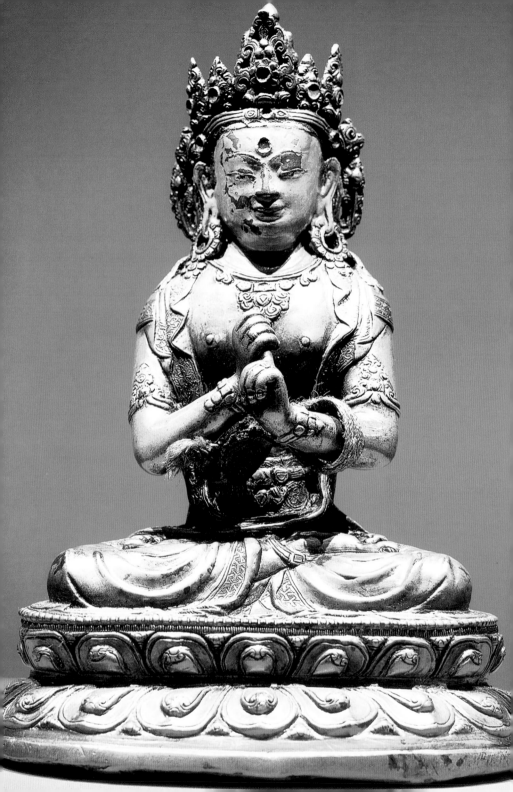

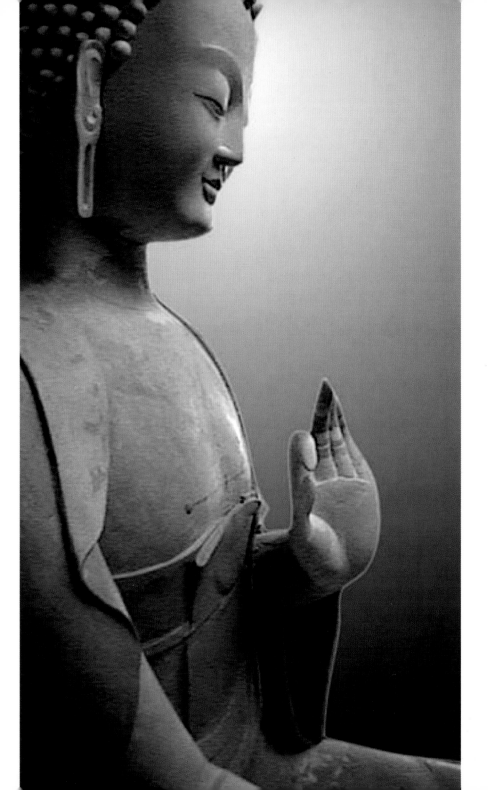

Neck

Images of the Buddha often reveal what appears to be a set of necklaces or torques (*niska*), but it is more likely that the artist has set out to convey folds in the flesh of the neck. In bizarre contrast to the reality of his austere existence, very rarely is the Buddha depicted in art other than as a man who is well fed and in the prime of his life. The familiar impression of a *buddha* is of a somewhat obese figure with three folds in the neck or stomach, known as the *trivali*. These not only symbolize good fortune but, in many oriental cultures, are considered a mark of beauty. The idea derives from the appearance of the conch shell or *sankha*, which has three folds around its opening. In Buddhism the conch is seen as a symbol of blessedness and of the strength of *dharma* (Buddhist teaching) because its shell turns auspiciously clockwise.

Right
Despite the austere life led by Gautama, *buddha* images often have a set of rings around the neck, representing the fleshy folds of a well-fed person – considered a sign of good luck. Amida Buddha (Amitabha) in wood, Japan, Heian Fujiwara Period, 11th century.

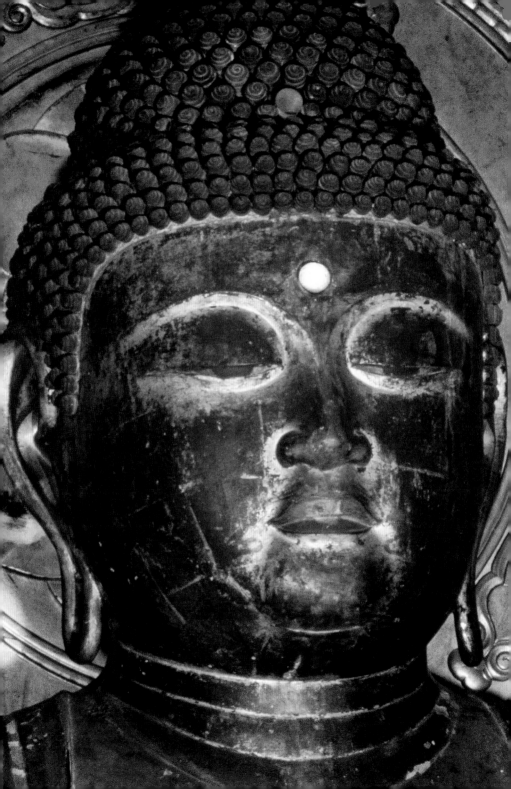

Hands

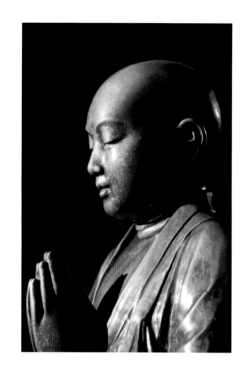

Gestures of the hands, fingers and arms, collectively known as *mudras*, represent just one of the tokens or signs of divine status. In Buddhist art, however, hand gestures are the most commonly used attribute and undoubtedly the most important. Each reflects a familiar and meaningful gesture made by the Buddha, and each emulates a certain position of the palms or fingers that is practised in religious worship. From early times these positions became fairly stylized, and they were eventually adopted across the range of Indian religions, each possessing similar meaning but with its origin traced in the myths and legends of the culture. Many of them even became incorporated into traditional oriental dances.

The first evidence of *mudras* is probably to be found in the art of the Indus Valley civilization, going back in time some 4,000 years. Some of these ancient representations of gods and goddesses show the *anjalimudra*, wherein the open hands are placed palms together and slightly cupped, in the traditional gesture of greeting. But thereafter the *mudras* become mainly

Above

In this image of a Buddhist disciple the hands are brought together in the traditional *anjalimudra* gesture of greeting. The palms are placed together and slightly cupped.

Right

In the classic *abhayamudra* gesture the right hand is lifted, palm outwards and fingers raised straight. This *mudra* represents fearlessness, safety and reassurance. Carving by Kaikei, Japan, 13th century.

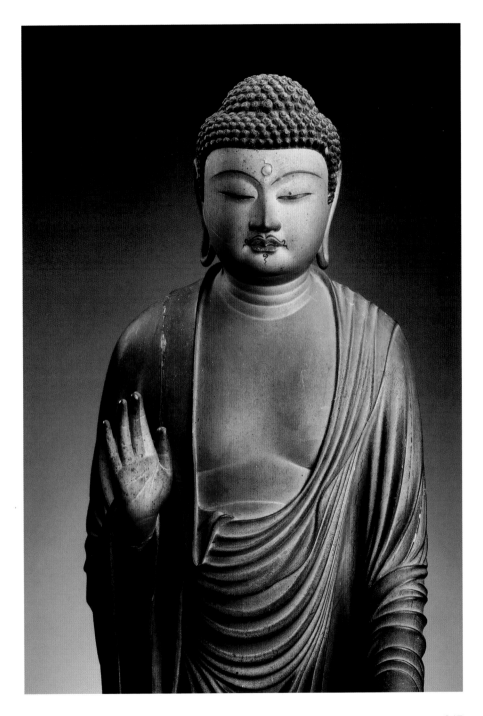

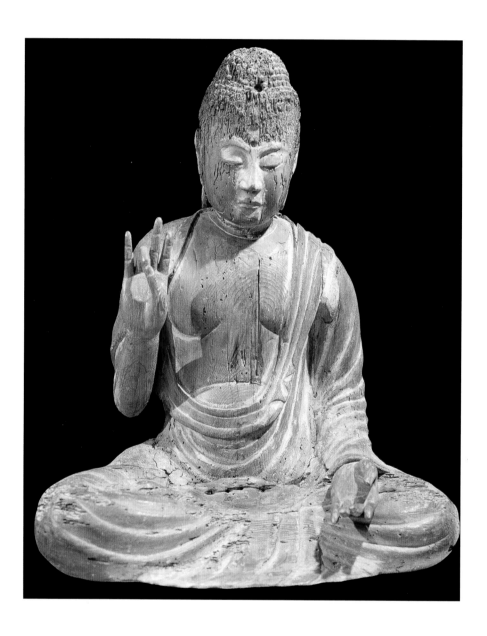

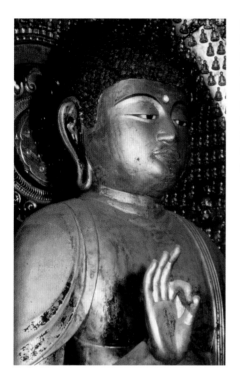

Left

Most commonly the *vyakhyanamudra* is depicted with the circle formed between thumb and index finger of the right hand. The gesture symbolizes perfect wisdom and the vow to teach others.

Opposite

In a variation of the *abhayamudra* known as the *vyakhyanamudra*, the "gesture of explanation", one of the fingers of the right hand curls downwards and meets the tip of the thumb to form a circle. In this wooden statue, unusually, the third finger is used. Japan, Fujiwara Period, 12th century.

"To live but one day by good morals and meditation is better than to live a hundred years of wrong and with the mind unstilled."

From the *Dhammapada*

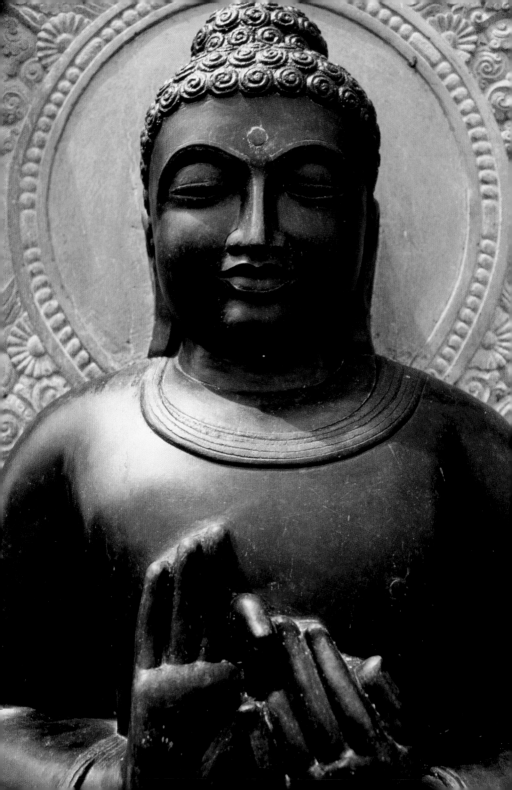

associated with Buddhist sculpture and only later are they seen to spread into Hindu religious art.

When the right hand is lifted, palm displayed outwards and fingers raised straight, the gesture is known as the *abhayamudra* and is said to represent fearlessness, safety and reassurance. In Buddhism it is no less a sign of the tranquillity and protection given by the Buddha to the worshipper. Sculptors occasionally incorporate the *abhayamudra* gesture into images of other *dhyanibuddhas*, but it is generally restricted to Gautama Buddha and is probably the most familiar of all his hand gestures.

This gesture appears at first to have signalled the teaching of *dharma*, but it also became associated with a more specific and violent incident in the life of Shakyamuni. Among the schemes of Devadatta, the fallen disciple, to assassinate the Buddha (see page 33), he recruited a drunken elephant named Malagiri to attack him as he was begging for alms. When Malagiri saw the right hand of the Buddha lift in the *abhayamudra*, however, the huge animal stopped dead in his tracks and lay down with his head to the ground in a gesture of submission. It is from this episode that the association with protection of the worshipper developed and thus the gesture's popularity spread to religions beyond India. It became familiar, for example, in Roman classical sculpture from about 200 CE (Common Era, equivalent to AD), where it is known as the *magna manus*.

Left
When the right hand performs the *vyakhyanamudra* and the left is brought towards it over the heart in a similar gesture called *jnanamudra*, the whole gesture is described as the *dharmacakramudra*, thought to reflect the setting in motion of the wheel or *cakra* of the *dharma* law. India.

251

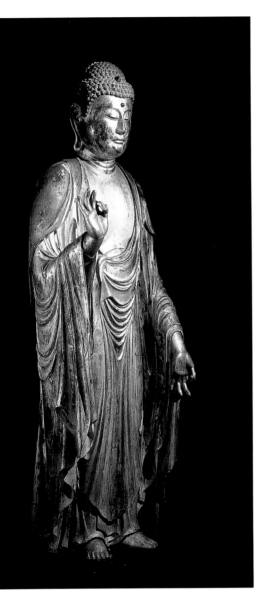

A slight variation of the *abhayamudra* with an altogether different meaning is known as the *vyakhyanamudra*, the "gesture of explanation". It is also sometimes referred to as the "triangular pose". Here the right hand is similarly raised with the palm outwards but, while three of the fingers remain pointing up, the tip of the thumb and the index finger touch one another, forming a circle. It symbolizes the perfect wisdom of the Buddha and his vow to teach dharma to others.

Still further elaboration comes when the right hand performs *vyakhyanamudra* and the left forms

Left

The *abhayamudra* of the raised right hand is most often associated with the left hand being lowered, palm outward and fingers slightly curled, a gesture known as the *varadamudra* that represents the granting of wishes. Lacquered wood, with gold leaf. Japan, middle Edo Period, 18th century.

Right

In common with toes, the fingers of the Buddha are often highly stylized and of more-or-less equal length. The nails may be heavily decorated. One of four giant *buddhas* seated back to back, built by King Dhammazedi. Kyaik, Pegu, Myanmar (Burma), 1476.

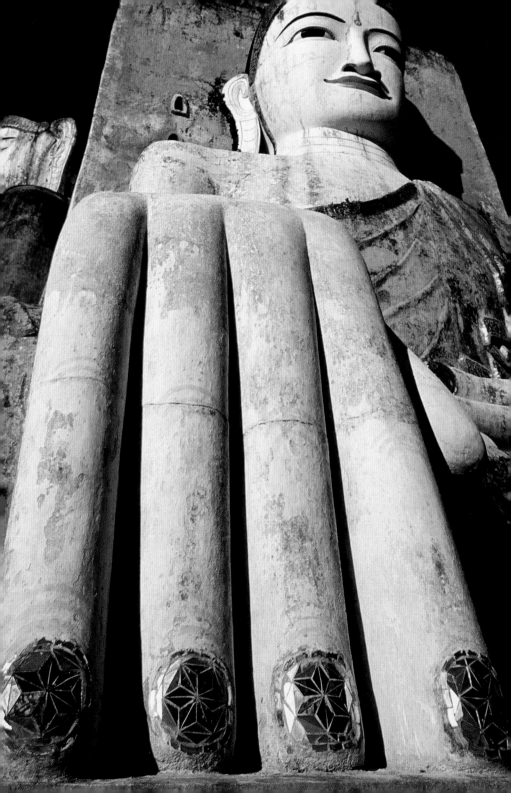

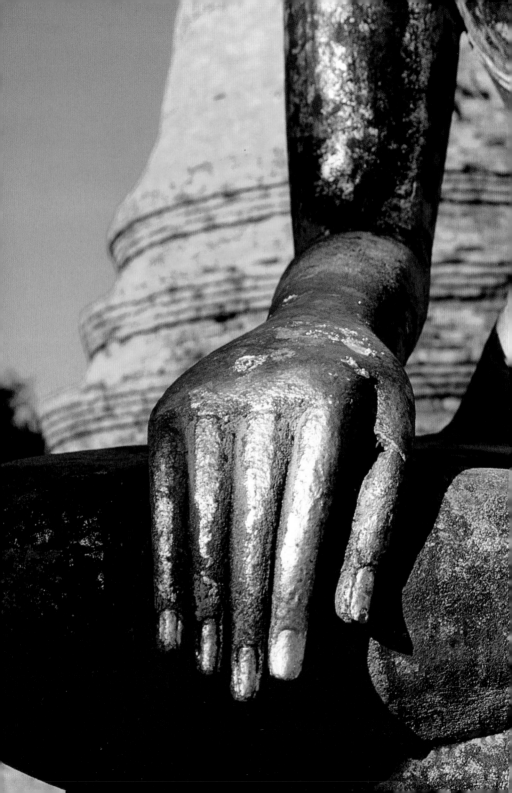

a similar gesture called *jnanamudra*. The two hands come together over the heart in a combined gesture that is known as the *dharmacakramudra*. In early Buddhist art this may have been symbolic of a sun disc but it came to be linked more closely with the wheel of law or *dharmacakra* and, more precisely, with the "setting in motion of the wheel of the law".

Very occasionally sculptors choose to portray the Buddha with his left hand raised while in a standing position. Buddhists generally consider that right-handedness is the more positive and auspicious characteristic. But the left-handed *abhayamudra* is said to relate to a particular episode after the return of the Buddha from heaven, having visited his mother with the intention of converting her to Buddhism (see page 36). A local ruler, Pasentikosol, had become sufficiently concerned about the Buddha's absence that he commissioned a likeness carved from sandalwood. When the Buddha returned to earth down his miraculous triple stairway at Samkasya, Pasentikosol invited him to see the sandalwood statue, which according to legend then arose from its seat in homage to the living Buddha.

Previous page
A *mudra* favoured by sculptors opting for the seated "lotus position" is that known as the *bhumisparsamudra* or the "touching the earth" gesture. It refers to the moment when the Buddha asked the earth to bear witness to his vow to renounce worldly values. Thailand, 13th century.

Right
Typically in the *bhumisparsamudra* the right hand stretches down near the right knee with the palm inward and the fingertips touching the ground, while the left hand rests passively in the lap, palm upward. Copper with silver and copper inlays, Tibet, 13th century.

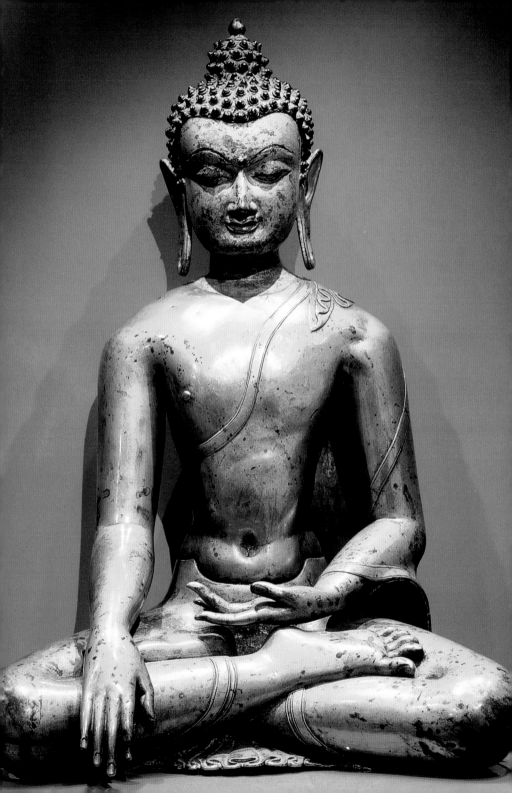

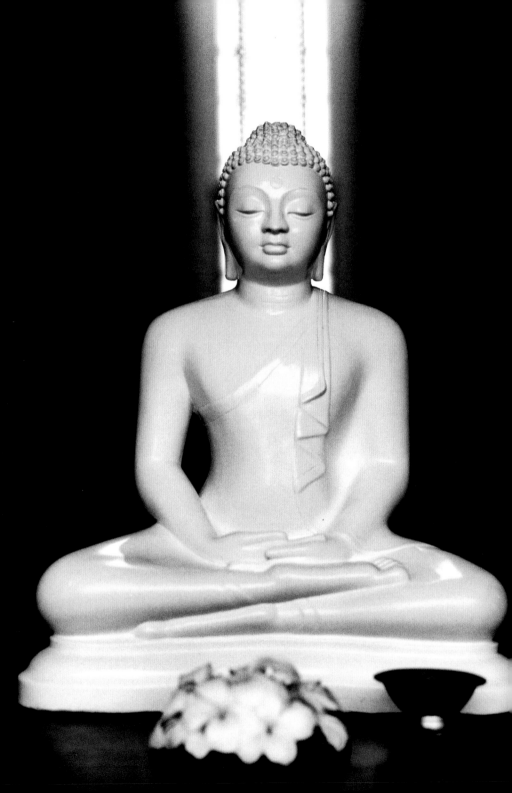

Shakyamuni, however, objected to this theatrical piece of adulation and raised his left hand, commanding the image, known as the Phra Kaen Chan, to remain seated.

When the right hand is raised in the abhayamudra, the left is often placed in another characteristic position, known as the varadamudra. Here the hand hangs down loosely, palm outwards and fingers outstretched or, occasionally, half closed. The gesture is generally associated with the conferring of boons and granting of wishes. According to one rather more specific legend, it has more to do with the Buddha urging a number of his relatives, from both sides of the family, not to quarrel. The story goes that some of his father Suddhodhana's clansmen were arguing with those of his mother, Maya, about who owned the rights to irrigation water for their rice paddies. The Buddha intervened as peacemaker, pointing out that human life was much more valuable than ownership of water.

A downward-pointing varadamudra is not to be confused with another very specific gesture that appears in countless sculptures when the Buddha is seated in the lotus or padmasana position. It is the famous "touching the earth" gesture, the bhumisparsamudra. Here the right hand rests on the right knee, palm downward, and the fingertips reach down to touch the earth. The left hand is held passively, palm up, in the lap.

The symbolism is explained in two quite distinct ways. More broadly it depicts the Buddha asking the earth to bear witness to his decision, while seated beneath the bodhi tree at Bodh Gaya, to renounce material values and to gain the wisdom that will lead him to

Left
When seated in repose, the hands of the Buddha may be laid passively in the lap, right hand on top of the left, palms upward and fingers straight. Known as the dhyanamudra, this position symbolizes a perfect state of meditation.

conquering the endless cycle of life and death. It is therefore sometimes known as the *mudra* of "calling the earth to witness".

It also reflects a more specific and considerably less tranquil incident that took place beneath the *bodhi* tree. Having failed to tempt the Buddha into renouncing the way of *dharma* (see page 28), the demon Mara resorted to another device. He urged the Buddha to perform a miracle in order to prove his credentials, to which the Buddha responded by calling upon the living earth for assistance. To do so he simply touched the ground beside him with his fingertips. Immediately the earth convulsed in a great earthquake and a terrified Mara fled with his demon horde, never to return. The *bhumisparsamudra* gesture is sometimes seen in *buddha* images other than those of Shakyamuni.

When the Buddha is seated in the repose of the lotus position, the hands are frequently laid in the lap with the right hand over the left, palms up and all fingers extended, an attitude known as the *dhyanamudra*. It is so called because it symbolizes perfect meditation or *dhyana*, the elimination of conscious thought through total and

Previous page
In a variant of the *dhyanamudra*, one or more of the fingers may be curled up to meet the thumbs, roughly forming triangles. Amida Buddha (Amitabha) cast in bronze, Kamakura, Japan, 1252.

Right
When seated in the lotus position the *buddha* image may hold an assortment of objects, commonly a begging bowl. In this bronze sculpture, however, the artist has made the Buddha's hands symbolically empty. Tibet, 11th century.

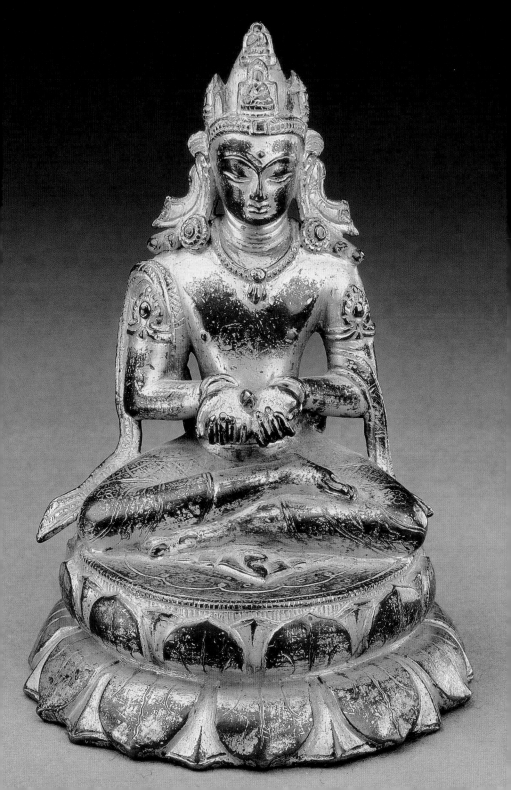

intense contemplation of a single object or sound, such as a *mandala* (see page 302) or the sacred syllables of a *mantra*. It is said to be the exact position adopted by the Buddha when he achieved perfect enlightenment beneath the *bodhi* tree.

A variation on the theme places the two hands with the fingers curled inwards and the thumbs touching in a manner that creates triangles. This is also known as a *dhyanamudra* but it is said to symbolize the three great strengths of Buddhism – namely *buddha*-hood, the *dharma* teachings and the *sangha* community of monks. A third variety allows one hand to be positioned in the lap while the other adopts an alternative gesture such as the *bhumisparsamudra*.

Inevitably the Buddha is also depicted with a special hand gesture that symbolizes the highest degree of perfection, that through which he entered *parinirvana* (the complete *nirvana* achieved after death). Known as *uttarabodhimudra*, this involves bringing the hands together, usually beneath the chin but sometimes over the chest, with the palms touching and the thumbs and index fingers extended upwards so that they touch at the tips. The remaining fingers are curled down against each other or interlocked.

Opposite
In a special gesture symbolizing the highest degree of perfection achieved by Gautama Buddha at Bodh Gaya and known as the *uttarabodhimudra*, the hands are brought together over the heart or under the chin with thumbs and index fingers pointing upwards and the other fingers curled or interlocked.

Overleaf
Buddha statues can be shown holding a variety of objects, often with particular local significance. This evocative modern sculpture of Gautama Buddha goes its own way in terms of artistic style. Hilton Waikoloa Village, Hawaii, USA.

Svastika

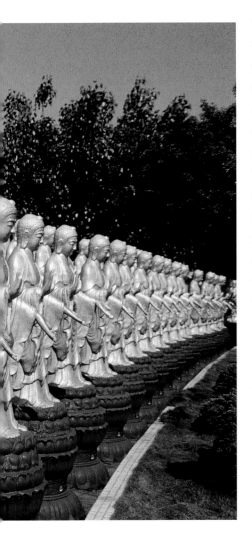

Today, with memories of the Second World War and Adolph Hitler still relatively fresh in people's minds, we tend to associate the symbolic device of a cross with its arms bent at 90 degrees with Naziism, but the *svastika* actually originates with the Indus Valley civilization of northern India about 4,000 years ago, and through most of history it has been considered a lucky object or one heralding auspicious circumstances. A *svastika* that turns to the right, in other words clockwise, is associated with the male principle, while a left-turning device is linked with the female. The *svastika* is often superimposed on the *paduka* or footprint of the Buddha in much the same way as the thousand-spoked wheel. More rarely it decorates another part of the body, and is sometimes emblazoned on the centre of the bare chest of a *buddha*.

Left

The *svastika* symbol in Buddhism is seen as an auspicious sign. Generally, though not in these ranks of *buddhas*, it is drawn right-handed for the male principle and left-handed for female. Fokyangsham monastery, Taiwan.

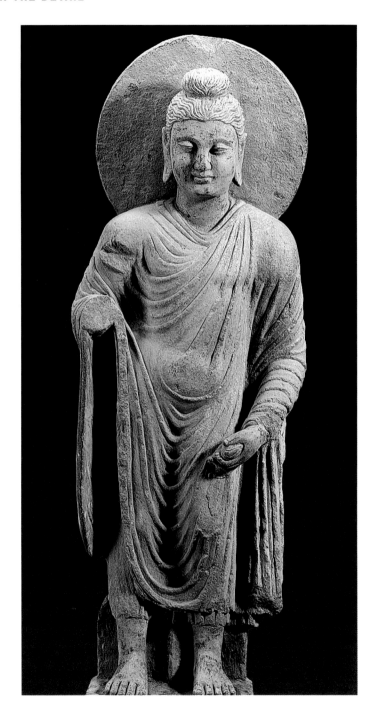

Robes

A Buddhist monk conventionally wears three types of garment, known collectively as the *tricivara*. These simple items of clothing include the *antaravasa*, a lower skirt that falls to the feet; the *uttarasanga*, a shirt covering the upper body and ending at the knees; and an outer robe, the *sangati*. But as a general rule, images of the *buddhas*, including Gautama Buddha, omit the *uttarasanga* and wear only two garments, albeit with variations in the style. On early standing images the Buddha is clothed only in the *antaravasa* held up by a belt, but as time passed sculptors added the *sangati*, the border of which he often clutches in his left hand. Occasionally the *uttarasanga* is included in token form, folded up and draped over the left shoulder rather than being worn.

The *sangati* is modelled in one of two styles: either in a mode that covers both shoulders or in a more revealing fashion with the right shoulder left bare. It is not clear why artists chose one style or the other and there is no symbolic explanation, but one possibility for the off-the-shoulder style is that it allows more scope to apply another of

Opposite

In this image carved from grey schist, the Buddha's *sangati* robe is draped in typically Graeco-Buddhist style, and he holds its hem in his left hand. Gandhara style, India, 3rd–4th century CE.

271

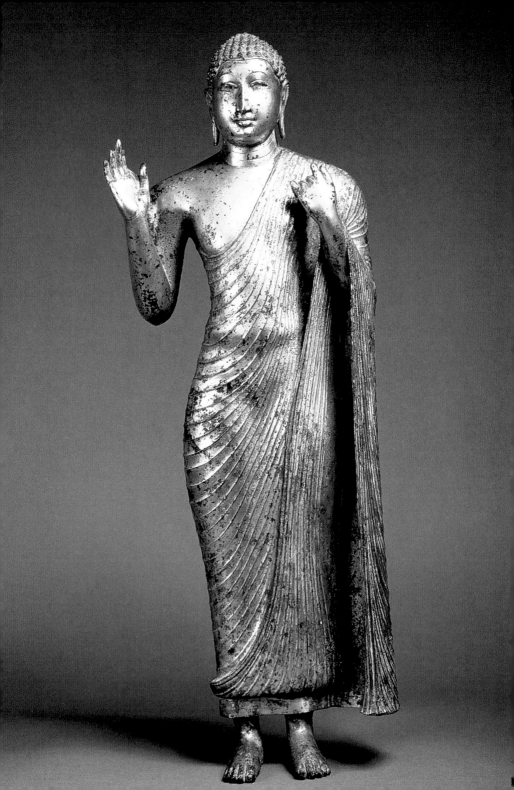

Left

When the outer robe or *sangati* is modelled in more revealing mode, it is draped over the left shoulder only, leaving the right upper torso nude. Anuradhapura School, Sri Lanka, 750-850 CE.

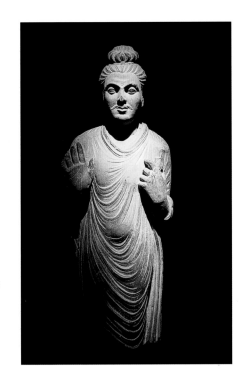

Right

In this image the *sangati* is draped in delicate folds over both shoulders. Strong Greek influence is evident in this standing *buddha* from the ancient northwest Indian empire.

"For one whose journey through life is over, freed from sorrow and with the chains broken, there is no more distress."

From the Dhammapada

273

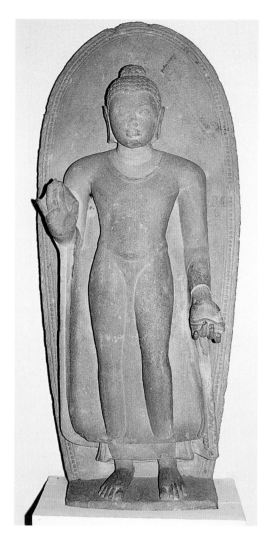

Above

Garments worn by *buddhas* may be sculpted to reveal folds and material texture or, as here, may be minimal and diaphanous. Sarnath, Uttar Pradesh, India, Gupta Period, 5th century CE.

Right

On this gilded statue, the *sangati* has been elaborated into complex folds. The *uttarasanga* is draped over the left shoulder. Shwedagon Pagoda, Yangon (Rangoon), Myanmar (Burma).

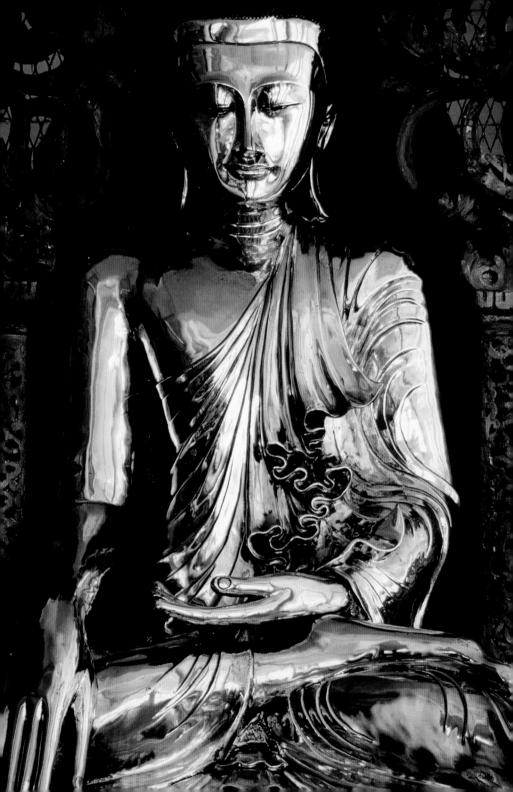

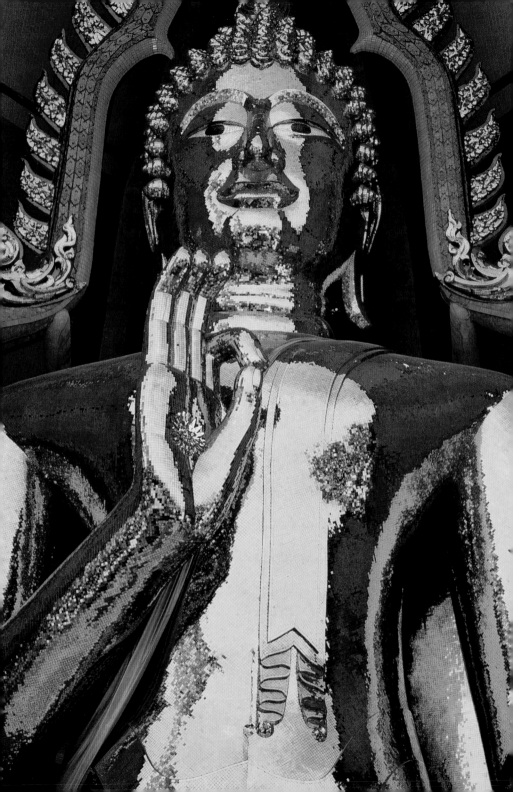

the Buddha's characteristic features, the colour gold. Most if not all the Hindu deities enjoy an identifying colour, and Buddhist artists follow this age-old convention. Subject to availability and the wealth of the commissioning patron, they may either mould the image in pure gold or cover the skin of the figure in gold leaf. The off-the-shoulder style may therefore be no more than a means of exposing as much of the golden skin as possible. In other cases, however, it is the robes that are coloured gold while the skin is left unpainted.

The material of the garments also varies according to the whims of one artist or another. In some portraits the robe is virtually invisible, like a second skin, while in others it is sculpted or painted quite realistically, with the cloth draped in folds. Sometimes the nature of the fabric is visible, and it may appear to be embroidered.

Buddhist monks' garments are often made from material that is dyed ochre. This was the conventional colour of the rags worn by ascetics in India, probably caused by staining from the ochre soil on which they rested. There is a custom at some temples to dress the *buddha* images in real orange or ochre-coloured fabrics for special occasions.

Opposite
On this gold *buddha*, which has a *cakra* wheel superimposed on the palm of the right hand, the artist has suggested a token third robe, the *uttarasanga*, draped over the left shoulder. Wat Tham Sua, Krabi province, Thailand.

Overleaf
The drabness of stone *buddha* images may be brightened by devotees using saffron- or ochre-coloured cloth to represent robes. Wat Si Chum, northern Thailand.

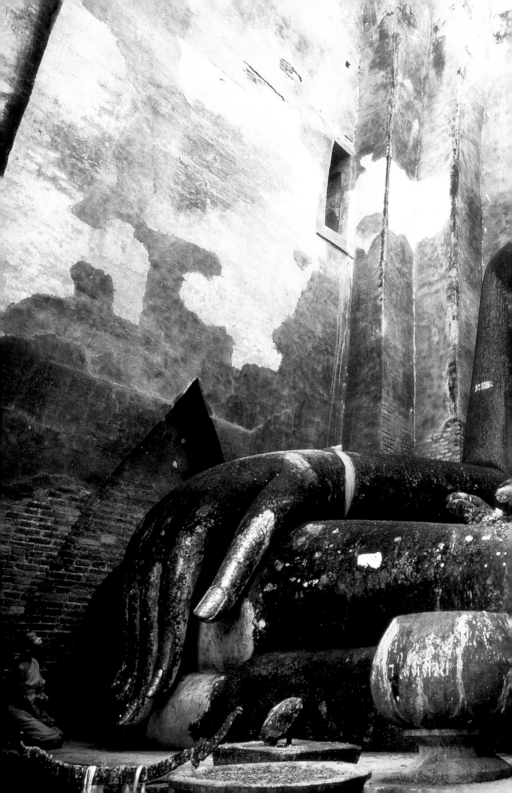

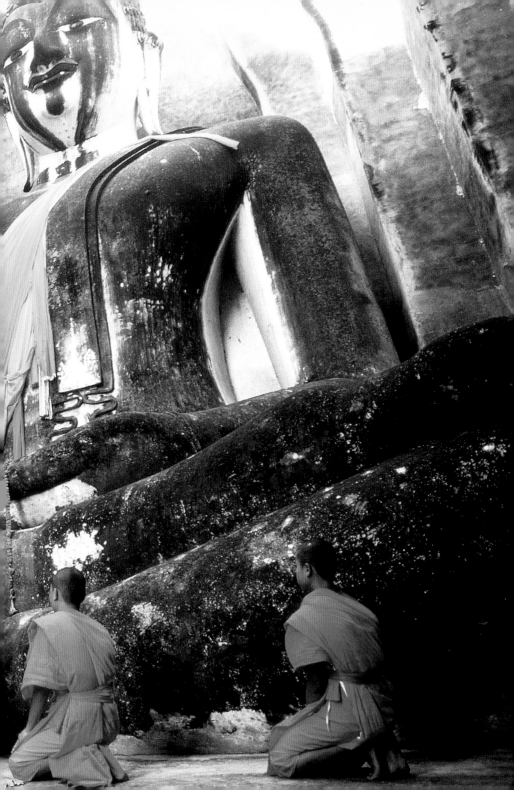

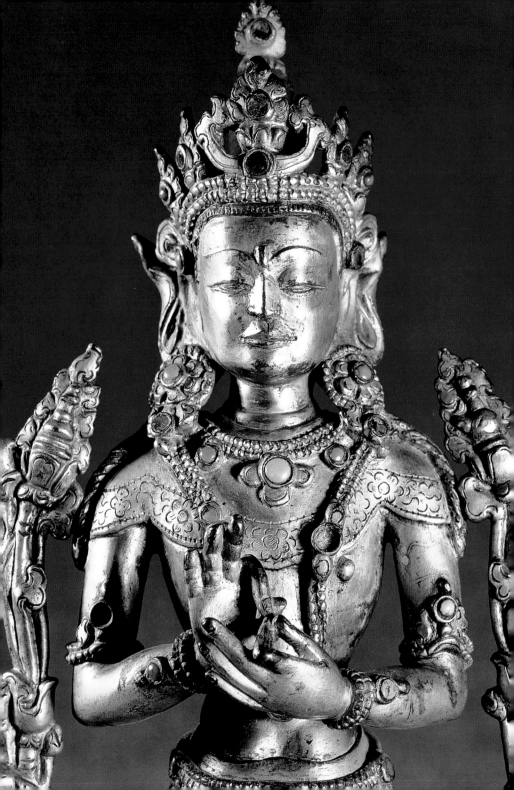

Ornaments

Buddhas-in-waiting, *bodhisattvas*, are allowed to wear an assortment of ornaments and garments that might be associated with princely life, but Gautama Buddha generally wears only his simple gowns and very few ornaments. These few include brooches or clasps that decorate his robe at the shoulders, most commonly in the form of flat discs. Peeping out beneath the *antaravasa* robe one can sometimes see an ankle bracelet called a *padajala*.

Left
This Tibetan *buddha*
image is richly adorned
with jewellery, including
earrings and crowns, that
make the most of local
gemstones. Maitreya, the
future *manusibuddha*,
Tibet, 15th century.

Sitting positions

Among Buddhist sculptors, seated poses are probably more popular than other positions; when these are associated with meditation they are known as *asana*-postures. Of these, the *padmasana*, the "lotus position", is most frequently depicted. In this classic pose of meditation adopted by the Gautama Buddha and also by other spiritual buddhas and many Hindu deities and Jain spiritual masters, the figure sits cross-legged, with the feet drawn up and resting on either the opposite thighs or the knee joints.

Sculptors and painters also portray *buddhas* and *bodhisattvas* in the "sitting on the throne" posture called the *paryankasana*, which can be shown with several minor variations. In one preference, the right knee is drawn up towards the chest while the left leg

Right
One of the most favoured postures for a *buddha* image is the *padmasana* or "lotus position". The figure sits cross-legged with the feet drawn up and resting on the opposing thighs or knees. Bodh Gaya, Bihar state, India.

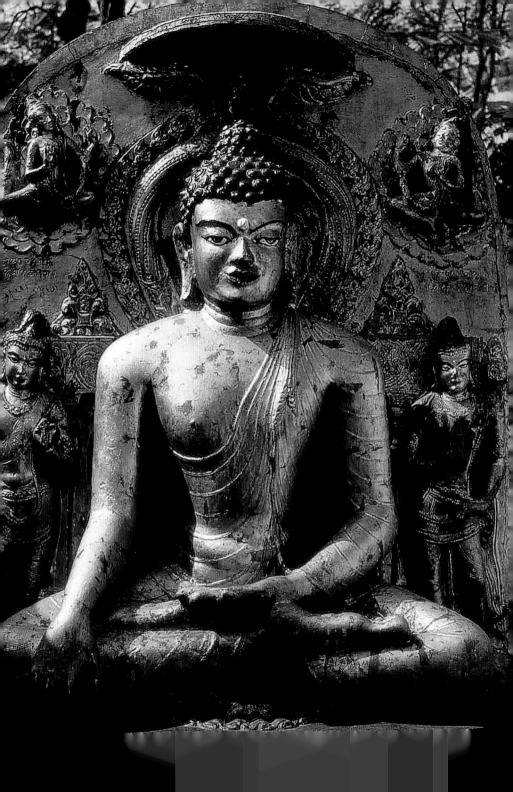

dangles down over the edge of the throne. In another, the right knee is flat against the seat as it appears in the *padmasana*, while the left leg hangs down. Sometimes the positions of left and right legs are reversed, and in yet another variation, known as the *virasana* or "hero sitting posture", the right leg hangs down while the left is bent and rested across the right thigh. Most of these *asana* attitudes do not in fact reflect any particular aspect of the Buddha's life or teaching and are really little more than artistic whimsy that has become part of Buddhist tradition. Some have been adopted as yoga meditation positions.

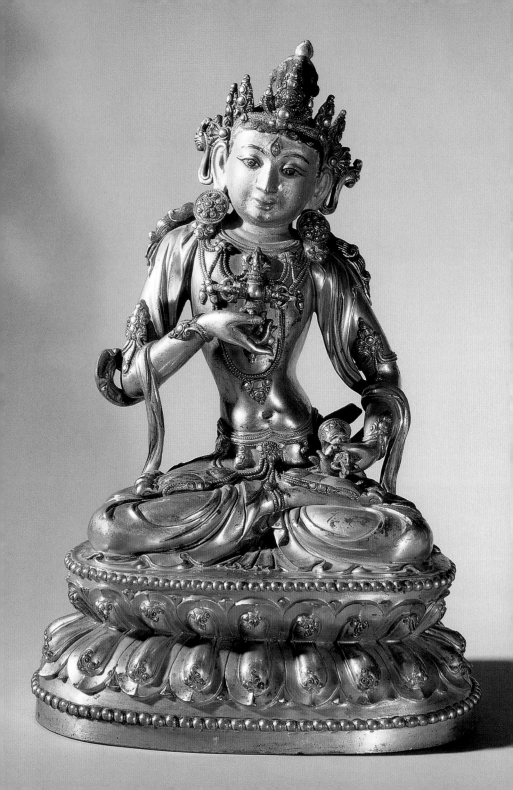

Throne

When the Buddha is seated, he is depicted on one of three types of throne. The most popular among artists has been the *padmapitha*, a throne in the shape of a lotus flower with eight petals, symbolizing the eightfold path of *dharma* teaching.

Alternatively, he sits on a more ornate "diamond throne" known as a *vajrasana*, often supported by snakes or *nagas*. Buddhist art, especially that of Indian origin and particularly in Sri Lanka, may reveal the Buddha actually resting on or surrounded by the protective coils of the seven-headed snake deity, Mucalinda. This curious serpent association recalls how Mucalinda wrapped the Buddha in its coils and spread its heads above him to shelter him from danger. The *nagas* are said to have the power to control the

Left

The seat or throne upon which the *buddha* sits is most frequently depicted as a lotus flower, reflecting the age-old belief in the lotus as a powerful symbol of genesis and purity. Image of Vajrasattva, Tibet, 17th century.

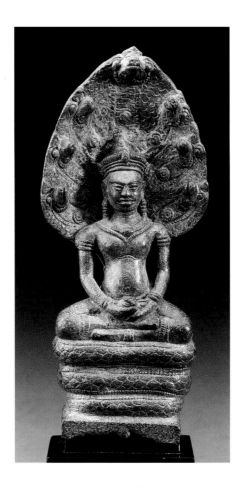

Above

Gautama Buddha is often depicted seated on the coils of the snake, a symbolism probably taken from Hindu tradition. This bronze statue shows the snake deity Mucalinda. Cambodia, Bayon Period, 13th century.

Right

The protective function of the *naga*, a many-headed serpent, is strikingly revealed in this seated statue of Gautama Buddha in which the *mandorla* takes the form of a cobra-hood.

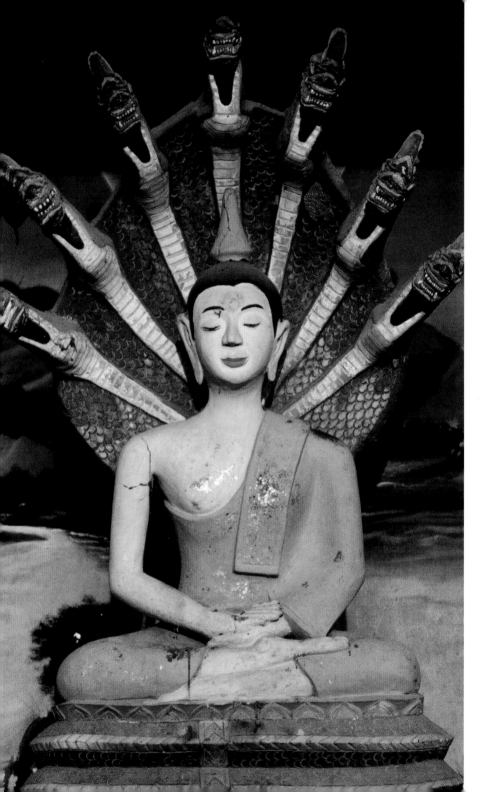

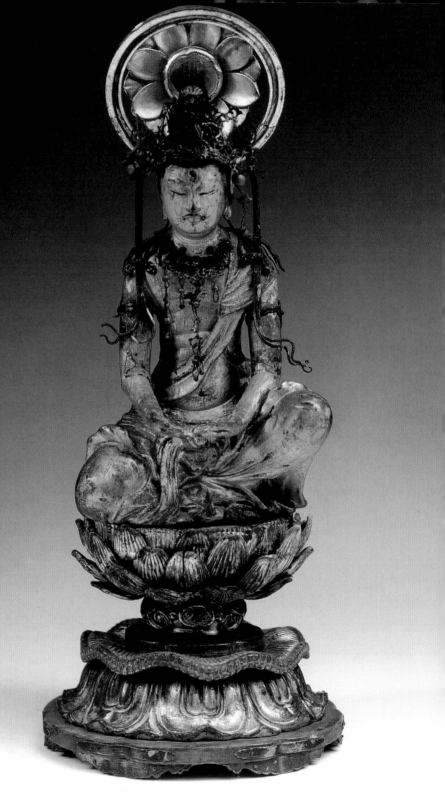

weather, especially rain, and one legend describes how Mucalinda shielded the Buddha from the ravages of a ferocious storm that threatened his life. The snake symbolism was probably copied from Hindu tradition, wherein the god Vishnu reposes on the snake Ananta, symbolizing the infinite.

In other works of art, the throne stands by itself, empty of any occupant, to symbolize the Buddha's presence. This absence of a figure is particularly employed when the throne is sited at the foot of the *bodhi* tree, capturing the exact moment of enlightenment.

Opposite
Thrones may vary greatly in their degree of ornateness. Here the lotus theme of the throne is echoed in the unusual eight-petalled nimbus.

"Like a lovely flower, beautiful and fragrant, fine words blossom in a person whose deeds are in accord."

From the Dhammapada

Nimbus

In many images the head of the Buddha is framed by a circle or disc. This conveys the idea of a luminous cloud or mist, a radiating spiritual aura of light that dispels darkness and ignorance and symbolizes wisdom and purity of heart. In this respect the nimbus carries a similar message to that of the flaming point atop the *ushnisha* or bun of hair on the crown of the head. It is a favourite tool of artists to draw on the imagery of a halo to signify that their subjects are deities or especially sanctified people, and the Buddhist nimbus is similar to that seen around the heads of principal Christian figures.

The sense may also be conveyed that the subject has been lifted up into the celestial realms of the sky. In Buddhist art the nimbus began as a simple disc emulating the sun, the principal source of light in the heavens, and some *bodhisattvas* may actually take the name Suryaprabha, "Light of the Sun". Gradually the nimbus became increasingly ornate, and if crafted in bronze or stone it can be elaborated into intricate fretted patterns.

Opposite
The nimbus or halo conveys the artistic impression of a radiating aura or luminous cloud and identifies a person who is especially sanctified. This Graeco-Buddhist statue has a simple disc nimbus. Gandhara, Pakistan/Afghanistan.

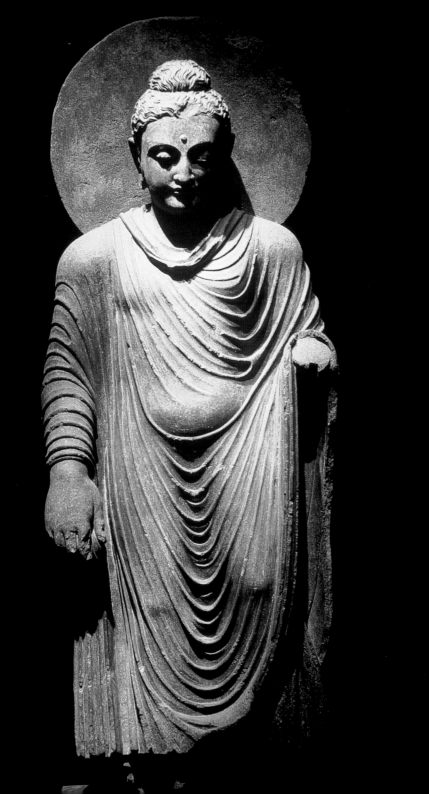

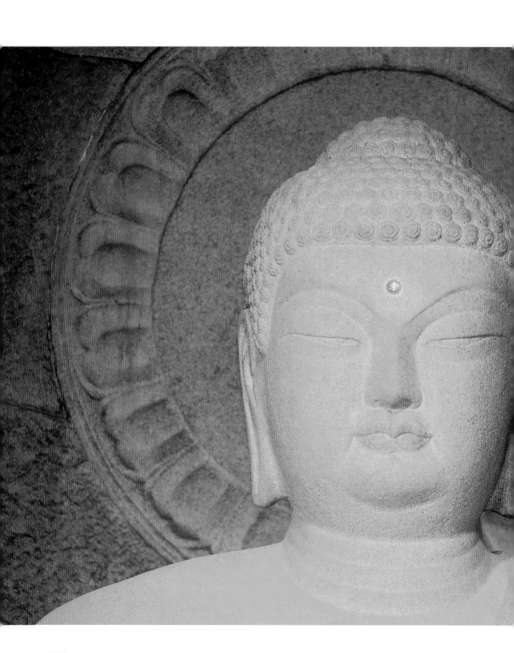

Left

A nimbus may be elaborated in an assortment of artistic styles. Here the sculptor has created the impression of a flaming sun disc. Shakyamuni Buddha, Sokkuram temple, near Kyongju, South Korea, 8th century CE.

Overleaf

This gilt nimbus has been ornamented with a design of fretwork and lotuses, complementing the scrolls and miniature *buddhas* in the *mandorla* outside it.

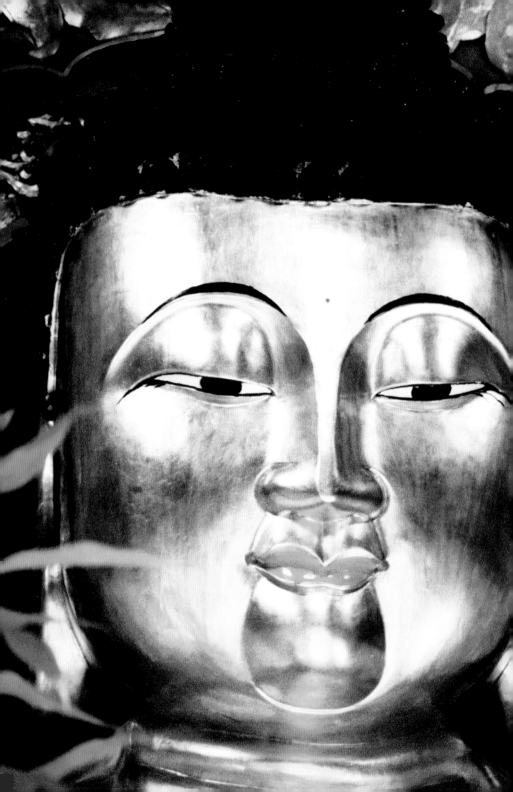

Mandorla and accessories

Beyond the nimbus there is often a *mandorla*, a shield-shaped or lyre-shaped plate, generally worked into the shape of flames. Its inspiration derives from the association of flames that Gautama Buddha made to appear miraculously leaping from the upper parts of his body during the miracle at Kapilavastu (see page 34). *Mandorlas* – which take their name from the Latin for almond, in reference to their shape – can provide the merest hint of a fiery backdrop or be extremely ornate, but in either case they supplement the imagery generated by the flaming pointed topknot. Sometimes the idea that the Buddha has ascended to the sky is also reinforced, with cloud-like designs and, on occasion, small celestial figures that flutter round his head like angels, perhaps playing musical instruments.

An umbrella or parasol, known in Sanskrit as a *chattra*, is also associated with *buddha* images, and in parts of the Orient one can come across a brightly coloured umbrella placed over a statue. Since very ancient times the *chattra* has been an emblem of royalty in India. But it also has a protective function against the elements, and in this way it came to symbolize the presence of the Buddha. His departure from his palace to become an ascetic is often depicted in the form of a riderless horse surmounted by an umbrella.

Right
The *mandorla* or backdrop to images of Gautama Buddha takes the form of a shield shaped into flames. This example is a relatively straightforward painted design of flames and miniature *buddhas*. Yungang grottoes, Wuzhou Mountains, Datong, Shanxi province, China, 5th century CE.

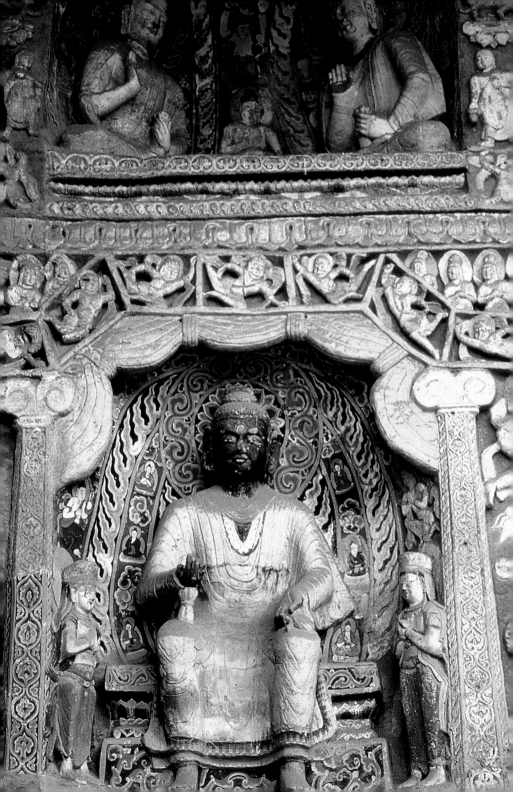

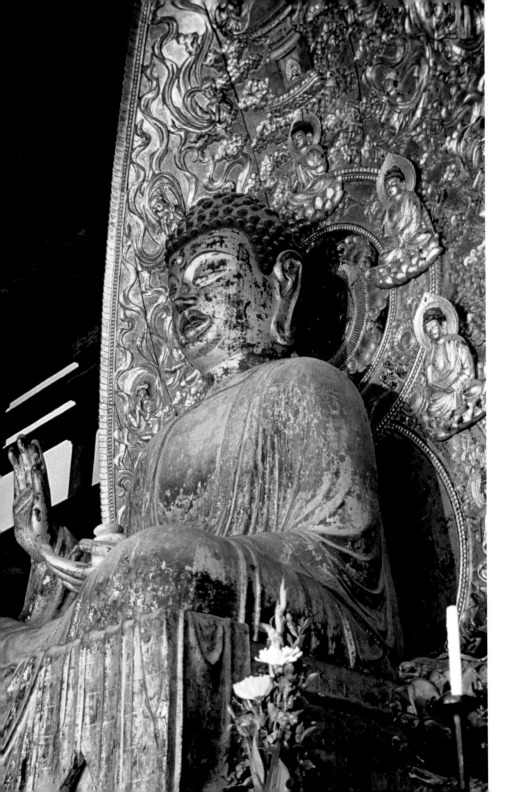

Left

The *mandorla*, here showing its fiery origins, is often sculpted in the shape of a lyre. Seated Amida Buddha (Amitabha) in marble. Japan, 6th century CE.

Below

This *mandorla* has been sculpted so as to blend with a stylized *bodhi* tree and three *buddhabimbas* (miniature *buddhas*). Double-sided altarpiece cast in bronze with silvery-green patina. Lop Buri, Thailand, 12th–13th century.

Left

The features of *mandorla* and nimbus are combined and greatly elaborated in the backdrop to this Buddha, which includes miniature *buddhas*, musicians and other angelic beings seated amid clouds. Yakushi Buddha (the *manusibuddha* Bhaisajyaguru), Kofuku-ji temple, Nara, Japan.

301

Mandala

An exploration of devices and symbols associated with the Buddha would not be complete without mention of the *mandala*. The word means literally a "magic circle" and this fairly accurately describes the device that the Buddha taught his disciples to use. It is a magical geometric pattern signifying not only the Buddhist world but also the mystery and orderly nature of the cosmos; if you like, a kind of map of the universe.

The *mandala* may be represented in a two-dimensional drawing on a piece of paper or as an engraved sheet of metal, or it can be in three-dimensional form as substantial as piles of bricks or stones. One of the most beautiful of all permanent *mandalas* is the colossal Borobudur monument in Indonesia (see pages 130–135), a vast stone structure built during the ninth century CE, its eight ranks of terraces adorned with bas-reliefs depicting notable occasions in the life of the Buddha. In its least substantial guise, a *mandala* may be scratched momentarily in the sand or created through scattering grains of rice on the ground in a regular pattern, as some Buddhists do each day when they make their symbolic offerings to the universe.

Put another way, a *mandala* is effectively the visible equivalent of a *mantra*, the mystic sound uttered repeatedly – sometimes in the form of a silent thought, sometimes chanted – of which the "om" syllable is perhaps the best known. Both the *mantra* and the *mandala* are psychological tools through which the mind can be focused and disciplined towards a state of calm, cleared of its jumble of distracting material thoughts.

Right
The *mandala* or "magic circle" is a geometric pattern, often painted or woven, representing the Buddhist world and the orderly, if mystical, nature of the cosmos. Tibet.

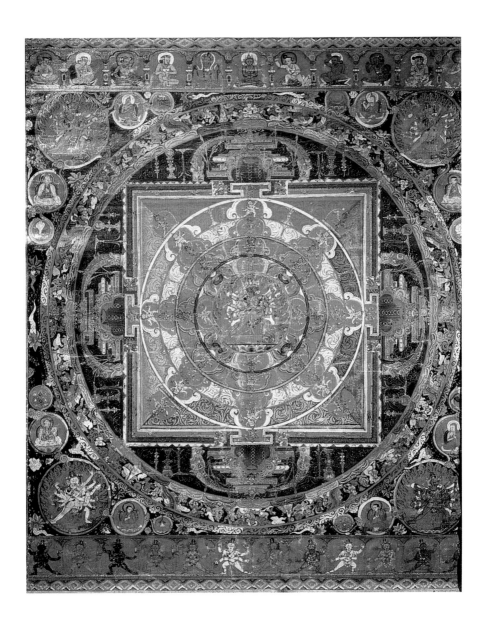

Right
A *mandala* is not merely a two-dimensional design but may be elaborated into a three-dimensional architectural structure. The great temple complex of Borobudur is laid out as a massive *mandala*. Java, Indonesia, 9th century CE.

Overleaf
A woman devotee kneels before an image of the Buddha and reaches forward to touch the wheels or *cakras* superimposed on the feet of the statue. Sri Lanka.

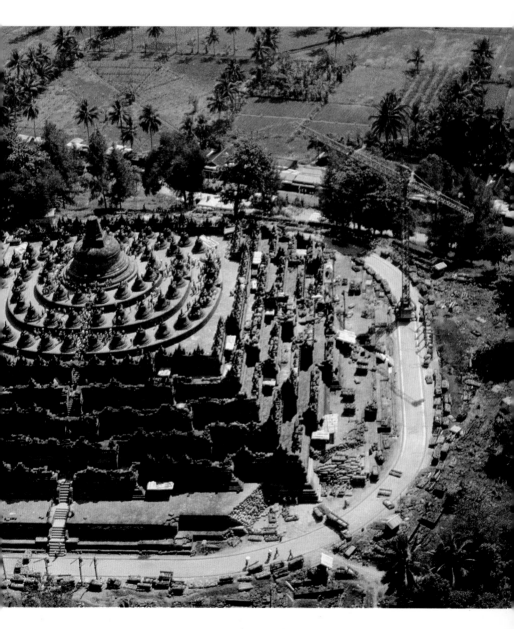

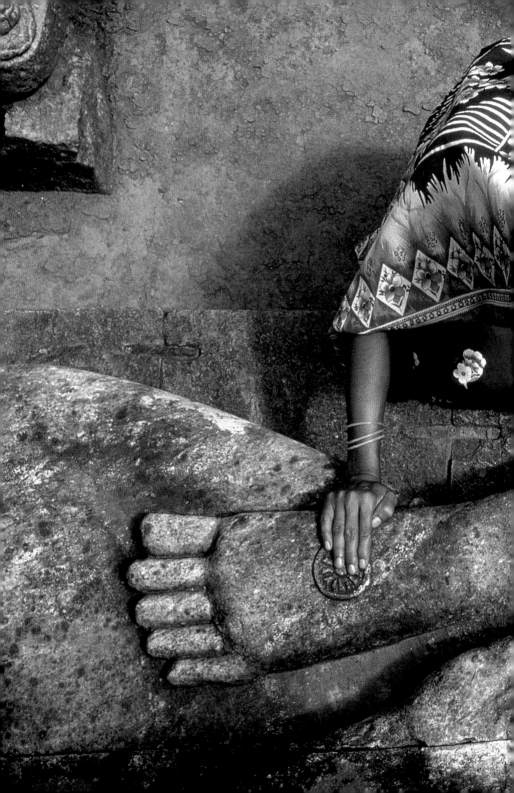

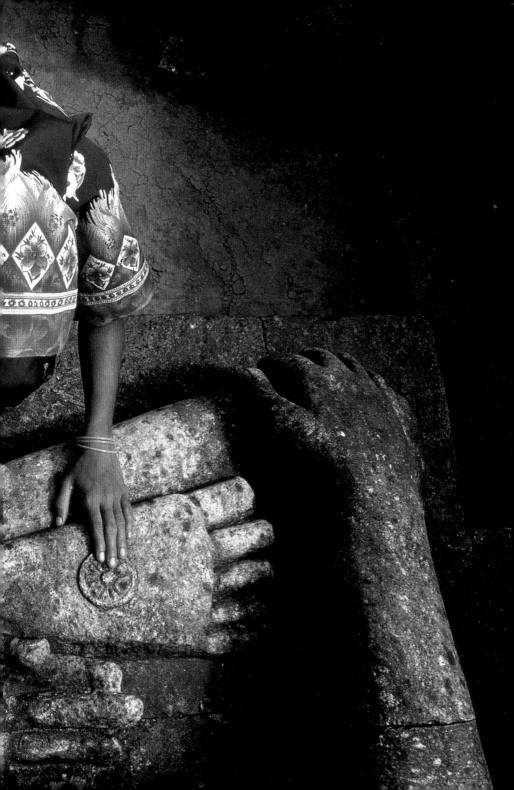

Glossary

abhayamudra A hand gesture symbolizing fearlessness and reassurance.

Adibuddha The primordial force in the universe, the essential divine Buddha.

agama A book containing a traditional doctrine or collection of doctrines.

Aksobhya One of the *dhyanibuddhas*.

Amida The Japanese name for Amitbha.

Amitbha One of the *dhyanibuddhas*.

Amoghasiddhi One of the *dhyanibuddhas*.

anjalimudra A hand gesture, traditional in greetings.

antaravasa A lower skirt falling to the feet.

Anuradhapura A style of Sri Lankan Buddhist art from third to tenth century CE.

asana A sitting position in Buddhist and Hindu iconography.

Ashoka A ruler (273–232 BCE) during the Mauryan Dynasty of India who strongly supported Theravada Buddhism.

asvattha A type of fig tree or pipal that became known as the *bodhi* tree.

Avalokitesvara Popular *bodhisattva*, seen as a saviour figure. Possibly originating from the Hindu god Vishnu, he became the tutelary Buddha of Tibet and was transformed in China, Korea and Japan into a goddess of mercy.

Bhaisajyaguru One of the *manusibuddhas*, seen as the medicine *buddha*, popular in Tibet.

bhumisparsamudra A hand gesture that symbolizes calling the earth to witness.

Bodh Gaya Place in India where Gautama Buddha attained enlightenment.

bodhi The tree beneath which Gautama Buddha gained enlightenment.

Bodhidharma Fifth- or sixth-century monk who introduced Zen-type Buddhism into China.

bodhisattva A *buddha*-in-waiting.

Bon The ancient magical and shamanistic religion of Tibet.

bosatsu The Japanese word for a *bodhisattva*.

Brahman A member of the first caste in India, the sacerdotal class.

Buddha The name given to Gautama Siddharta, but also the term applied to someone who has achieved the state of perfect enlightenment.

buddhabimba A small model or mannequin representing a *buddha* manifestation.

cakra The mystical wheel that became a central symbol of *dharma* teaching.

candi Indonesian Buddhist temple or *stupa*.

Chan Original Chinese version of Zen.

chattra An umbrella representing the traditional symbol of both spiritual and material protection in Buddhism.

Ching Tu Chinese Buddhist school allied to Zen that focuses on the *dhyanibuddha* Amitbha.

chorten Tibetan word for a *stupa*.

cintamani A jewel originating in Hindu tradition and said to grant wishes.

Confucianism Ethical system emphasizing justice and devotion to family, influential in China and Korea.

dharma The law of Buddhism and the way to perfection.

dharmacakra The symbolic wheel of the law.

dharmacakramudra A gesture involving both hands and symbolizing the setting in motion of the wheel of the law.

dhyanamudra A hand gesture symbolizing meditation.

dhyanibuddha One of a line of spiritual buddhas with no temporal form, manifestations of Adibuddha.

Eightfold Path The central theme of Mahayana teaching and discipline.

Gandhara The ancient region now encompassed by northern Pakistan and northeastern Afghanistan.

Gandhara style An artistic tradition revealing strong classical Greek influence.

Gautama One of the names of the historical Buddha, favoured during and after his search for enlightenment.

Guanyin The Chinese version of the *bodhisattva* Avalokitesvara.

Hinayana A branch of Buddhism, synonymous with Theravada. Its literal meaning is "the Lesser Vehicle", but it is the more widespread form.
Hui Neng Seventh-century Zen patriarch, influential in China and Korea.

Jizo The Japanese version of the *bodhisattva* *Kshitigarbha*.

kami Japanese Shinto deity or deities.
Kannon The Japanese version of the *bodhisattva* Avalokitesvara.
karnika Decorative earrings.
Kshitigarbha *Bodhisattva* who protects children, travellers and the suffering.
Kuan Yin Korean name for the *bodhisattva* *Avalokitesvara*.

laksana See *mahapurusalaksana*.
Lokanat Burmese name for the *bodhisattva* Avalokitesvara.
Lokesvara Thai name for the *bodhisattva* *Avalokitesvara*.
Lotus position See *padmasana*.
Lotus Sutra Buddhist scripture that stresses the importance of emptiness, morality and compassion, central to the Tiantai (China) and Tendai (Japan) sects.

Magadha Ancient kingdom that existed before becoming part of northern India.
Mahabodhi The great tree (of enlightenment).
mahapurusalaksana The 32 "Great Marks" of a *buddha*.
Mahasanghaka A school of Theravada that became established in Afghanistan.
Mahavamsa One of the most important sacred Buddhist texts in Sri Lanka.
Mahayana Liberal, democratic branch of Buddhism developed in the first century CE, the "Great Vehicle" that expanded from northern India to Nepal, Tibet, Mongolia, China, Korea and Japan.
Maitreya The anticipated incarnation of the *buddha* of the future. In China and Japan he is also incorporated into the fat, laughing *buddhas*, bringers of good fortune.

mandala Magical geometric pattern symbolizing the Buddhist world and the mystical, orderly nature of the universe.
mandorla A shield-shaped (or almond-shaped) plate set behind an image, generally worked into the resemblance of flames.
mantra A mystical sound, uttered repeatedly as a psychological tool aiding meditation.
manusibuddha One of a line of living or historical *buddhas*.
Mathura style An artistic tradition with strongly Indian and yogic influence.
mudra A symbolic gesture generally associated with the hands.
mukutadharin A special representation of a *buddha* wearing a crown.

naga A protective cobra-like serpent, often with many heads.
Nagarjuna An influential Buddhist sage who lived in the second century CE.
nimbus A decorative circle or disc behind the head of a *buddha* symbolizing a spiritual aura.
nimilita A description of the eyes when almost closed in meditation.
nirvana A state of perfect enlightenment, the end of *samsara*.

padajala An ankle bracelet sometimes worn by a Buddhist monk.
padmapitha A throne in the shape of a lotus flower.
Padmasambhava Eighth-century monk who popularized Buddhism in Tibet.
padmasana The seated posture known as the "lotus position".
paduka The footprints of Gautama Buddha.
parinirvana The totality of *nirvana* or perfect enlightenment.
paryankasana The posture known as the "sitting on the throne" position.
Polonnaruwa A style of Sri Lankan Buddhist art flowering briefly in the 13th century.

Ratnasambhava One of the *dhyanibuddhas*.

samsara The material cycle of birth and death leading to rebirth.

sangati An outer robe which may be worn exposing one shoulder.

sangha Buddhist community of monks.

Sanskrit Script used by *Mahayana* Buddhists.

Shakyamuni "The wise man of the Shakya clan", a name given to the historical Buddha.

Shingon One of the main forms of Japanese Buddhism, a Tantric-influenced school founded by Kobo Daishi.

Shinto Indigenous shamanistic religion of Japan.

Siddharta Given name of *Gautama Buddha*, used in his early life.

sinhakundala Earrings in the shape of lion heads.

Son Korean word for Zen.

srivatsa A curl of hair between the eyebrows or on the chest, symbolizing the source of the natural world.

stupa A traditional shrine or monument in pyramidal or dome-shape reflecting the topknot of hair worn by *Gautama Buddha*.

sunyata The concept of emptiness in which there is neither existence nor non-existence.

sutra A religious work consisting of verses strung together in a sequence.

svastika A lucky symbol in the form of a cross with arms bent.

Tantrism A magical and ritualistic cult expression, not strictly religious.

Taoism Shamanistic native religion of China.

Tendai Japanese version of *Tiantai* school of Buddhism.

Theravada The older and more conservative branch of Buddhism, concentrated mainly in southern India, Sri Lanka and Indo-China.

Tiantai Chinese school of Buddhism focusing on the teachings of the *Lotus Sutra*.

tilaka The secular equivalent of an *urna*.

Tipitaka The book of Theravada scriptures composed in Pali, the ancient script of the first Buddhist communities in India, and carved on 729 marble slabs in Myanmar (Burma).

Tribhumikatha A compilation of 30 Buddhist religious works in a single volume, the earliest Buddhist literary work in Thailand.

tricivara The collective term for the three items of clothing worn by a Buddhist monk.

trivali Three folds in the neck of a *buddha*, symbolizing good fortune.

Tryastrimsa The realm of heaven occupied by the 33 major Hindu deities.

urna A decorative spiritual mark in the centre of the forehead.

ushnisha A turban-like hair style emulating that of *Gautama Buddha*, sometimes depicted as a raised bump.

uttarabodhimudra A hand gesture symbolizing the highest degree of perfection obtained in *nirvana*.

uttarasanga A shirt covering the upper body and ending at the knees.

Vairocana One of the *dhyanibuddhas*.

vajrasana A diamond throne.

Vajrayana A form of Buddhism found mainly in Tibet with a strong focus on magical elements.

varadamudra A hand gesture symbolizing blessing.

Vedic Relating to the Vedas, the most ancient texts of Hinduism.

vinaya The set of monastic rules laid down by *Gautama Buddha*.

virasana The sitting position known as the "hero posture".

vyakhyanamudra A hand gesture symbolizing perfect wisdom and explanation.

wat The Thai word for a *Theravada* Buddhist temple.

Wu The ancient shamanistic religion of China, but also used in Taoism to mean a state of nothingness.

Yakushi Japanese name for Bhaisajyaguru.

Zen A sectarian development of Buddhism focused on introspection and intense meditation, mainly practised in Japan, China and Korea.

Places to Visit

Afghanistan
• Valley of Bamiyan, 230 kilometres (145 miles) northwest of Kabul. Site of massive Buddha statues dating from the third to fifth century CE, blown up in 2001 but planned for reconstruction. (See pages 90, *91*.)

Cambodia
• Angkor Wat, Angkor Thom – including Bayon temple. Stupendous collection of ruined temples, half overgrown by jungle, built between the ninth and 13th centuries. (See pages *136*, *137*, *139*, *140*, 141.)

China
• Datong, Shanxi province – Yungang caves. Indo-Gandharan-style cave-temple art from the late fifth century. (See pages *162*, *163*, *164*, *170*, 181, *224*, *299*.)
• Dazu, Sichuan province. Southwest Chinese cave temples created between the ninth and 13th centuries. (See pages *172*, *173*.)
• Dunhuang, Gansu province – Mogao caves. Unique array of cave temples in the desert, dating from the fourth to 14th centuries and revealing various styles. (See page 181.)
• Hangzhou, Zhejiang province – Lingyin-si temple and grounds. Characterful rock carvings. (See pages *52*, *178–179*.)
• Lantau island, Hong Kong – Tian Tan Buddha, Po Lin monastery. Large outdoor Buddha, built in the 1990s, with panoramic views. (See pages *159*, *174–175*, *177*, *223*.)
• Leshan, Sichuan province. The world's largest statue of Gautama Buddha, carved in a cliff face in the eighth century. (See pages *3*, *166–167*, *168*, 180.)
• Luoyang, Henan province – Longmen caves. Typical Chinese-style sculptures from the fifth to tenth centuries. (See pages *171*, 181.)
• Mount Wutai, Shanxi province. One of China's four Buddhist mountains, with surviving temples from various eras, reflecting both Chinese-style and Tibetan-style art and architecture. (See pages *182*, *284*.)
• Xining, Qinghai province – Ta'er-si (Kumbum) monastery. Tibetan monastery specializing in *buddha* statues made from yak butter. (See page *183*.)

India
• Ajanta, Maharashtra state. Ancient cave temples, from the second century CE. (See pages *51*, *71*.)
• Bodh Gaya, Bihar state. Scene of Buddha's enlightenment under the *bodhi* tree. (See pages 22–28, 58, *60*, 64, 68, 259–262, *283*.)
• Delhi – National Museum. Contains treasures of Buddhist art.
• Kusingara, near the Nepalese border. The place where Gautama Buddha died and entered *nirvana*. (See pages 44, 58, *58*.)
• Rajaghra. Where the Buddha overcame attempts on his life by Devadatta. (See pages 58, 64.)
• Sanchi, Madhya Pradesh state – Great Stupa built by King Ashoka (273–232 BCE), a devout Buddhist. (See pages *32*, *219*.)
• Samkasya. Place of the Buddha's legendary return to earth down the triple staircase. (See pages 36, 58.)
• Sarnath, Uttar Pradesh state. Where Buddha first taught, in a deer park. (See page 58.)
• Sravasti. Where the Buddha lived for over 20 years. (See page 58.)
• Tikse, Ladakh, and nearby towns – Tibetan Buddhist monasteries. (See pages 65, *68*.)
• Vaisali (or Vaishali), Bihar state. Where the Buddha ended a plague. (See page 58.)

Indonesia
• Borobudur, Java. Extraordinary Hindu-influenced, *mandala*-structured temple complex dating from the eighth and ninth centuries. (See pages *130*, 131, 132, *133*, *134*, 135, *305*.)
• Kalasan, Java. Eighth-to-ninth-century Hindu-influenced temple. (see page 135.)
• Sari, Java. Hindu-influenced temple from the eighth to ninth century. (See page 135.)

Japan

• Kamakura, near Tokyo – Daibutsu (Great Buddha), charismatic 13th-century bronze statue (see pages *198*, *199*, *260–261*); fine *buddha* images in temples such as Hase-dera.
• Kyoto – Koryu-ji temple, home to a delicate wooden eighth-century Korean statue of Maitreya Buddha; To-ji temple, Shingon-sect seminary with an excellent *mandala*; Mount Hiei, founding temple of the Tendai sect (see page 200).
• Mount Koya, Wakayama prefecture. Peaceful mountain monastery, headquarters of the esoteric Shingon sect. (See pages *195*, 198–200.)
• Nara and environs – Todai-ji, one of Japan's prime temples and home to the world's largest bronze *buddha* (see page *194*); Kofuku-ji temple, containing excellent seventh- and eighth-century images (see page *300*); Toshodai-ji temple, with Chinese-influenced eighth-century works (see page *40*); Horyu-ji temple, the cradle of Japanese Buddhism, containing classic *buddha* images; Yakushi-ji temple, including eighth-century Buddhist images showing Central Asian influence; Nara National Museum and Shoso-in, repository of Buddhist art from the Silk Road as well as from Japan.
• Tokyo – National Museum. Numerous fine Buddhist statues, both from Japan and from overseas.
• Uji, near Kyoto – Byodo-in temple, prime example of 11th-century *buddha* image. (See pages *201*, 202.)

Laos

• Luang Prabang and environs. First capital of Laos, site of fine 16th–18th-century Buddhist art (see page 143) – temples of Wat Xieng Thong and Wat Winusalat (see page 145); Pak Ou caves, evocative early-eighth-century statues (see pages *144*, *147*).
• Vientiane – Pagoda of One Thousand Buddhas at Wat Si Saket (see pages *142*, 145–146); sculpture park; Wat Phra Keo temple,

1930s-rebuilt former home of the Emerald Buddha (see page 143).

Myanmar (Burma)

• Bagan (Pagan). Mass of temples spread across the plain, dating from the 11th century onwards. (See pages *92*, 96, *96* [Paya Thonzu temple], *98*, *99*, *101*.)
• Mandalay (see pages *95*, 106) – 11th-century Mahamudi Buddha, Mahamuni temple (see pages *103*, 106); Kuthodaw pagoda, home to the world's "largest book", carved on 729 marble slabs (see page 106).
• Shwedaung – Shwemyethman pagoda, with an unusual bespectacled Buddha. (See pages *107*, *237*.)
• Yangon (Rangoon, see page 106) – Shwedagon pagoda, bejewelled 11th-century repository of hairs of the Buddha (see pages *94*, *97*, *275*); and many more fine examples of Buddhist imagery.

Nepal

• Kathmandu – Bodhnath *stupa*, popular centre for Tibetan Buddhists (see page *77*); Swayambhunath temple, showing Hindu influence (see pages *72*, *74–75*).
• Lumbini (Kapilavastu), near the border with India. Buddha's birthplace and the scene of his miracle of fire and water. (See pages 12, 34, 58, 70.)

South Korea

• Kochang – Sonun-sa temple. (See pages *192–193*.)
• Kyongju – Sokkuram "cave of the stone Buddha", tranquil eighth-century granite image of Buddha, attended by *bodhisattvas*. (See pages *188*, *294*.)
• Monasteries of the Nine Mountain Schools: Mount Kaji, Mount Tongni, Sorak Mountains (Songju), Mount Chiri, Mount Pongni, Mount Paekdal, Mount Saja and Mount Sumi.
• Pusan – Pomo-sa temple, Kumjong-san peak, home to a seventh-century painting of the *dhyanibuddha* Vairocana. (See page 191.)

• Seoul – Chogye-sa, the only major temple within the old city walls (see pages *17*, *186*, *187*, 190); Shilluk-sa temple, headquarters of Korea's largest Son (Zen) sect (see pages 190–191); National Museum, fine Buddhist statues.

• Taegu – Haein temple complex, an active monastic centre on a wooded mountainside, for both monks and nuns, containing fine Buddhist imagery dating from the ninth century. (See page *190*.)

Sri Lanka

• Anuradhapura, North Central province. Ancient capital of Sri Lanka in the third to tenth century – Mahavihara temple. (See pages 78, 81.)

• Polonnaruwa, 12th/13th-century centre – Gal Vihara rock shrine. (See pages *30*, *42–43*, *80*, 81, *83*, *84*.)

Thailand

As Thailand has around 27,000 temples or *wats*, any selection of locations is inevitably somewhat arbitrary. Below are some of those featured in this book, but any trip through Thailand will unearth a profusion of Buddhist images that show skill, artistry and the serenity and significance of Buddhist faith.

• Ayutthaya. (See pages *122–123*, *124*, *125*.)

• Bangkok – Wat Benchamabophit temple, with its superbly crafted 20th-century *buddha* (see page 116); Wat Chai Watthanaram (see page *117*); Wat Phra Keo temple, containing the Emerald Buddha (Phra Keo) originally from Laos (see page 143); Wat Pho for its huge reclining *buddha* (see pages 116, *120*, *121*); National Museum, home to many a fine *buddha* image.

• Ko Tao island – Big Buddha. (See page 115.)

• Krabi province – Wat Tham Sua. (See page *276*.)

• Sukhothai. (See pages *109*, *110–111* [Wat Mahathat].)

Tibet

• Lhasa and environs (see pages *150*, *156*) – Potala palace; Jokhang temple; Drepung monastery; Sera monastery (see pages *154–155*), all containing many fine statues and *mandalas*.

• Samye. The first Buddhist monastery in Tibet, founded in the eighth century and structured as a giant *mandala*. (See page 149.)

• Shigatse – Salu monastery (see page *148*); Tashilunpo monastery. Numerous Buddhist statues and paintings, some ancient, some modern.

Index

Acknowledgements

The Dalai Lama: *The Path to Enlightenment* ed. and transl. Glen H. Mullin. New York 1982

The Dhammapada transl. John Richards, Pembrokeshire (UK). Internet 1993

The Dhammapada transl, Acharya Buddharakkhita.
<www.ishwar.com/dhammapada>

Picture Credits

Alamy 1, 4, 44/5, 51, 114, 132/3, 173, 178/79, 181, 236 **Axiom** 8, 80t, 82, 204 **Art Archive** 10–11.13,16, 29, 35, 46–7, 100, 112, 149, 152, 157, 170, 196, 200, 220, 245, 248, 290 **AKG** 41, 42–3, 56–7, 58, 63, 71, 87, 85, 148, 153, 163, 168, 201, 224, 229, 242, 248, 249, 257, 272, 273, 274, 278–79, 285, 293, 299, 306–7 **The Bridgeman Art Library** 25, 27, 36–7, 88, 105, 130, 136, 158, 161, 182, 205, 228, 232, 263, 280, 284 **Corbis** 2, 6, 14–15, 17, 21, 24, 32, 48–49, 62, 66–67, 72, 73–74, 76, 77, 79, 90–91, 92, 104, 107, 113, 118, 122–23, 124, 125, 126, 127, 128–9, 151,172, 174–75, 183, 188, 190, 191, 192–93, 195, 197, 199, 202, 203, 208, 213, 214–15, 216–17, 219, 230, 233, 234–35, 247, 258, 260–61, 266–67, 268, 289, 294–95, 296–97, 304–5 **Christies Images** 22, 23, 38, 270, 288, 301b **Getty** 30, 52, 42–3, 64–5, 80b, 84, 97, 110–11, 137, 139, 142, 144, 159, 166–67, 177, 184, 206–7, 223, 253, 256, 275, 276 **Panos Pictures** 40, 98, 99, 101, 103, 187, 188b, 189 **Photonica** 246, 250 **Photos 12** 20, 102, 108–9, 115, 117, 120, 154–55, 156, 162, 186, 283 **Powerstock Zefa** 68, 94, 95, 96, 140, 180, 254–55, 264 **Rex Features** 19, 21, 121, 134, 160, 165, 210–11, 212, 243 **Catherine Rubinstein** 146–47, 198, 300 **Topham** 54–55, 69, 106, 209 **Trip and Art Directors** 60, 171, 194 **Victoria & Albert Museum** 138, 301t **Werner Foreman Archives** 59, 83, 89, 150, 164, 185, 226, 239, 240, 252, 286, 303